J. P. Hodin
was a distinguished art historian
and critic who contributed frequently to various
international art periodicals. His many books include *Oskar
Kokoschka: A Biography*, *Emilio Greco: Sculpture and Drawings*,
Modern Art and the Modern Mind and monographs on John
Milne, Else Meidner, Elisabeth Frink, Douglas Portway and
Franz Luby. He received his doctorate at Prague University,
and was honoured with many other degrees and awards,
including the Norwegian Order of St Olav
(in recognition of Munch studies).

Thames & Hudson world of art

This famous series
provides the widest available
range of illustrated books on art in all its aspects.
If you would like to receive a complete list
of titles in print please write to:
THAMES & HUDSON
181A High Holborn, London WC1V 7QX
In the United States please write to:
THAMES & HUDSON INC.
500 Fifth Avenue, New York, New York 10110

Printed in Singapore

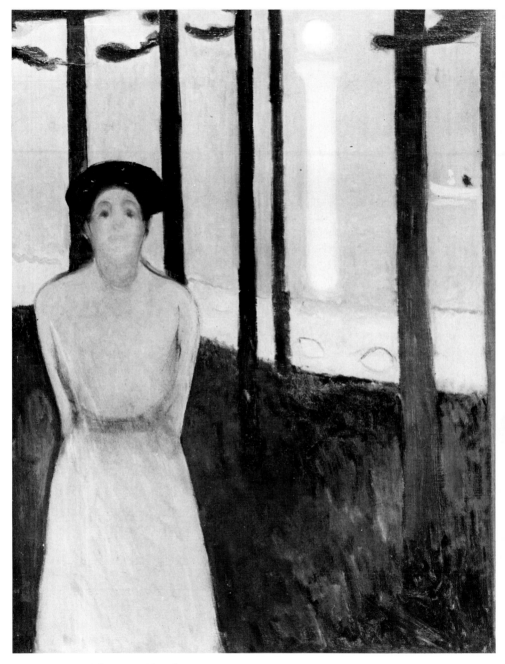

1 *The Voice* (detail), 1893

J.P. HODIN

EDVARD MUNCH

168 illustrations,
30 in colour

Thames & Hudson world of art

ACKNOWLEDGMENTS

My sincere thanks are due to Mr Leif Østby, Chief Curator of the
National Gallery in Oslo; Mme Ragna Stang, formerly Director of
the Munch Museum, Oslo, and Mrs Frida Tank, Librarian of the
Museum, for their assistance and advice. I also wish to thank my wife
Pamela for her devoted help during the preparation of the manu-
script; and last but not least, Miss Ann Stevens for her untiring and
dedicated editorial work.

J. P. H.

First published in the United Kingdom in 1972 by
Thames & Hudson Ltd, 181A High Holborn,
London WC1V 7QX

www.thamesandhudson.com

First paperback edition 1972
Reprinted 2004

ISBN 0-500-20122-6

Printed and bound in Singapore by C.S. Graphics

Contents

Introduction 7

CHAPTER ONE 11
Childhood and early studies

CHAPTER TWO 27
The Norwegian scene

CHAPTER THREE 33
Christiania's Bohemia

CHAPTER FOUR 45
What Paris meant to Munch

CHAPTER FIVE 55
The Frieze of Life

CHAPTER SIX 61
Munch in Berlin

CHAPTER SEVEN 73
In Paris again

CHAPTER EIGHT 81
The lonely path of Edvard Munch. Love and death

CHAPTER NINE 103
Years of restlessness

CHAPTER TEN 121
Crisis and homecoming

CHAPTER ELEVEN 137
The Oslo University murals

CHAPTER TWELVE 147
Reminiscences and premonitions

CHAPTER THIRTEEN 169
Munch's graphic works

CHAPTER FOURTEEN 189
How Munch worked. His style. The draughtsman

Epilogue 205

Notes on the Text 210

Short Bibliography 211

List of Illustrations 211

Index 215

Introduction

Before we can realize the stature of Munch in his time and his significance for our age, he has to be seen against the background of the radical change in spiritual values – religious, ethical, philosophical and aesthetic – which the last hundred years have witnessed; a change which, although having its roots deep in the seventeenth century when the foundations for our present scientific outlook on life and the universe were laid, became the main concern of our modern consciousness and of practical consequence only in the second half of the nineteenth century.

The artist, who is often considered to be the most sensitive tentacle of mankind in its encounter with the complexities of life, has in the twentieth century, by proclaiming the non-art quality of art, by adopting an attitude of anti-art and of hatred towards culture, not only expressed his hatred of bourgeois art and bourgeois culture, but more than this. Through denying or lowering the value of tradition in art, he has destroyed its very roots for the present generation. Whether a recovery from such nihilism is possible must be left to the future.

Having stated this, what more pertinent could be said of an artist such as Edvard Munch than that he, as few others, has maintained for Western art the place which it had conquered through the achievements of two millennia? He suffered, and depicted the condition of modern man, in a time which was not yet conscious of its own predicament. Furthermore, he proclaimed this predicament to be the content and meaning of his art.

Writing about Edvard Munch on the occasion of the large posthumous exhibition of his work in the Tate Gallery in London, in 1951, Oskar Kokoschka, the heir to Munch's Expressionism and his spiritual outlook, said: 'As a rule turning-points in history are overlooked by contemporaries. This obituary is intended to recall, eight years after Edvard Munch's death, the work the eighty-year-old master left behind; so we base it upon the fiction that we are looking towards a future that already considers the work of the great painter her own,

when even today it is foreign to the great cultural centres of the world – Paris, London, Venice. We turn to a future, when in our time – a time of ravaged rubble and stagnant land, an epoch that exhausts itself in experimenting with form without the appearance of any meaning – the artist rises in the background like a statue with lowered torch. For this is the last thing he gave expression to, in The Medusa's Head of Love, which no one has since had the courage to approach and which to his contemporaries seemed at best the rigidified mask of the eternal, but in which nevertheless faithful men of the past recognized themselves as images of the divine.'[1]

The doctrine of 'art for art's sake' aimed to save art from relegation to a role of utility within a mechanized society, and to that extent it was justified. But when the formula was taken to the extreme in which the work of art was deprived of any meaning, and satisfaction was found only in introversion, experiment and the search for new formal values, then a reaction was inevitable. Munch's art cannot be divorced from his world of ideas, and in this fact lies his importance for us today.

Munch created what may be called a 'spiritual climate'. Two, even three generations of artists have produced works under his influence and spiritual inspiration. He was the initiator of the style of art termed Expressionism, defined as 'expressiveness . . . by means of exaggerations and distortions of line and colour; a deliberate abandonment of the naturalism implicit in Impressionism in favour of a simplification which should carry far greater emotional impact'.[2]

Behind Expressionist art stand men who regard it as a sin against the spirit to produce anything by coldly rational means. Van Gogh, Edvard Munch, Oskar Kokoschka have made statements to this effect.

The Expressionist artist is aware of an archetypal imagery in Jung's sense, that is, he expresses a collective unconscious whose content and functions are of an 'archaic' nature. 'It is not a matter of imitating the archaic, but of qualities which are in the nature of a relic. All those psychological traits which in essentials correspond to the qualities of the primitive mentality are of such a nature.' The artist's images are archaic when they have definite although at first unrecognizable mythological parallels. Hence the Expressionist artist is associated with the myth-building force, that truly creative, primordial spiritual force out of which the symbols were created that gave form to men's conception of life and of the world.

2 *The Lovers*, 1896

'Expressionism' is in fact a universal style which appears in times of great spiritual tension. Michelangelo's Rondanini *Pietà* and the Descent from the Cross in Florence Cathedral both belong to this type of expression, as do works of El Greco, the aged Rembrandt, the late Goya, Mathias Grünewald, the master of the Isenheim Altar in Colmar, or the artists of the Baroque. The Viennese art historian Alois Riegl showed in the example of the Baroque that one of its characteristics is a profound religious emotion. It is a sombre, passionate art – the art of Van Gogh, Lovis Corinth, Edvard Munch, Ernst Josephson, the late Turner, James Ensor, Oskar Kokoschka, the painters of Die Brücke, Rouault, the early Chagall, Jack B. Yeats, Soutine, Max Weber, Francis Bacon – in which spiritual experience asserts itself against the tyranny of mathematical thought and technical progress, in fact against the dehumanization and mechanization of culture.

3 *The Sick Child* (detail), 1885–6

Childhood and early studies

Edvard Munch was born on 12 December 1863 in Løten, in the county of Hedmark, on a farm called Engelhaugen. He was the second of five children born to Laura Cathrine (*née* Bjølstad) and Christian Munch, a doctor in the army medical corps and later district physician in Oslo. Before he married, Munch's father had spent several years at sea as a ship's doctor. He was descended from an old Norwegian family of high intellectual distinction, who could boast among their number a well-known Norwegian painter, Jacob Munch, a bishop, Johan Storm Munch, a poet, Andreas Munch, and the famous author of a history of the Norwegian people, Peter Andreas Munch, Edvard Munch's uncle, who died in Rome in 1863. Edvard Munch was very conscious of the family tradition, and the historian's enormous industry particularly impressed itself on him. His mother's family were farmers and seafaring folk, and her father who, after working up and down the coast of Norway in a sailing-ship, settled down in business as a merchant, was said to be as strong as a bear. He had twenty children, but his daughter did not inherit his physical strength; she died of tuberculosis when her son Edvard was only five years old. The father was a friendly man but shy, a great reader, fond of animals, religious, with strong social convictions – he often assisted people in the poverty-stricken district where the family had moved when Edvard was one year old, without taking any fees. After his wife's death he became melancholy, and led from then on a life of seclusion. His religious inclinations grew out of all proportion. Dr K. E. Schreiner, Edvard Munch's physician, recalls his saying that his father had a difficult temper, with nervousness and periods of religious anxiety which bordered sometimes on insanity. 'Disease, insanity and death were the angels which attended my cradle, and since then have followed me throughout my life. I learned early about the misery and dangers of life, and about the after-life, about the eternal punishment which awaited the children of sin in Hell. . . . When anxiety did not possess him, he would joke and play with us like a child. . . . When he punished us . . . he could be almost insane

4 *From Bygdøy*, 1881

in his violence. . . . In my childhood I always felt that I was treated unjustly, without a mother, sick, and with the threat of punishment in Hell hanging over my head.'[3]

Christian Munch's household was conducted according to strictly puritanical principles. Money was scarce, and only the presence of the dead wife's sister, Karen Bjølstad, who became his housekeeper and the educator of his children brought an element of friendliness and joy into an otherwise sombre atmosphere. Edvard's older sister Johanne Sophie died in 1877 when he was fourteen years old. He himself was often ill – rheumatic, feverish and sleepless – but still a good companion to his brother and sisters, telling them stories after his father had stopped doing so, and entertaining them with his drawings. His aunt soon discovered Edvard's artistic gift. She herself painted landscapes, and from the proceeds of their sales she bought painting materials for her nephew as well as for herself. As he drew well, his father decided that he should study engineering. Edvard went to the Technical College in 1879, but poor health prevented him from attending classes regularly. Increasingly he wanted to become an

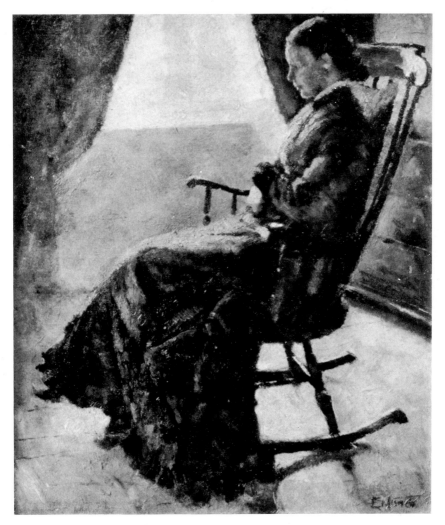

5 *Karen Bjølstad*, 1884

artist. In May 1879 he produced his first sketches of the town and its surroundings. His father hesitated to let him embark on an artistic career partly on moral grounds – for in bourgeois circles the artist's life was known only for its licentiousness and libertinism – partly for economic reasons, since there was much poverty among artists.

13

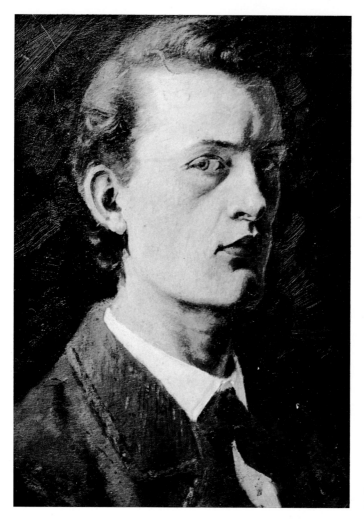

6 *Self-portrait,*
1881–2

Nevertheless on the advice of a friend, the lighthouse-director and draughtsman C. F. Diriks, he gave his permission, and in November 1880 Edvard left the Technical College and started to study art history.

6 The two self-portraits which Munch painted in 1880–2, when he was still in his teens (particularly the second one, with head and shoulders turned to the right) reveal few traces of his unhappy childhood. Those deep scars came out only later. There is, however,

determination and strength in his observant look, and around the sensitive mouth. As well as the early landscape studies from Aker (1880) and the self-portraits (he produced another in 1886), Munch painted interiors, such as the living-room of the daughters of Bishop Johan Storm Munch, and that of their own flat in Pile Street (both of 1881), still-lifes, studies of heads and figures, such as *Girl sitting on the* *Edge of her Bed (Morning)* (1884), and in this same vein, portraits of his father reading in an armchair (1883), of his Aunt Karen in a

7
10
5

7 *Girl sitting on the Edge of her Bed (Morning)*, 1884

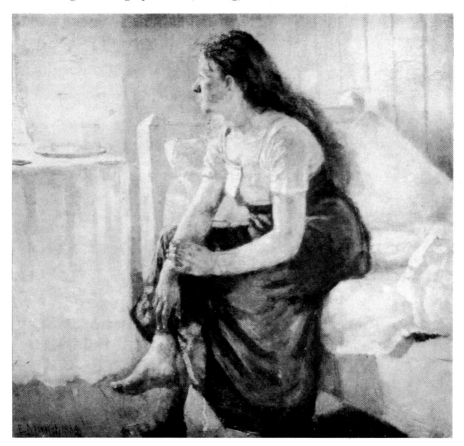

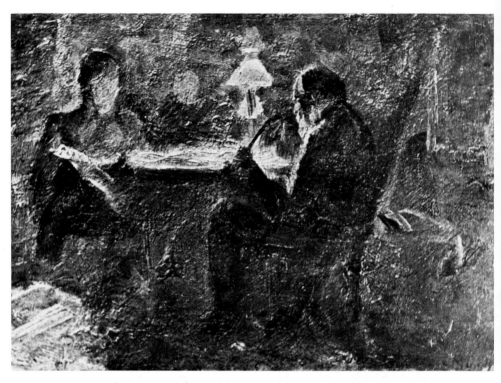

8 *Family Evening*, 1884

rocking-chair (1884), of his brother Andreas sitting in front of a
bookcase reading (1883), of Andreas studying anatomy with a skull
on his table (1883) and of the painter Th. Torgersen (1886). A portrait

9 of his sister Inger (1884) is one of the most accomplished paintings of
his earliest period. It is a dark picture from which only the expressive
face and hands stand out, painted with an austere intensity of vision,
almost reminiscent of an old master, and different from the pictures
Munch had produced up to this time. The artist, young as he was,
already possessed a fully mature technique. He had put much of him-
self into the painting of this portrait, for he was devoted to this
musically gifted and sensitive sister. Of all the early compositions,

8 the one of the family at table grouped round a lamp, *Family Evening*
(1884), is simplified and concentrated with striking chiaroscuro effect,
and comparable to Van Gogh's *Potato-Eaters*.

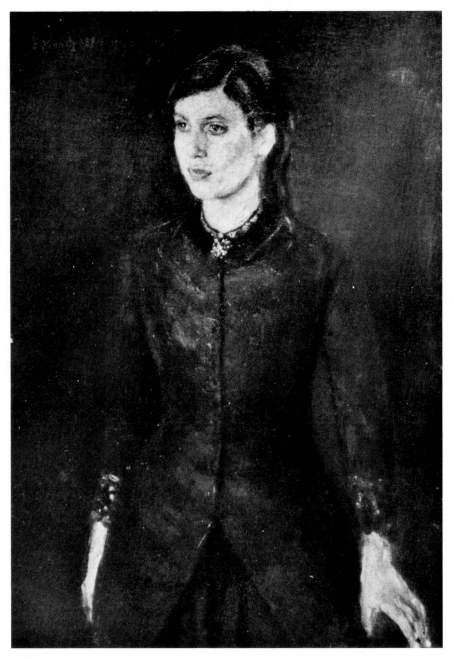

9 *Sister Inger*, 1884

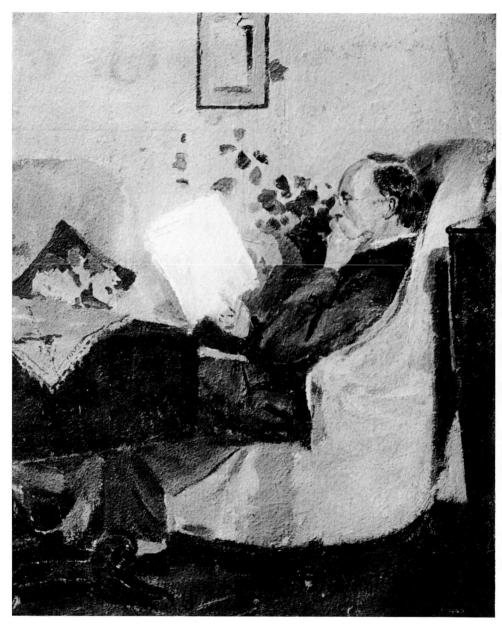

10 *Munch's father*, 1883

11 *Jørgen Sørensen*, 1885

Munch entered the Oslo School of Design in 1881, attending first the drawing and later the modelling classes. Fine studies of nudes from this time are to be found in Norwegian museums. His first teacher was the sculptor Julius Middelthun. In the following year, Munch and six other young artists rented a studio in the Storting Square, where many well-known artists had their studios, among them Christian Krohg. Although the young men wished to work independently they accepted the supervision of Krohg. In 1883 Munch exhibited for the first time in a group exhibition, with his *Study of the Head of a Red-haired Woman*, and also attended the Open-Air Academy of Fritz Thaulow, another Norwegian master, in Modum. Among the students were Jørgen Sørensen (who was to die at the early age of only thirty-three, and of whom Munch in 1885 made a sensitive portrait head, one of his finest early ones) and Kalle Løchen, a talented youth who committed suicide at the age of twenty-eight. Both were Munch's friends. The portrait of Sørensen shows the young artist viewed slightly from above. It is executed in an airy technique which brings out the dreaminess of his friend's personality.

11

12 *Net Mending*, 1888

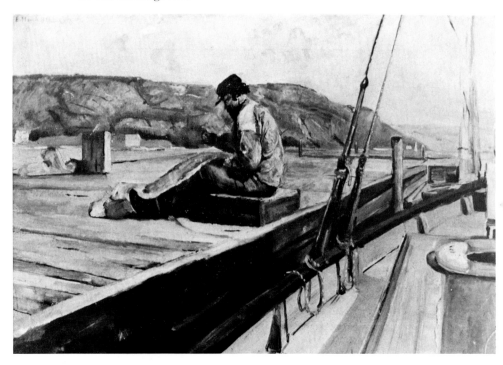

13 *Landscape*, 1880

Munch's earliest pictures were painted in a *plein-airist* and natura-
listic technique. In the beginning hesitant and timid (his first paintings
were all small), Munch soon showed a tendency to free his brushwork
and to produce larger and more summary pictures. Many of them are
rather dark; some, however, are lighter in colour. It was only the
confrontation with French Impressionism that impelled Munch to
use clear colours, complementary and unbroken, also fine hues, with
the intention of producing the impact of light. But even in the later
periods of his work, some of his important pictures were to remain
relatively dark. Munch never accepted any doctrine or 'ism' ex-
clusively. The predominant element remained for him always the
mood, the emotional quality out of which the picture sprung. If it
were sombre and dark, depressed or melancholy then it commanded
a different colour scale from a serene picture. We find here and there
in Munch's earliest work even an allusion to the 'golden' gallery tone

of the generation of Norwegian artists who studied in Munich or Düsseldorf.

14 Of all Munch's early paintings the most important is *The Sick Child* (1885–6) now in the National Gallery in Oslo. In this picture his experience of the death of his mother and of his sister Sophie is the psychological driving power behind a work which far surpassed anything produced in Norwegian painting at that time. Here the great master is already apparent: the master of colour, of composition and of human expression. This picture is not naturalistic, it already belongs to a more advanced school of painting. The eye is drawn to the two central figures. The sick girl is sitting up in bed and looking yearningly towards the window, as if still hoping for recovery, while the mother sitting at the bedside lets her head sink on her breast in sorrow and despair, no longer able to hide her pain. The large surfaces give the picture its distinctive character, and the intensity of the expression is achieved by the colours which have a certain symbolic quality: the ruddy orange tint of the girl's hair, the cold sea-green of the curtain, and here and there a touch of red. *The Sick Child*, compared with the works of other artists of the period, especially with the similarly named picture by Christian Krohg, painted in 1880–1, shows plainly that Munch was representing an inner experience, not an outer happening.

Munch had worked on this picture for a whole year, and returned to the theme several times both in his paintings and in his graphic works. Its place in the history of Norwegian art can be judged by the words of Jens Thiis (an ardent supporter of the artist and later Director of the National Museum of Oslo): 'It is the first monumental figure-painting, and represents an enormous development in the painterly conception of a theme, when compared with the informative-realistic painting of those times.' It was, moreover, the forerunner of the series of pictures depicting death which is included in the first
43 version of the artist's *Frieze of Life* (see Chapter Five), just as *Puberty*
35 and *The Day After* can be said to contain the germ of the series in the *Frieze of Life* which depicts love. The critics, however, saw nothing but 'incoherent daubs of paint', and one writer remarked that 'the kindest service one can do for the painter E. Munch is to pass over his pictures in silence.'

It is astonishing to find that Munch's other famous picture on the same subject, called *Spring*, was painted in 1889, three years later than

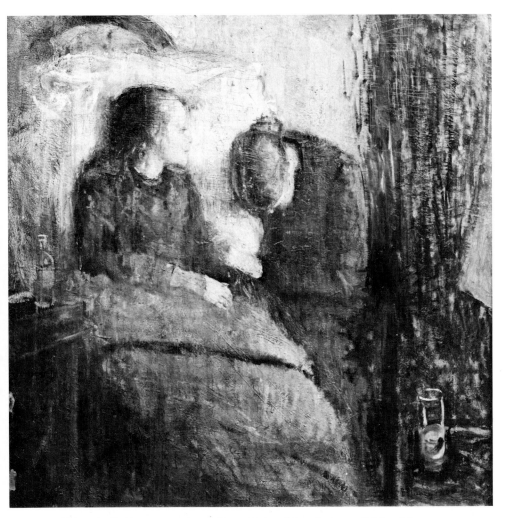

14 *The Sick Child*, 1885–6, the earliest of Munch's paintings of this subject

The Sick Child. Spring is in a style of lyrical naturalism with minute *15, 16*
realistic details. In this picture the girl sitting in an easy-chair and
leaning her head against a white pillow, is looking away from the
window as if unable to stand the sight of the spring sunshine which
streams into the room, drenching the flowers on the window-sill

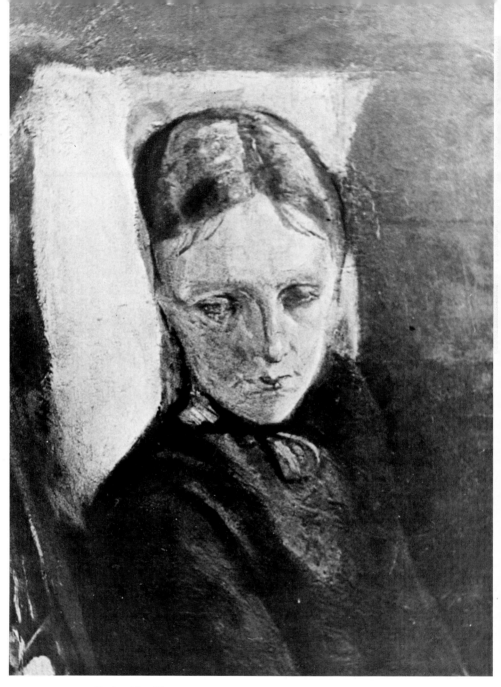

15 *Spring* (detail), 1889

16 *Spring*, 1889

with warm, generous light. It is the youth of the year whose cool breath makes the shimmering white curtains swell like sails, the sails of hope and of dreams of life and beauty. The mother sitting beside her looks towards the light with her back against a table covered with a cloth on which we see a vase and other objects. In the background of the room stands a high chest of drawers. There is a great tranquillity about this picture. One can say that Munch's *Spring* is the climax of his naturalistic style, whereas *The Sick Child* was already Expressionist. This regression, albeit on a masterly level, points to the difficulty which the artist encountered in finding himself, and his intense struggle for the establishment of his personal style.

It will prove useful in assessing the step which Norwegian painting has taken through the work of Edvard Munch, from entire dependence on foreign schools to becoming a significant influence on a whole age, if we cast a glance at the development of painting in Norway and the stage which it had reached at the time when Munch matured for his great task.

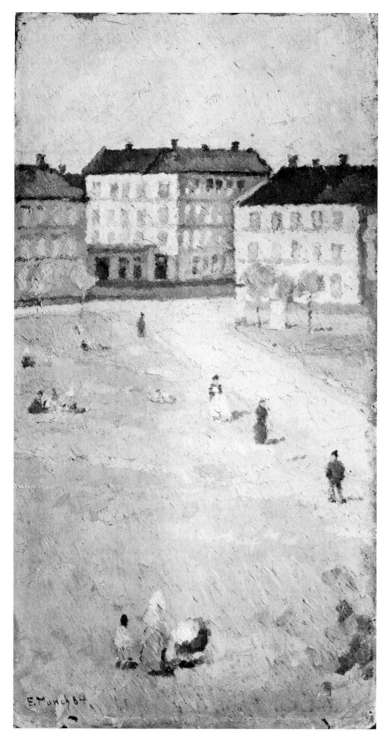

17
*Afternoon at Olaf
Ryes Square,*
1884

The Norwegian scene

The whole tradition of Norwegian painting is not more than one hundred and fifty years old. Norway regained its political independence in 1814, and only then were efforts made to bring it into the mainstream of European art. Christiania (modern Oslo) was a small provincial town, and artists could not succeed there for economic and cultural reasons. They were forced to live in exile if they were to have reasonable working conditions. The landscape-painter J. C. Dahl, for instance, was a Professor of Art in Dresden. Norwegian artists lived in Germany and Italy, Paris and London. Some forty years later, the next generation joined the Academy of Düsseldorf and became painters of historical scenes. From the beginning of this development a Romantic attitude towards the landscape and people of Norway appears, a certain national nostalgia, particularly in the work of Adolph Tidemand and Hans Gude. The Düsseldorf school had a great influence on Norwegian painting. Only Olaf Isaachsen was a heretic. He left Düsseldorf in 1859 and went to Paris, whence he came back to Norway proclaiming Courbet's Realism.

However, the time of historical and Romantic painting did not suddenly draw to an end. Munich replaced Düsseldorf as the centre and exercised a steady European influence during the 1870s. Eilif Peterssen was highly appreciated in Munich (historical compositions) as was Hans Heyerdahl, whose lyrical talent exercised a certain influence on the young Munch. Erik Werenskiold who had been practically in opposition to the whole Academy was also there. He can be called a 'poetic realist'. Theodor Kittelsen, on the other hand, was firmly rooted in Norwegian folklore, as was Christian Skredswig. We recognize in the Norwegian painting of this time two clear tendencies, two main streams of ideas. On the one hand, influences from abroad, on the other, the emotional bond tying the Norwegian painter to his country, its landscape and people. A new synthesis had to be produced, but how? At the international art exhibition of 1879 the French had a fine collection in Oslo. As a result Erik Werenskiold declared Munich with its historical painting and its perpetual dialogue

with the old masters to be dead. In 1880 he was in Paris. Frits Thaulow had already been studying there for some years. Werenskiold was joined in Paris by the best known of the Norwegian realists, Christian Krohg. In *plein-airism* Werenskiold saw hope for the foundation of a genuinely Norwegian school of painting. After his return to Oslo Werenskiold broke the power of the Art Association founded by Tidemand and Dahl, and in 1882, supported by Krohg and Thaulow, 'the three giants of the eighties', he persuaded the National Assembly to agree to an annual State-aided exhibition, the Autumn Exhibition, with all the artistic decisions to be taken by the artists themselves. Norwegian art thus gained acceptance in the community. Krohg's aim was mainly socially-critical, 'to seize the public by the scruff of the neck'. He painted pictures calling attention to contemporary social evils. Thaulow, on the other hand, aimed merely to delight the eye, while Werenskiold was anxious to establish a purely national tradition, and proclaimed that it was the use of colour, the expression and the drawing that made a picture Norwegian, not only the subject-matter. The next generation were to base their art on Realism, the technique of which had to be learned in Paris, not in German art galleries. And at the Autumn Exhibition of 1894, Realism was preponderant. But in the same year, Munch was already exercising a strong influence in Germany with his expressionistic and symbolic style.

Oslo was still a small town. In 1875 it had only 77,000 inhabitants. Dependence on foreign art schools and national nostalgia, lack of tradition, uncertainty of judgement in art matters, economic difficulties and restrictions still continued. This explains many of the difficulties in Munch's career, his restlessness during the first half of his life. In the nineties with the decline in importance of the various European Academic traditions, Norwegian artists went as already once before to Copenhagen, to learn, this time, from their teacher Zahrtmann that the emphasis was to be laid on the cultural and humanistic, rather than on the national and the social. This, however, remained a Scandinavian programme, of no consequence for the development of European art. Even the pupils of Matisse's international school in Paris during the first decade of the twentieth century, Henrik Sørensen, Axel Revold, Jean Heiberg, with all their good qualities, were of importance only for Norway.

From the very first, when he exhibited at the Autumn Exhibition in Oslo – and he did so regularly for many years until 1891 – Munch

18 *Street Scene*

was attacked by the Norwegian critics. The savagery and persistence
of these attacks, with very few exceptions of understanding and
acceptance, can be accounted for only by the provincial narrowness
of outlook of Norwegian opinion. Munch was not recognized in his
homeland until he was fifty years of age and already famous on the
Continent. Even in 1909–14, the struggle for the acceptance of
Munch's designs for the murals for the Great Hall of Oslo University
shows the difficulty presented for an artist of genius by residence in a
small country lying on the outskirts of Europe. In the case of Munch,
however, there was an added European facet to the problem. Why
did *all* modern art – Realism, Impressionism, Fauvism, etc. meet with
such violent opposition in Paris during the second half of the nineteenth
century? Why did Van Gogh, Gauguin, Cézanne have so to suffer
for their art that they may be said to have become the martyrs and
saints of the modern movement? Because modern art, starting with
Realism, must be seen as a complete break with the sterility of
Academism (though not with tradition). The new masters were those

who secured for European art a new vitality, a new truthfulness. Among them was Edvard Munch.

Without the support in Norway of some of the artists of the older generation and a group of friends who believed in him, Munch would have had to wait even longer to achieve recognition in Norway. When Christian Krohg praised his *Sick Child*, Munch was so moved that he gave him the painting. (It is of interest to note that in spite of these adverse conditions, the young artist sold paintings in auctions as early as 1881 and 1882.)

Munch as a young man was reticent, even shy, but he reacted proudly and sharply to criticism which did injustice to his art and his ambitions. From the very beginning it was obvious, to some at least, that his was a dedication and talent out of the ordinary. 'With him a tremendous will-power came into the world,' wrote Julius Meier-Graefe.

In March 1884 Frits Thaulow offered the young Edvard Munch a visit to Antwerp and also some money to study the Paris Salon.

19 *Sister Laura*, 1888

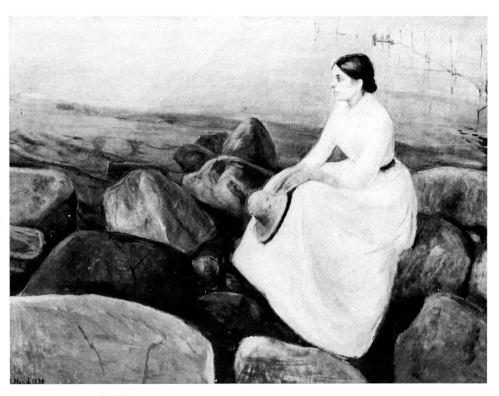

20 *Inger on the Shore,* 1889

This journey had to be postponed owing to Munch's illness, but with the support of Christian Krohg and Eilif Peterssen, Munch applied to the Schäffer Bequest Fund and twice received money. In the same year, 1884, supported by Werenskiold, he received a grant from the Finne Bequest. In May 1885 Munch travelled by way of Antwerp, where a picture of his was exhibited, to Paris, where he stayed for three weeks. He studied in the Louvre and the Salon and received many strong impressions, particularly from Manet's work. These were of great importance to him as the painter of the life-size full-length portraits for which he became renowned.

Already in 1884 Munch had come into contact with the Bohemian set of artists and writers who were to provide the second *milieu* of his youth. Both Paris and the Bohemians were of the utmost significance for his development as an artist and as a man.

31

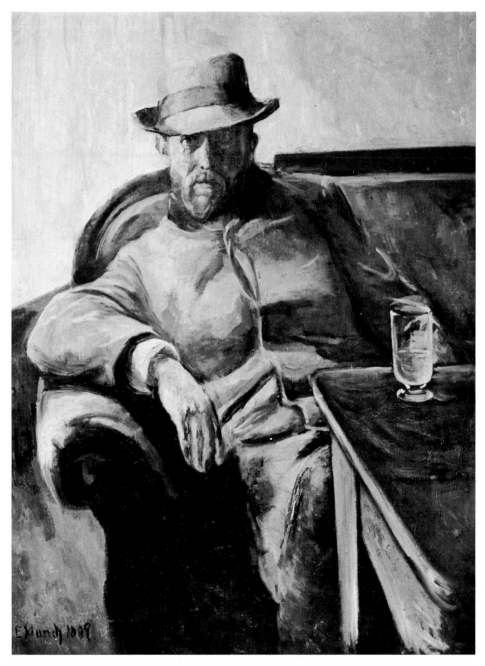

21 *Hans Jaeger*, 1889

Christiania's Bohemia

In Oslo as in other European centres, in the second half of the nineteenth century, a group of young radicals questioned all the values on which the State and society were based. The leader of this militant group was the writer Hans Jaeger, author of a book entitled *Christiania's Bohemia*, whom Munch befriended and of whom he painted a portrait in 1889 in a naturalistic style. It shows a middle-aged 21 man sitting in the corner of a sofa and facing us with a thoughtful, even sad expression, his coat buttoned up to the neck, as if against the wind. A Zola-like face reveals his critical approach to society. They were atheists, those nineteenth-century rebels, understandably so after the publication of Darwin's *Origin of Species* (1860) and his *Descent of Man* (1871), the knowledge of which had spread in Europe like a fire. They were anti-bourgeois, infected by Marx's early romantic-revolutionary writings including the *Communist Manifesto* of 1848 and the first volume of *Das Kapital*, published in 1867; aristocratic socialists and nihilistic anarchists on the model of Prince Peter Alexeivich Kropotkin's theories. They hated the suffocating narrowness of the middle classes. They detested their petty prejudices and their hypocrisy, their materialism in resolving everything into terms of debit and credit, their craving for security, their dogmatism and intolerance. They fought for the equality of the sexes, the release of woman from the yoke of family despotism, they advocated the liberation of love from the fetters of the property instincts, they represented a collective protest against false morality. They demanded intellectual freedom and a better social order. They read Nietzsche and based their repudiation of the Christian faith on his teaching. Hans Jaeger, who was a thinker nurtured in the school of Hegel, Kant and Fichte, examined with contemporary revolutionary ideas as his master key the family, the State, religion, law and morals, and came to the conclusion that the premises on which these institutions were based must be discarded to clear the way towards a new life.

Munch's rather romantic paintings *The Men of Letters* of 1887, depicting three writers sitting at a table, reading and discussing books

by the light of a paraffin lamp, and the brilliant *Tête-à-Tête* of 1885 showing a bearded man in lively conversation with a young lady, the smoke of his pipe drifting over the canvas, reveal the new *milieu* in which he now found himself. It was the world of an intellectual and artistic élite, composed of those who had passionately caught up the trends current in modern Europe, developed them and merged them with their own specifically Nordic consciousness to form a unity of astonishing freshness.

Many artists remained entrapped in Bohemian life and made the youthful freedom and the individualistic revolt of that world their life's principle. Munch passed through the Bohemian stage unharmed; it could not retain him, any more than artistic theory. What he stood for exclusively was his art, the determined step by step conquest of his own style, his ability to express his own comprehension of life and with it that of his time. This period, however, in spite of all its extremism, was of significance to him, and looking back in his old age he once said: 'When will the history of the Bohemian period be written, and who is there capable of writing it? It would take a Dostoevsky, or a blend of Krohg, Hans Jaeger and myself, perhaps.

22 *Tête-à-Tête*, 1885

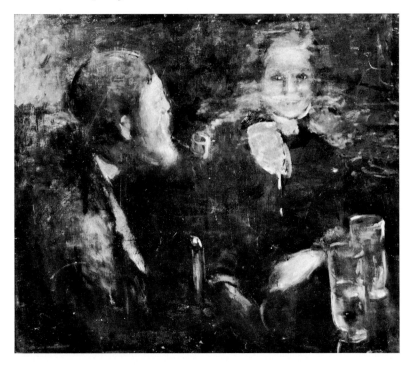

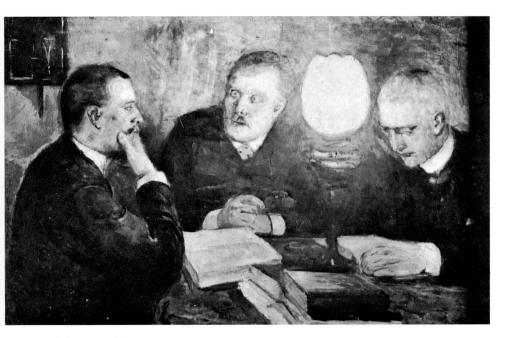

23 *The Men of Letters*, 1887

Who will describe the Russian period in that Siberian town which Oslo was then and still is? For many artists it was a testing-time and a touchstone.'

The Bohemian world provoked the strongest resentment by its attitude towards sex. The petit-bourgeois prudery of the time can be most strikingly conveyed by examples. At the opening of the Christiania Museum of Sculpture in 1883, a professor of the history of art was obliged in the course of a public address to swear, with his hand on the Bible, that the art of the nude was pure and beautiful and that no one need feel shame at contemplating and admiring it. Jens Thiis records that 'Munch had arranged for his first nude, *Puberty*, to be hung at an exhibition together with other pictures. When his father came to visit the exhibition, Munch had a cloth put over the picture in order to spare the feelings of the old man who could otherwise not have avoided seeing the large canvas.'

Through his connection with the Bohemian circle Munch drew the attention of the already hostile critics to himself. His full-length

24 *Portrait of the Painter Jensen-Hjell*, produced in 1885, when Munch was only twenty-two years old, attracted their particular hatred. This Jensen-Hjell seemed a provoking, cigar-smoking fop, nonchalantly supporting himself on his stick and seeming to gaze superciliously down on the world! A Bohemian! This masterpiece of characterization and a monumental likeness as was hitherto unknown to Norwegian painting was attacked ruthlessly: 'There is not even any proper underpainting in the picture; the colours have been crudely daubed on the canvas; indeed, it looks as if it has been painted with the blotches of paint left over on the palette after another picture. . . . That is what this superficial Impressionism is, a blurred travesty of art. This picture amuses people as if it were a caricature.'

In the following year the critics attacked *The Sick Child*, exhibited under the modest title *Study*.

No one reads Hans Jaeger's writings nowadays. He was one of those short-lived enthusiasts who inflamed by the great ideas of their time burn brightly for a brief while, giving no lasting light. Ibsen, on the other hand, pondered profoundly on the tragic conflicts inherent in his age and its society and still today makes the listener deeply aware of the conflicts in the human soul, its pains and joys. Ibsen and Edvard Munch are the great contributions Norway made to the world of art and literature in the second half of the nineteenth century. Their time was one of genius. It produced Tolstoy and Dostoevsky, Dickens and Zola, Mallarmé, Baudelaire, Verlaine and Rimbaud.

Decadence, Romanticism, Symbolism made their impact in the wake of Realism with the anti-rationalist forces gathering under the aegis of Henri Bergson's philosophy of intuition. In the visual arts *plein-airism* and Realism were followed by Impressionism with its great masters, by Cézanne and Post-Impressionism. In this creative century the North took an active part. Sweden produced Strindberg, and Denmark besides Hans Christian Andersen, Jens Peter Jacobsen who wrote morbid novels pervaded by a sense of the weariness of life which deeply impressed R.M. Rilke, and Herman Bang who spoke of the hopelessness of his generation with bitter resignation. There was also the literary-critic Georg Brandes who proclaimed Nietzsche's greatness and discovered Hamsun and Søren Kierkegaard, the latter of whom proved in the long run a thinker of universal significance. Like Nietzsche he was one of the pioneers of Existentialism.

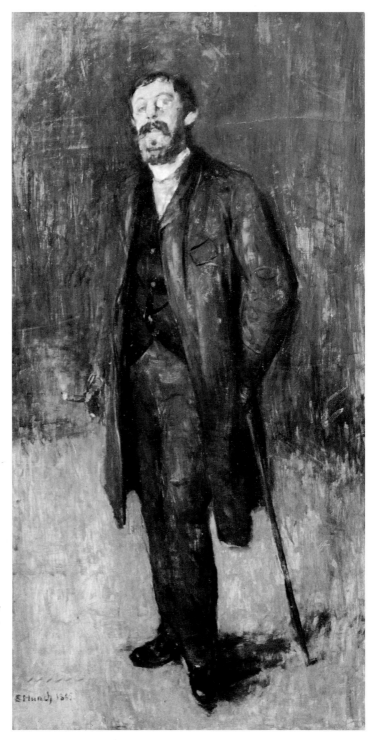

24 *Portrait of the Painter Jensen-Hjell,* 1885

Considering how small the population of the Scandinavian countries and how decisive their influence was, we must duly admire the uniqueness of their achievement.

For the biographer of Munch the Scandinavians Ibsen, Kierkegaard and Strindberg are of vital importance. About Dostoevsky, Munch said that *The Idiot* and *The Brothers Karamazov* were among his favourite books. Nietzsche's *Zarathustra* made a deep impression on his mind, as we shall see in connection with his murals for Oslo University. Munch knew Mallarmé personally and frequented the Symbolist circle in Paris. With Baudelaire's mind too he had much in common.

In this great literary era, literature made its impact on the visual arts.

The range of paintings Munch produced in the years between 1884 and 1889 is awe-inspiring. There are genre pictures such as *Morning* of 1884, with its Impressionist touch (a young girl dressed, and sitting

25 *Dansemoro*, 1885

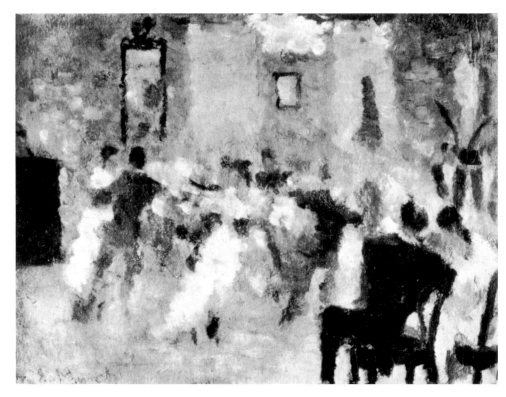

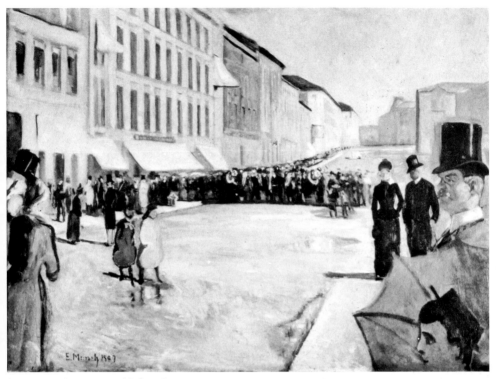

26 *Music on Karl Johan Street*, 1889

on the edge of her bed looking towards the window whence the morning light streams in), or *Sister Laura* of 1888 showing her profile 19
wearing a hat, sitting outside a house near the water. There is the lyrical painting of *Inger on the Shore* of 1889, the artist's sister sitting 20
in a white dress on a large boulder on the shore holding her hat in her hand – a picture breathing all the romance of nature which was so typical of the Northern scene. *From Munch's Home* (*c.* 1888) depicts an interior with a sofa and a girl knitting in front of a sunlit window on the sill of which there are flowering plants. The realistic *Net Mending* (1888) shows a fisherman sitting on the quay beside his boat, 12
working.

 Afternoon at Olaf Ryes Square (1884) is a near-Impressionist town- 17
scape, as is also *Karl Johan Street in Oslo* or *Music on Karl Johan Street* 26
(both 1889) of which Munch himself said: 'When a band came down

39

Karl Johan Street on a clear sunny day in spring my mind was filled with festivity, spring, light; music became quivering joy, music painted the colours. I painted the picture and in the colours the rhythm of the music quivers. I painted the colours I saw.' There is *The Girl at the Piano* (*c.* 1886) or *Dansemoro* of 1885, trying to catch the couples in a dance with the help of blurred colour patches, a remarkable attempt at representing movement. In 1886 Munch painted himself after his first visit to Paris. We see a young man with a keen, searching glance, filled with inner tension. He had by that time created his first masterpieces, met his first setbacks, and experienced his first insight into the recesses of the soul. He is now on the threshold of deeper explorations and deeper sufferings.

27 *Spring Day on Karl Johan*, 1891

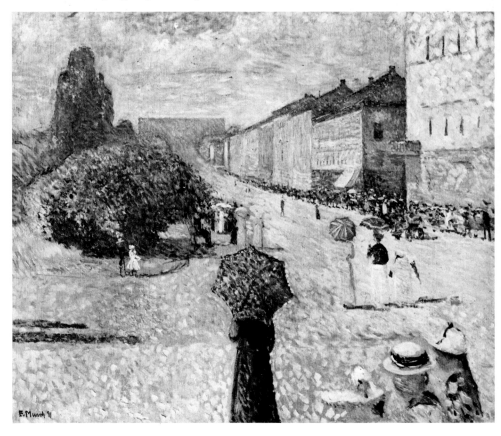

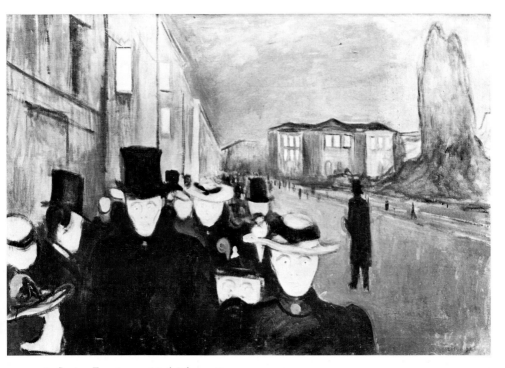

28 *Spring Evening on Karl Johan*, 1892

When we compare the Impressionist scenes from Karl Johan Street *27*
with the picture *Spring Evening on Karl Johan* of 1892 where the stream *28*
of pedestrians move with ghostlike faces towards the spectator – only
Munch himself, the tall figure in coat and top hat in the middle of
the street, moves in the opposite direction – we realize that it is the
force of his thoughts and feelings about life that drove Munch on
relentlessly, whatever else he tried to depict and in whatever style or
manner he did it. *Puberty* (the first version, now destroyed, was *43*
painted in 1889, the later in 1895) or *The Day After* (1885–6) are both
already deep in the problems connected with the nature of woman-
hood and eros. A loving couple the artist described in 1889 thus:
'A strong bare arm, a powerful tanned neck, and a young woman
leans her head on a swelling chest. I wanted to show this as I now saw
it, but in a blue haze: both of them at the moment when they are not
themselves, but only a link in the chain of a myriad generations.'
(*Diary*, Saint-Cloud.)

41

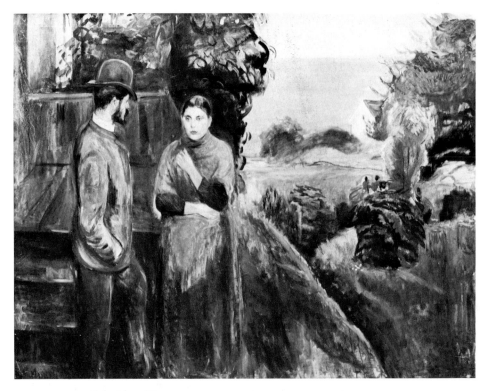

29 *Eventide*, 1889

29 Then again, we find quiet pictures such as *Eventide* painted in the
same year, 1889, with a great sureness of artistic execution, showing
a young man (the poet and critic Sigurd Bødtker) with a bowler hat,
his hand in the pocket of his jacket and a young woman (Munch's
sister Inger) with a woollen scarf round her shoulders, in the stillness
of the evening landscape, with the sea in the background. But even such
a lyrical painting the Norwegian critics found only comical. They
were roused to indignation because it was 'an atmospheric picture'.
Munch was called 'undeveloped in his art', his pictures composed
'without regard to established laws and forms and often associated
with a tendency to fantasy'. The painter Erik Werenskiold bought
the picture *Eventide* in 1889 and Frits Thaulow the picture *Morning*.
This gave some hope. For if Munch was to continue his work he
needed a State scholarship.

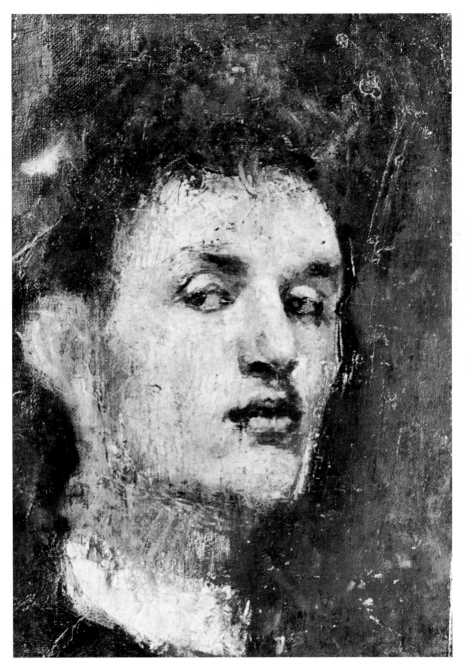

30 *Self-portrait*, 1886

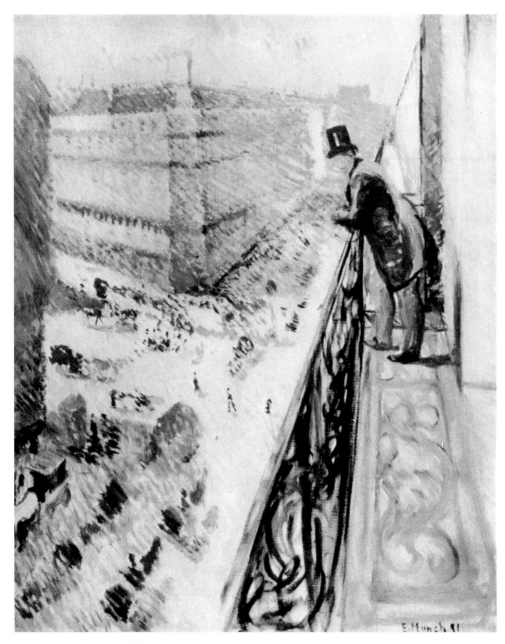

31 *Rue Lafayette*, 1891

What Paris meant to Munch

In 1888 with a recommendation from Werenskiold Munch applied for a State grant which he obtained the following year. To support his application Munch organized his first one-man exhibition in Oslo in 1889, which was also the first one-man exhibition held in Norway. About October 1889 Munch left for Paris and started his studies officially at Léon Bonnat's art school. In November Munch's father died. Bonnat was a famous teacher in his time but Munch did not stay long with him. After several months of drawing he proceeded to painting, but disagreements arose between pupil and teacher, mainly about the former's palette, and Munch continued to work on his own. Some time before, Manet had similarly rejected his teacher Couture by declaring: 'I paint what I see and not what you want me to see.' Together with a Danish friend, the poet Emanuel Goldstein, Munch moved to Saint-Cloud at the end of the year. Here he painted among other pictures *Night in Saint-Cloud* (1890), a dark interior in blue and green with the moonlight entering the room through the large window. A brightly lit steamer passes by on the river. Near the window is seated a man in a top hat, his head leaning against his hand. The model is Goldstein.

34

In January 1890, Munch, still living in Saint-Cloud, again attended Bonnat's art school in the mornings. But he had grown tired of the teacher's dreary Realism. In May he returned home via Antwerp and spent the summer in Åsgårdstrand. His grant was renewed for another year. Munch left in November for Le Havre but developed rheumatic fever and was admitted to hospital. Some of his pictures stored in Oslo at that time were destroyed in a fire (*The Morning After, A French Inn, The Canal in Paris, Lady in a Landscape*, a beach picture). Only in January 1891 could the artist leave Le Havre and, via Paris, travel to the South, to Nice, for his health was not yet fully restored. In April he returned to Paris, then back home again in May where he was granted the State scholarship for the third time. After the summer spent in Norway Munch travelled via Copenhagen again to Paris, and in the winter to Nice. The writer Bjørnson protested

in Oslo's *Dagbladet* against the re-award of the State grant to Munch. The painter Thaulow replied the day after; Munch himself answered in the *Dagbladet* later.

The tendency that we see in Munch's early production to work in different styles continued. The painting *Seine* (1890, depicting the Saint-Cloud bridge) is a quiet *plein-air* picture, as is *Spring Day on*
27 *Karl Johan* (1891) and also two paintings with night views of Nice:
32 *Night in Nice* and *Moonlit Night in Nice*, both of 1891. Munch was later on to paint many night pictures. Their mood corresponded to his own melancholy. Then again in 1890 Munch painted *Summer Night*, a picture which allows us to read deep in his psyche in telling the story of two people in love who remain lonely, as if love instead of uniting them would separate them for ever. The girl in white,

32 *Moonlit Night in Nice*, 1891

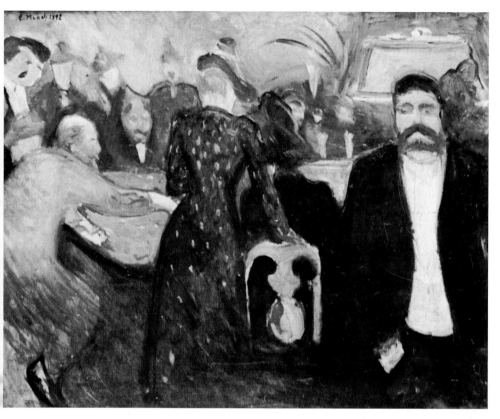

33 *Gambling-hall in Monte Carlo*, 1892

the man, a dark figure, stand facing the sea so that only their backs are seen in the picture. *Evening* or *The Yellow Boat* was also painted in 1891, but it has been lost. There is a pastel drawing of it from the same year which gives us a fair idea of the painting. The picture that we know under this title (it was sometimes called *Melancholia* or *Jealousy*) dates from 1891–3. It shows the typical undulating line of the shore covered with large boulders and in the foreground, looking out of the picture, the head and shoulders of a man with his head resting on his hand. It is a picture so simplified, so intense in feeling and in its lyrical colour harmony that it is rightly considered as one of Munch's greatest achievements. *The Day After* of 1894–5 (there was a first version painted in 1885–6) is probably a Bohemian theme with erotic intimations. There are bottles and glasses on the round table

36

35

47

on the left and a young woman asleep is stretched out on a bed behind it, dressed in a skirt and open blouse so that her breast is partly visible. Her hair hangs down to the ground over the untidy pillow, her left arm is outstretched. The picture is painted with a free masterly brushwork, the paint thinly applied as in a watercolour. In the same year *The Kiss by the Window* was painted, and in 1893 *Madonna*, the symbolic picture of the loving woman. Here the artist's brush has followed the outlines of the body to create a colour space in which the body seems enclosed. This intensifies the dramatic accent of the painting which speaks of the loving woman as of a suffering Madonna. In the same year Munch painted *Vampire*, with its cruel accusation of womanhood.

The picture that is most strongly allied with Expressionism, and frightening in its power, is *The Scream* of 1893. Munch wrote of it: 'One evening I was walking along a path, the city was on one side and the fjord below. I felt tired and ill. I stopped and looked out over the fjord – the sun was setting, and the clouds turning blood-red. I sensed a scream passing through nature; it seemed to me that I heard the scream. I painted this picture, painted the clouds as actual blood. The colour shrieked. This became *The Scream* of the *Frieze of Life*.' (*Diary*, Saint-Cloud, 1889.) In this picture the Existentialist position in which modern man finds himself is represented as pene- tratingly as by Kierkegaard in his analysis *The Concept of Dread*. The composition shows an exaggerated perspective, the pier leading deep into the landscape which is dominated by wavy lines in the sky, the sea and the land. In front a screaming figure holds both hands in terror to its head, the mouth wide open, the body convulsed. In the background two elongated figures on the pier walk forward, slowly and threateningly, as if invented by Kafka. The face of the terrified man is yellow, like a skull. The colours symbolize the psychic situation: strong reds and yellows in the sky, blues, yellows and greens in the landscape, the railing reflecting the sky. The colours and the dynamics of the curved lines express in the features of the landscape the anxiety which is an inner state of mind. What a step between *The Yellow Boat* and this disquieting scene!

Speaking of these pictures Munch wrote: 'Painting picture by picture, I followed the impressions my eye took in at heightened moments. . . . I painted only memories, adding nothing, no details that I did not see. Hence the simplicity of the paintings, their apparent

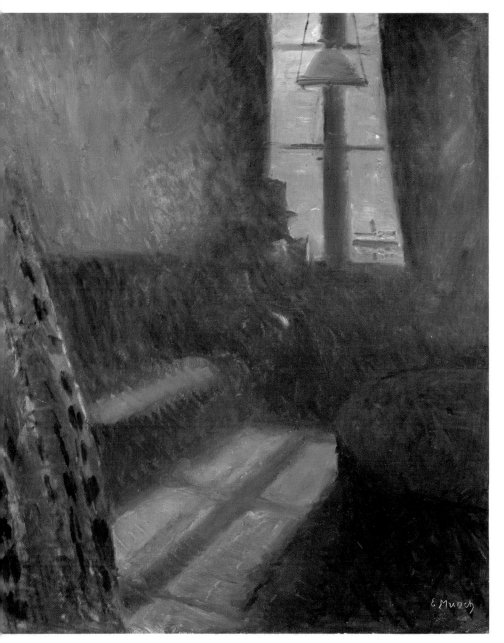

34 *Night in Saint-Cloud*, 1890

emptiness. . . . By painting colours and lines and forms seen in quickened mood I was seeking to make this mood vibrate as a phonograph does. This was the origin of the paintings in the *Frieze of Life*.' (*Diary*, Saint-Cloud, 1889.)

Christian Krohg said in 1886 when writing about Munch: 'We – the generation of painters to which I belong – are no Impressionists, unfortunately. We may stand on the mountain and look down upon the promised land.' And three years later: 'He is an Impressionist, even now our only one', before Munch had even produced a painting fully in the Impressionist technique; and in 1891 he spoke of the picture *Jealousy* as follows: 'Thus we are confronted with the strange fact that Munch, who here at home is regarded as the most incorrigible of all Realists and the most impudent and presumptuous of all painters of hideousness, is really the first and the only artist to have embraced that Idealism which bends and forces nature and his model beneath the influence of mood, and changes them in order to get more out of them.'

An important entry from Munch's *Diary* in Saint-Cloud in 1889 reads: 'No more interiors should be painted, no people reading and women knitting. They should be living people who breathe, feel, suffer and love.' Munch intended to paint a series of such pictures, and added: 'People shall understand the holy quality about them and bare their heads before them as if in church.' This was a declaration which finally resulted in the *Frieze of Life*, that series of paintings depicting man's life and death, his loving and suffering, which runs like a red thread through Munch's first great creative period.

In 1892 some of these pictures were exhibited in Oslo and were rejected by the critics. On this occasion Krohg again paid tribute to him, this time hailing him as the painter of the *Frieze of Life*: 'He joins us as the fourth of our great poets.' (The others were Ibsen, Bjørnson and Garborg.)

The exhibition of 1892 was of the utmost importance for Munch, for it resulted in his being invited to Berlin by the Society of Artists there, whose Director was the Norwegian painter Adelsten Normann. It was the prelude to Munch's impact on the Continent.

Let us now return to Paris and to what Munch's years there meant to him on the whole. What he gained there above all was his personal experience of Impressionism. Bonnat's Academy had only strengthened his aversion from Realism. Raffaelli's proto-Impres-

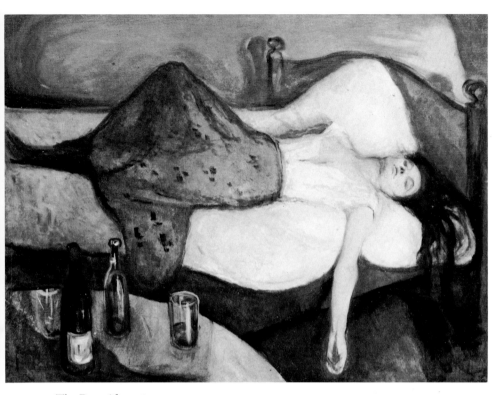

35 *The Day After*, 1894–5

sionist paintings of the worker's life in Paris attracted Munch to some extent, but it was mainly Pissarro and Monet whose technique he studied thoroughly. He even painted some pictures in their style. There is a *Landscape from Nice* or *Rue Lafayette* or *On the Riviera* (a man sitting on a bench in a public garden under palm trees) or *Promenade des Anglais in Nice* or *Outdoors* (a lady in blue dress and straw hat in the countryside), or again *Rainy Day on Karl Johan*, all painted in 1891. The best known is the *Rue Lafayette* showing a man in a top 31 hat looking down on to the street with its blurred colourful figures.

Impressionism lightened Munch's palette, but the surface rendering of vibrating light could not hold him for long. According to his own statement, it was the technique of Couture which interested him more. Munch often returned to Paris during the following years and as a result of these visits and his studies we may fairly state that he was

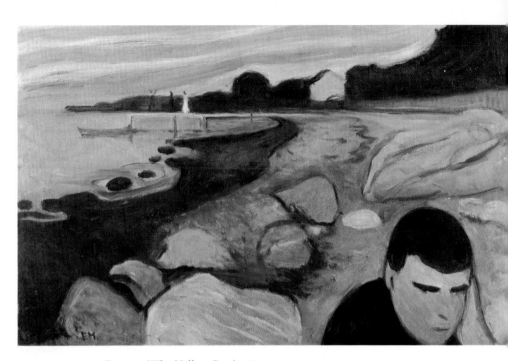

36 *Evening (The Yellow Boat)*, 1891–3

inspired by the decorative and sensitive paintings of Gauguin, by the simplification of Japanese prints (a source for Art Nouveau), and also by some works of Emile Bernard and Félix Vallotton, on the basis of which he developed his own style of rhythmical and decorative colour surfaces. The flaming and vehement fantasy of Van Gogh made a deep impression on him, deeper than Gauguin, and there were the strange Symbolist graphic compositions of Odilon Redon which left many traces in Munch's *œuvre*. There was the melodramatic work of Carrière, and the powerful genius of Rodin. Here in Paris Munch saw the delicate paintings of Degas and the daring colour lithographs of Toulouse-Lautrec. Certain works by Renoir, Bonnard and Vuillard, particularly the paintings by the latter in which the artist set dark figures inside a room against windows flooded with light, had much to tell him. Munch absorbed all these new impressions and also devoted his time to studying the old masters, above all Goya, Rembrandt, Velazquez. His range of vision widened and he worked intensely to build up his own world.

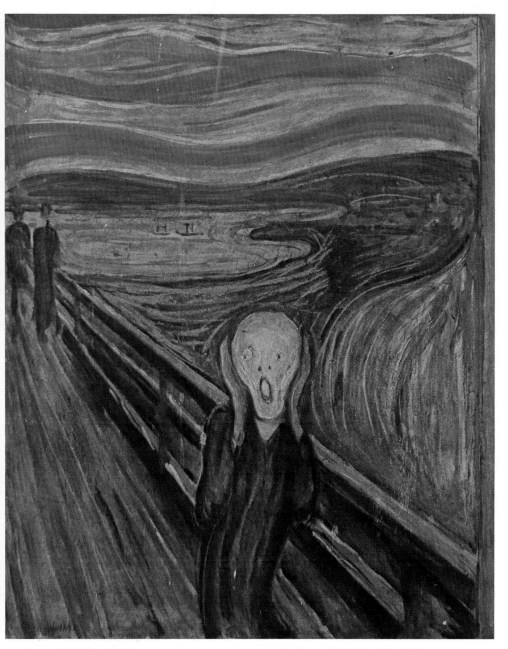

37 *The Scream*, 1893

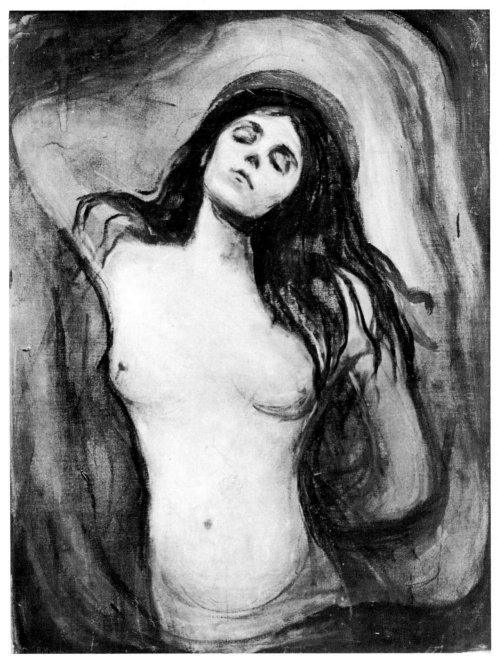

38 *Madonna*, 1893

The Frieze of Life

The years between the entry in the Saint-Cloud *Diary* of 1889 and 1909, when Munch suffered a nervous breakdown on his way home from Germany, are the years in which the main core of the pictures called the *Frieze of Life* were painted. The name was not established at first, there was only a general idea in Munch's mind, and even this unfolded only during the years when the work was in progress. It has never been possible to decide quite definitely how many pictures belong to the *Frieze*, and as Munch painted several versions of various themes in it, this makes the decision even more complicated. But there is a central group of paintings which are quite certainly part of this series and they were mentioned as such by Munch himself. At the Berlin exhibition of 1893 a sequence of his pictures was presented as *Man's Life* (*Ein Menschenleben*), and as a series called *From the Modern Life of the Soul*. In 1895 a cycle was called *Love*. All contained pictures belonging to the *Frieze*.

Later, in 1918, Munch himself wrote a commentary on the *Frieze*:[4]

'I have worked on the *Frieze* at long intervals for over thirty years. The first rough sketches were made in 1888–9. *The Kiss*, the so-called *Yellow Boat*, *The Riddle*, *Man and Woman*, and *Fear* were painted in 1890–1, and were first shown in the Tostrup Gården here in Oslo in 1892, and also in the same year at my first exhibition in Berlin. In the following year new works were added to the series, including *Vampire*, *The Scream* and *Madonna*, and were exhibited at the Berlin Sezession.... Finally the *Frieze* was shown at Blomqvist's in Oslo in 1903 and 1909.

'Some art critics have sought to prove that the intellectual content of the *Frieze* was influenced by German ideas and by my contact with Strindberg in Berlin. The foregoing facts will, I hope, suffice to refute this assertion....

'The *Frieze* is conceived as a series of paintings which together present a picture of life. Through the whole series runs the undulating line of the seashore. Beyond that line is the ever-moving sea, while beneath the trees is life in all its fullness, its variety, its joys and sufferings.

'The *Frieze* is a poem of life, love and death. The theme of one of the pictures, *Man and Woman in a Forest*, showing two figures, is perhaps somewhat removed from the rest, but it is as necessary to the *Frieze* as a whole as a buckle to a belt. It is the picture of death as an aspect of life, the forest which sucks its nourishment from the dead, and the city that rises beyond the tree tops. It portrays the powerful forces that sustain our life. . . .'

There is a unity in all the pictures of the *Frieze of Life*. Not only the unity between the concept and the inner tension which gave them birth but also unity from a formal point of view. They are a whole and it was Munch's intention that the entire *Frieze of Life*, the tale of man's destiny, should be accommodated in one hall. Munch's idea of monumental art has fundamentally a social function. His wish was never fulfilled and the pictures have been scattered. This also may explain

39 *Ashes*, 1894

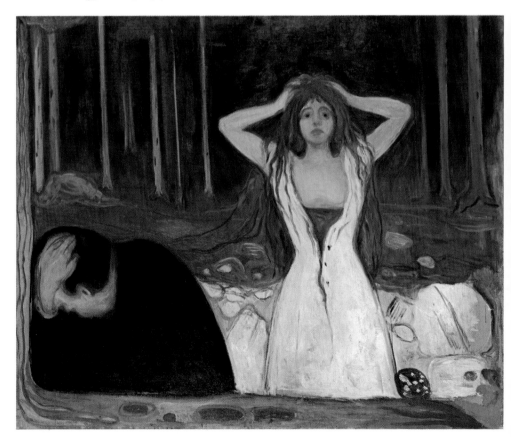

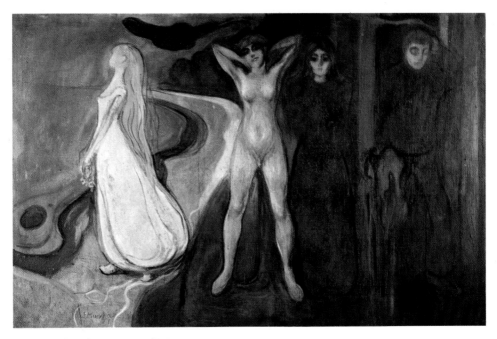

40 *The Three Stages of Woman*, 1894

the doubts that exist as to whether the *Frieze* has ever been finished. Munch himself wrote on this question: 'I should have considered it wrong to have finished the *Frieze* before the room for its accommodation and the funds for its completion were available.' He also said: 'It is only now that I have succeeded in putting together what was left of it so that in some respects it corresponds to what it was twenty years ago. But it has remained a torso.'[5] And as to the unity he said: 'It is incomprehensible to me that a critic, who is at the same time a painter, cannot find any connection between the various pictures in the cycle. No connection whatever, he asserts. Half the pictures have such a strong connection with each other that they could very easily be fitted together to form a single long composition. The pictures showing a beach and some trees, in which the same colours keep returning, receive their prevailing tone from the summer night. The trees and the sea provide vertical and horizontal lines which are repeated in all the pictures; the beach and the human figures give the note of luxuriantly pulsing life – and the strong colours bring all the pictures into key with each other. Most of the pictures are sketches,

documents, notes – and in that lies their strength. One must remember, however, that these pictures were painted over a period of thirty years: one in a garret in Nice; one in a dark room in Paris; one in Berlin; a few in Norway, the painter constantly wandering and travelling, living under the most difficult circumstances, subject to incessant persecution – without the slightest encouragement. The hall they would most fittingly decorate is probably a castle in the air.

'It was always my intention that the *Frieze* should be housed in a room which would provide a suitable architectural frame for it, so that each picture could stand out individually without impairing the total effect, but unfortunately, I have not yet met anyone who would put this plan into practice.

'One critic ironically observed', he continued, 'that a patron was bound to appear who would buy a site for the *Frieze* and build a house and provide a room specially designed to accommodate it. He was right for once. I myself have built a house for it, and if the critic leaves his capriciousness behind, he may come and look at it.'[6]

Munch, in fact, built a large fireproof studio to house the *Frieze* on his estate Ekely at Skøyen, near Oslo. It could scarcely be called an ideal solution. He kept some of the paintings, of others he painted replicas. The pictures which were in his possession were bequeathed in his will to his home-town of Oslo, and now that the Munch Museum has been completed it is there that they can be seen.

The colours in the *Frieze of Life* pictures are applied thinly and fluidly. Only rarely did Munch paint with a thick impasto. They are restrained in force, often dark, particularly in the early compositions, yet glowing like a banked fire, and intensified into a symbolic language. At times the colour harmonies seem cruel and venomous, *39, 48* as in *Ashes* (1894) or *Jealousy* (1895); then again they are contra-*72* puntal, as in *The Dance of Life* (1900). The compositions form compact wholes enclosed and held together by sinuous lines – lines like those of Art Nouveau yet not, as in the case of the latter, purely decorative, a mere application of linear patterns. In Munch's art their meaning is profoundly established by their tension and fidelity to nature. An influence can perhaps be traced to the old Nordic ornamental style known to Munch from the excavation of the Oseberg ship.

The painterly conception of all his themes is an outstanding feature in Munch's career. He is a painter first and foremost. It is not the

41 *Vampire*, 1893

literary content, the allegory or the symbolism which dominates his work as it did that of his contemporaries Klinger, Böcklin or Hodler. While they often drifted into pathos and false romanticism, Munch's ideas and his artistic expression fused to give his works the intensity and suggestive power which makes them unique.

To call the paintings of the *Frieze* Symbolist may also be misleading as they are not symbols of reality, but convey the very essence of it, the image of man's mind and soul at a crucial moment of change in European culture, and also the artist's own predicament.

Munch returned to the concept of a *Frieze* several times. There is the smaller *Frieze* which he painted for Dr Linde in Lübeck in 1904. It was refused as not suitable for its purpose. Then there is the *Frieze* painted for Max Reinhardt's Kammerspiele in Berlin to decorate the new foyer of the theatre (1907). (For Max Reinhardt Munch also designed sets and costumes for Ibsen's *Ghosts*, 1906, and for *Hedda Gabler*, 1906–7.) Finally, in 1922, Munch produced twelve oil-paintings as a *Frieze* for the workers' canteen at the Freia chocolate factory in Oslo.

125, 128-9

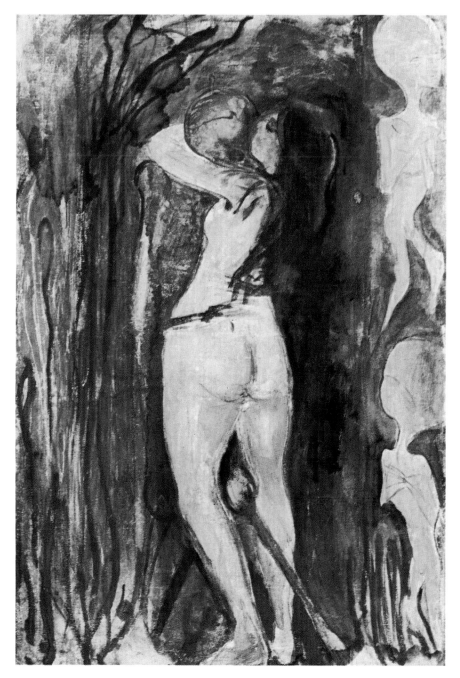

42 *Death and the Maiden*, 1893

Munch in Berlin

In 1892, as already indicated, Munch went to Berlin with fifty-five pictures. The exhibition duly opened, was closed after one week owing to a heated debate and a vote taken at the Verein Berliner Künstler. Munch's painting was described by Berlin critics as 'an insult to art'; and 'out of reverence for art and artistic effort', the Council of the Berlin Society of Artists decided that the exhibition should be suspended. The younger members of the Society were already restless, and took the opportunity presented by this breach of hospitality to part company with the conservative leaders of the Society. This revolt was led chiefly by Max Liebermann, who at this time established himself, in common with a number of other artists, as the champion of French Impressionism. The outcome of 'the Munch Affair' was the founding of the so-called 'Berlin Sezession', which marked the ultimate victory of Impressionism in Germany; but by no means the victory of Munch's art. This was to come only much later.

Munch rented a gallery in the Friedrichstrasse where most of his pictures were hung. The exhibition was later sent to Düsseldorf and Cologne. The artist had his admirers in Berlin. Among them was Theodor Wolf, later editor of the *Berliner Tageblatt*, who wrote a glowing article in his defence. Germany at this time was witnessing a process very similar to that taking place in France. Impressionism had scarcely begun to establish itself before some artists were adopting entirely different programmes.

Munch appreciated in spite of all difficulties the possibilities that Berlin offered for his artistic development, and with the exception of short visits to Copenhagen in 1893, Dresden, Munich and Stockholm in 1894, he was to remain there until the late spring of 1895.

In Berlin, then, Munch found the soil in which he could thrive. The great city attracted him; the spirit of Berlin in the nineties was receptive to every novelty, and her artists showed much more readiness to accept the stranger than did the more exclusive artistic circles of Paris. It was here that Munch found a second Bohemian

world. He was soon surrounded by friends who displayed the most profound understanding of his ideas and his mission. Though his financial circumstances at this time were straitened, he painted indefatigably, and the idea of the *Frieze of Life* began to take definite shape. It was at this period, too, that he began to devote himself to graphic work (see Chapter Thirteen).

Munch's circle of friends included the German–Polish author Stanislaw Przybyszewski, the German poet Richard Dehmel and Julius Meier-Graefe, the art historian and writer; it was here too that he met August Strindberg, the Norwegian poet Sigbjørn Obstfelder, the Norwegian sculptor Vigeland, Axel Gallén, the Finnish painter and illustrator of the Finnish national epic, the *Kalevala*, and Jens Thiis. Of great importance to Munch was his acquaintance with Walter Rathenau, then Director of the powerful AEG (Allgemeine Elektrizitätsgesellschaft) and after the First World War Foreign Minister until he was assassinated. Rathenau bought his first Munch picture as early as 1893. Further there was the art collector Albert Kollmann, to whom Munch owed his acquaintance with his future patron Dr Max Linde of Lübeck, and the art dealer Paul Cassirer.

The life of the Berlin Bohemia generally went on in the beer-hall Zum Schwarzen Ferkel (The Black Piglet), once the favourite haunt of Heinrich Heine and E. T. A. Hoffmann, in the Café Bauer, and in the homes of Przybyszewski and Dehmel. Several accounts have been published of this circle and their doings. Hermann Schlittgen, whose portrait Munch painted later (it is known as *The German*, 1901) said of Munch in this period that 'he always lived in "pensions" with his pictures scattered all over the room. He often started to paint late at night and worked much from memory. Once during the night, after a visit to a ball, he had painted a picture of it, a confused blur of dancing figures in the brilliant light of the ball-room, faint lines, and in the midst of it all the sharply defined figure of a woman, the only focused object in the picture.' Adolf Paul, chronicler of the Schwarze Ferkel, witnessed the creation of some famous Munch pictures. 'He was at that time living in a furnished room at the corner of the Friedrichstrasse and the Mittelstrasse, two floors up opposite the Polish pharmacy. He was painting. On the edge of the bed a naked girl was sitting. She did not look like a saint, yet there was something innocent, coy and shy in her manner – it was just those qualities which had prompted Munch to paint her, and as she sat there in the

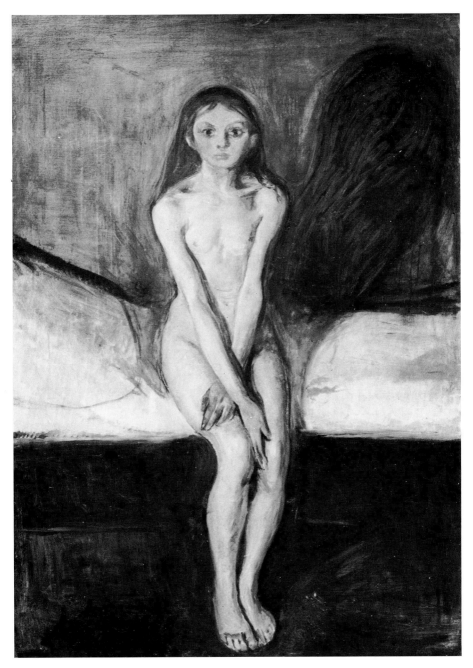

43 *Puberty*, 1895

44 *The Sick Child*, 1896, lithographic version

dazzling light of the brilliant spring sunshine, the shadow cast by her body played as though fatefully behind and above her. This picture was called *Puberty*. Another time in the same room I encountered a different model, a girl with fiery red locks streaming about her like flowing blood. "Kneel down in front of her and put your head in her lap," he called to me. She bent over and pressed her lips against the back of my neck, her red hair falling about me. Munch painted on, and in a short time he had finished his picture, *The Vampire*.'

41

Julius Meier-Graefe recalled a ground-floor room in the Luisenstrasse in the north of Berlin where a red paraffin lamp burned brightly every night until the early hours of the morning. 'It was there that the Przybyszewskis lived. He was a Pole, known to his friends as Staczu (short for Stanislaw), who wrote his bold, ecstatic works in German and who suffered from hallucinations. She was a Norwegian, very slender, with the lines of a thirteenth-century Madonna and a smile that drove men to distraction. Her nickname was Ducha (which

46

47

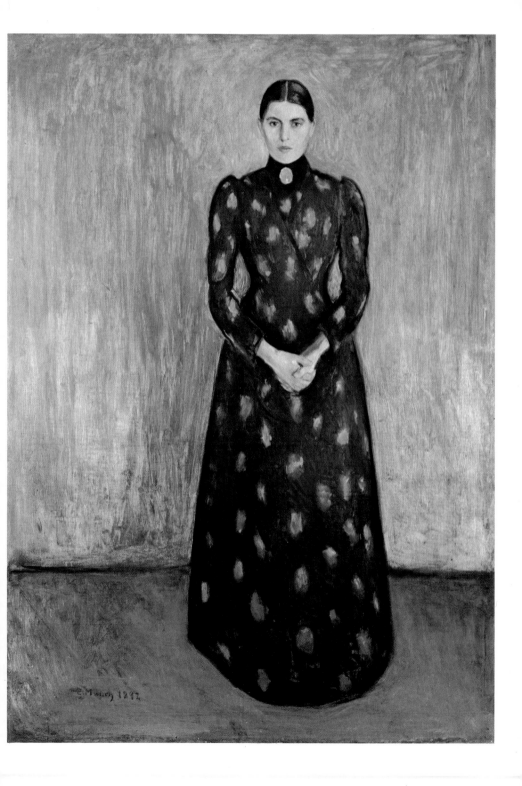

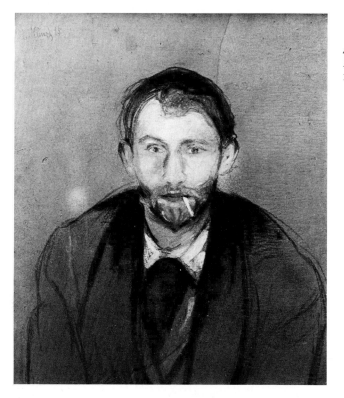

46 *Stanislaw Przybyszewski,* 1895

47 *Dagny Juell (Ducha),* 1893

means soul) and she drank absinth by the litre without ever getting tipsy. . . . Against the wall by the door stood an upright piano, a peculiar instrument. It could be toned down by means of a lever, so that the other inmates of the house were not disturbed even when Staczu hammered on it with his fists. . . . One of us would dance with Ducha while the other two looked on from the table: one spectator was Munch, the other was generally Strindberg. The four men in the room were all in love with Ducha, each in his own way, but they never showed it. Most subdued of them all was Munch. He called Ducha "the Lady", talked drily to her and was always very polite and discreet even when drunk. . . . The Paris of Huysmans and Rops provided the background of the conversation about patho-logical eroticism carried on by Staczu . . . Strindberg would talk about chemical analysis while Munch remained silent. . . . It was in that room in 1893 that the review *Pan* was born. Ducha gave it that name, which is probably the reason why Munch was against it. . . . *Pan* played a

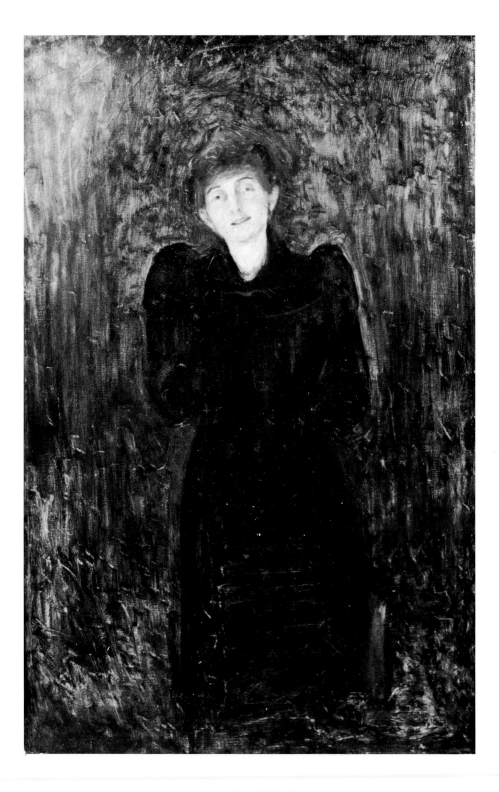

role in the art life of Berlin like that of the *Revue Blanche* in Paris. Sometime later Ducha went to Tiflis and there she became involved with a strange character, a barbaric young Russian who held a revolver to her forehead, and as she continued to laugh, deliberately pulled the trigger, shooting first her and then himself. . . .'

Jens Thiis recollects an evening at the home of the poet Dehmel – an artist's evening which lasted twenty-four hours – with the two Przybyszewskis, Munch, Gallén, Vigeland and Obstfelder. 'Dehmel, the "wild man", as Strindberg called him, whose name was beginning to be famous as Germany's new poet, began by reciting his beautiful verses. With his remarkable, dark, Mephistophelian appearance and his intensity he made an unforgettable impression. Obstfelder was also persuaded to recite some of his poems with Ducha as interpreter, and the strange low voice in which they did this gave the others an impression of the character and rhythm of the poems. Vigeland showed photographs of his works, *Hell* and the first passionate lovers' groups, which had aroused great interest. Meanwhile, Munch interjected his lightning paradoxes and sarcastic remarks. The music was provided by Staczu, who played Schumann and Chopin with all the

48 *Jealousy*, 1895

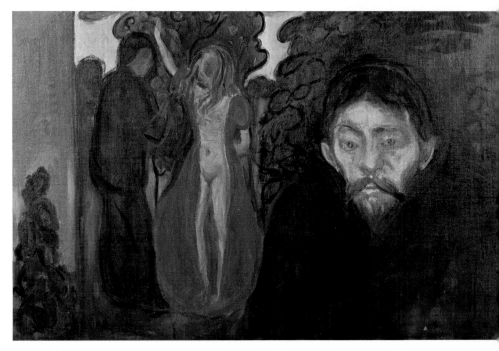

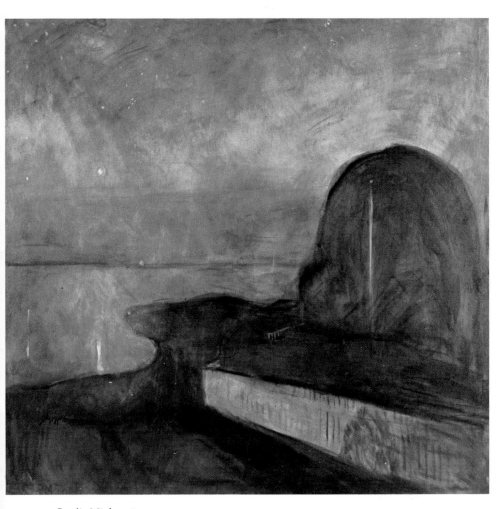

49 *Starlit Night*, 1893

vigour of his temperament, and by Obstfelder who took his violin
with him everywhere he went and was at his best playing Grieg,
Svendsen and Bach. After that the party continued at Przybyszewski's.
Then we noticed the sudden disappearance of our host. When we
found him he was not in bed but outside in the woodshed, sitting by
himself, stark-naked, on a high pile of birch logs, playing Satan; so
profound was the impression Vigeland's *Hell* had made upon him.

69

Remarkably enough, he escaped pneumonia: it was 10 February and bitingly cold.'

In this *milieu* Munch's powers came to full maturity and he began to exercise a decisive influence on the development of modern European painting.

His paintings at this time were on such themes as *Despair* (1892),
64 *By the Deathbed* (1892), *The Girl and Death* (1893), *Stormy Night* (1893),
1, 40 *The Voice* (1893), *Anxiety* (1894), *The Three Stages of Woman* (1894),
39, 48 *Ashes* (1894), *Death Struggle* (1895), *Jealousy* (1895), as well as pictures full of the romantic aspects of nature such as *Coastal Mysticism* (1892),
49 *Evening (Melancholy)* (1892–3), *Moonlight* (1893), *Starlit Night* (1893), *Sunrise at Åsgårdstrand* (1893) and *The Evening Star* (1894). He also painted many portraits, among them those of Strindberg (1892),
47 Przybyszewski's wife Dagny Juell (Ducha) and her sister Ragnhild.
46 There is the pastel drawing of Stanislaw Przybyszewski with a cigarette (1895) and a lithograph of him from 1898. A lithograph of
144 the poet Sigbjørn Obstfelder (1896) and an etching of him (1898)
45 are also from this period. The portrait of *Sister Inger*, 1892, is an early masterpiece.

After the exhibition of his series *Man's Life* (*Ein Menschenleben*) in Berlin in 1893, a pamphlet was published in praise of Munch, *Das Werk des Edvard Munch*, with contributions by Przybyszewski, Franz Servaes, Willy Pastor and Julius Meier-Graefe (1894).

Berlin Symbolism had some undesirable repercussions in Munch's work, and when today we consider his *Self-portrait under a Female Mask* of 1892 or his self-portrait *In Hell* of 1895, a yellow half-length male nude with a background partly red (fire) and partly black (smoke), we realize that Munch came dangerously near to a literary
50 art from which only his sound instinct saved him. In his *Self-portrait with Burning Cigarette* (1895) we still find a theatrical illumination, but the allegorical tendency has been overcome.

For Munch the Bohemian period in Berlin, too, was only a passing phase, more in keeping with Przybyszewski's character than his own. In the days that followed, Munch travelled extensively, restlessly, searchingly. From Germany he went to France, Belgium, Italy, and in the summer invariably back to Norway, to his adored Åsgårdstrand, whose light and atmosphere and undulating coastline provided him with the colour scheme and compositional unity of the *Frieze of Life*.

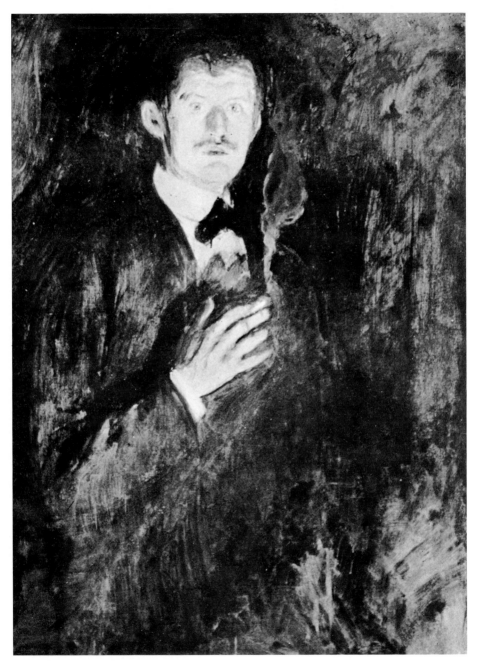

50 *Self-portrait with Burning Cigarette*, 1895

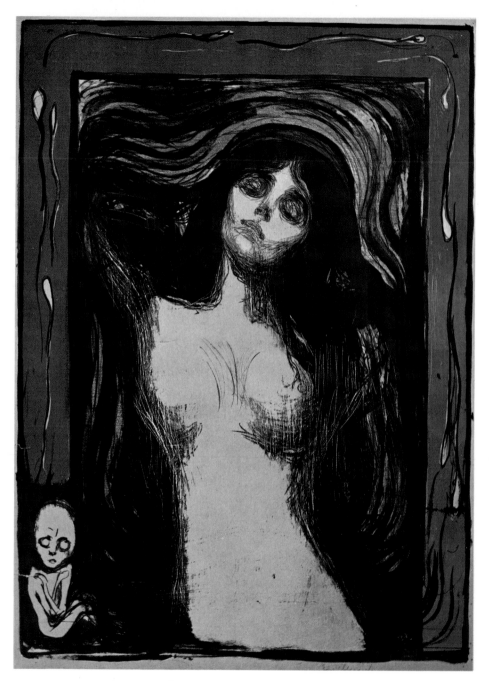

51 *Madonna*, 1895/1902

In Paris again

In 1895 we find Munch twice in Paris, in June and September. An exhibition of his in Oslo was reviewed by the famous French critic Thadée Natanson, the friend of Bonnard, who wrote on the whole generation of contemporary artists in the *Revue Blanche*. The same periodical published in its December issue Munch's lithograph *The Scream*. The Bureau de Pan in Paris had original etchings by Munch 53 for sale. Meier-Graefe published in Germany a Munch portfolio with eight etchings, and also organized exhibitions in Paris and Brussels. In 1896–7 Munch was again in Paris, where he became closely associated with the Symbolists round Mallarmé, the *Mercure de France* circle. He made a fine lithograph portrait of the poet and an aquatint (1896) for which he received an appreciative letter.[7] The fact that the lithograph *Anxiety* was included in Vollard's *Album des peintres graveurs* and that Munch produced lithographs for two programmes of the Théâtre de l'Œuvre (for Ibsen's *Peer Gynt*, 1896, and *John* 55 *Gabriel Borkman*, 1897) and also for Baudelaire's *Les Fleurs du Mal* (Ed. Les Cent Bibliophiles) shows clearly that Munch had found a measure of recognition among the Paris intelligentsia.

Strindberg published an article on Munch in June 1896 in the *Revue Blanche*, on the occasion of the exhibition in the then famous Bing Gallery.

At this period Munch was deeply perturbed to witness the religious crisis through which August Strindberg was passing. Strindberg was writing his autobiographical *Inferno* (1897) and *Legends* (1898), to be followed by the play *To Damascus*, and was also engaged in dangerous alchemistic experiments in a hotel room near the Luxembourg Gardens. Munch had been asked by a publisher to make a portrait of the author. When Munch approached him, Strindberg, who was suffering from persecution mania, repulsed him with the words: 'You too are plotting with my enemies, with that devilish Pole and the others who persecute me from afar with their evil spells, but I shall know how to defend myself.' Munch nevertheless managed to see him again and to draw a portrait of him.

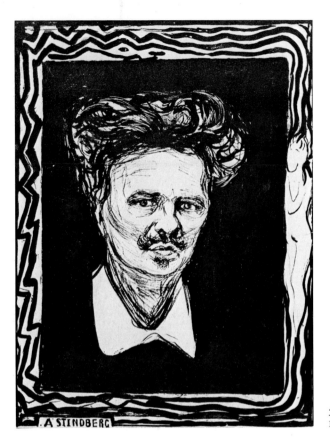

52 When he added a symbolic frame to the picture made up of zigzag
lines and the naked figure of a woman, Strindberg complained:
'You know how I hate women, and that is just why you have intro-
duced one into my portrait.' Munch later removed the frame.

It may be of interest to quote Strindberg's prose-poem written on
some of Munch's pictures for the *Revue Blanche*:

'Thirty-two-year-old Edvard Munch, the esoteric painter of love,
jealousy, death, and sorrow, has often been the victim of deliberate
misunderstanding on the part of the hangman-critics who exercise
their craft impersonally like executioners at the rate of so much
per head.

'He came to Paris to find the sympathy of the connoisseurs, without
fear of that derision which destroys cowards and weaklings but makes
the shield of the brave shine like the sun.

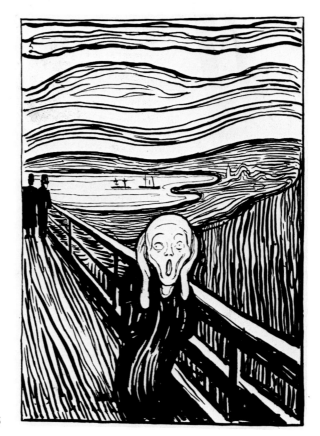

53 *The Scream*, 1895

'Someone has said that music must accompany Munch's pictures if they are to be well and truly explained. That may be so, but while we are waiting for the composer, I will sing the praises of some of his pictures which are reminiscent of Swedenborg's visions – of *The Joy of Wisdom in Conjugal Love* and *The Pleasures of Madness in Sinful Love*.

'*The Kiss*, the fusion of two beings one of which in the form of a carp, seems to be about to swallow the larger after the manner of vermin, microbes, vampires and women. Or: The man who gives awakens the illusion that woman gives in return. The man craves the privilege of being allowed to sacrifice his soul, his blood, his freedom, his peace of mind and his happiness, in return for what? In return for the bliss of sacrificing his soul, his blood, his freedom, his peace of mind and his happiness.

'*Red hair* (*Vampire*): Golden rain falls on the unfortunate kneeling creature who craves of his evil genius the boon of death by the prick of a needle. Golden fibres which bind to earth and to suffering. A rain of blood flows in torrents over the accursed head of him who seeks the misery, the divine misery of being loved, that is – of loving.

'*Jealousy*: Sacred feeling of spiritual purity, which abhors the idea of mingling itself by proxy with another of the same sex. Jealousy, that justified egoism born from the instinct of self-preservation – one's own and that of one's race.

'The jealous one speaks to his rival: Go, detestable creature! You will warm yourself at the fire I have ignited, you will inhale my breath from her mouth, you will drench yourself in my blood and then you will remain in my thrall, for it is my spirit that will rule you through this woman that you have made your master.

'*Conception* (*Madonna*): Immaculate or not, it is all the same. The red or golden halo crowns the consummation of the act, the only justification of this creature's life with no existence of its own.

'*The Scream*: A scream of dread at Nature, which, flushed with rage, is about to speak through storm and thunder to those foolish, puny beings who imagine themselves to be gods without resembling gods.

'*Twilight*: The sun sets, the mantle of night descends, the twilight transforms mortals into spectres and corpses at the very moment when they return home to wrap themselves in the winding-sheets of their beds and give themselves over to sleep. Sleep, that appearance of death which regenerates life, that capacity for suffering which originates in heaven and in hell. . . .

	The Triple Form of Woman			*The Three Stages of Woman*	
	Man-Woman			The Painted Woman	
	I		*or*	I	
2		3		2	3
Sinner		Lover		The Pregnant Woman	The Saintly Woman

'*The Stormy Night*: The wave has broken the trunks, but the roots, subterranean, live anew, coiling themselves in the greedy sand in order to draw up into themselves the eternal springs of mother ocean. And the moon rises like the dot over the "i" and completes the picture of infinite sorrow and desolation. Venus arises from the sea and

76

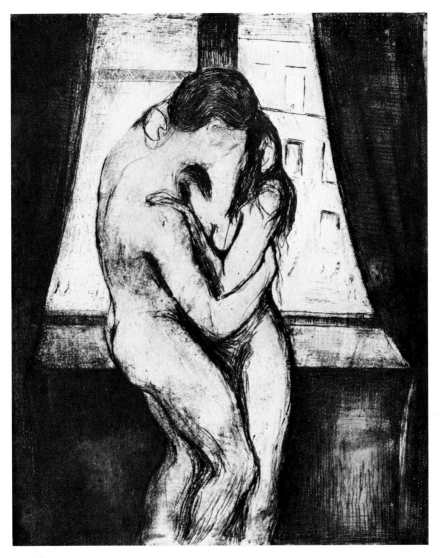

54 *The Kiss*, 1895

Adonis descends from the mountains and the villages. They pretend
to be watching the sea, for they fear to be drowned in a gaze which
would make them lose themselves in an embrace so engaging that
Venus would become partly Adonis and Adonis partly Venus.'

55 Programme for Ibsen's *Peer Gynt*, Paris, 1896

'Strindberg was shy', Erich Büttner recalls, 'but not Munch! He knew many people. At his Paris studio I often met E.R. Weiss and Otto Hettner among the German artists there. They were quite young men then. Munch had need of other people; for example, his first studio in Paris was in a corner house, and his landlord kept watch on the front door because Munch owed him money. But Munch had to get some pictures to the exhibition at the Indépendants. He solved the problem simply by throwing the pictures from the window of his studio down into the street over which his landlord was unable to command a view, where we caught them. A hole was made in one of the pictures in the process – the one showing three women under a tree which I think he called *The Fates* [*The Three Stages of Woman*], but we repaired it on the way. According to French law, a landlord may not seize a debtor's property if it is outside his house. Anyhow, Munch settled with the man later. He never remained in debt to anyone, even though he was often without money.'

56 The Maiden and the Heart, 1896

Munch devoted himself during this time in Paris almost exclusively to graphic art. He printed colour lithographs and his first woodcuts with the famous printer Clot, reserving his painting for his summer visits to Åsgårdstrand. There he had acquired a small house of his own as a permanent summer residence. In 1897 he exhibited pictures from the *Frieze of Life* and other paintings with the Indépendants in Paris and was accorded a place of honour in the main hall. As Munch himself has pointed out, it was the pictures of the *Frieze of Life* which were best understood in France; nevertheless the outspokenly nationalist policy in art matters in Paris meant that a blind eye was turned to artists who were not resident there, and the same applied to the international art market, which was not always readily receptive to art from beyond French frontiers. The outcome was that after this exhibition little was heard of Munch in France. He was to take part in no less than seven future exhibitions of the Indépendants[8] but in Elie Faure's *History of Modern Art* Munch is not mentioned, and Christian Zervos's *L'histoire de l'art contemporain*, published in 1938, did not include him.

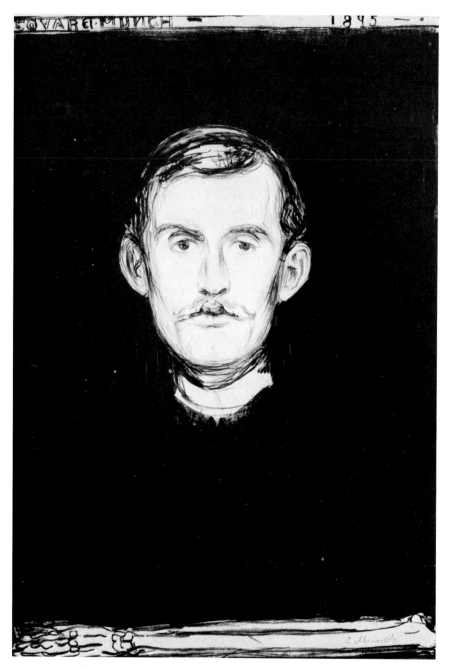

57 *Self-portrait with Skeleton Arm*, 1895

The lonely path of Edvard Munch. Love and death

It has been said that the hatred and bitterness of Munch's generation was directed mainly against itself. If no happiness was to be found in life, who was to be held responsible for the frustration, the solitude, the fruitless striving? *'Ne cherchez plus mon cœur; les bêtes l'ont mangé . . .'* so complained Baudelaire in his *Causerie*. Love turned into distrust of woman. When Nietzsche spoke of love he saw it as the eternal war, the mortal hatred between the sexes. 'Man fears woman when he loves, he fears her when he hates.' The same venom is distilled in Frank Wedekind's dramas and in the writings of the young Otto Weininger. Strindberg wrote in his diary in 1897: 'What is Woman? The enemy of friendship, the inevitable scourge, the necessary evil, the natural temptation, the longed for misfortune, a never-ending source of tears, the poor masterpiece of creation in an aspect of dazzling white. Since the first woman contracted with the devil, shall not her daughters do the same? Just as she was created from a crooked rib, so is her entire nature crooked and warped and inclined to evil.' Baudelaire hated and feared the vampire in woman. When Félicien Rops brought out a series of etchings entitled *Vengeance d'une Femme*, Przybyszewski hailed it with admiration; and after Munch had painted his picture *The Scream* he commented: 'There is something dreadful and macrocosmic in that picture. It is the finale of a cruel battle between brain and sex, from which the latter has emerged victorious.'

There are indeed in Munch's work pictures which express the hatred between the sexes, the destructive force of love. The *Death of Marat* is such a picture, or *Ashes*, *Vampire* and graphic works like *Salome, The Maiden and the Heart, Under the Yoke, Cruelty, The Woman and the Urn* and also the series of lithographs entitled *Alpha and Omega*, the pessimistic story of the life and death of the first and the last human being. Munch himself wrote the story in 1909:

'Alpha and Omega were the first human inhabitants of the island. Alpha lay on the grass and slept and dreamed; Omega broke off a fern-stalk and tickled him so that he awoke.

90

39, 41

56, 61–2

58–60

58 'Alpha loved Omega. They sat clasped together in the evening and watched the golden pillar of the moon in the shimmering sea.

'They walked in the forest, and in the forest there were many strange animals and plants; it was dark in the forest, but many small flowers grew there. Once Omega took fright, and threw herself into Alpha's arms. For many days there was only sunshine on the island. One day Omega was lying in the sunshine at the edge of the forest. Alpha was sitting in the shade somewhat deeper within the forest. Then an enormous cloud formed and floated overhead casting its shadow over the island.

'Alpha called to Omega, but Omega did not answer; then Alpha saw that she was holding the head of a serpent and gazing into its eyes, a huge serpent which had emerged from the ferns and reared up its body; suddenly the rain poured down and Alpha and Omega were filled with terror.

'When Alpha encountered the serpent in the field one day he fought and killed it, while Omega looked on from the distance.

59 'One day she met the bear. Omega quivered when she felt the soft fur against her body, and when she placed her arm round the animal's neck it sank into the bear's soft coat.

58 *Moonrise (Alpha and Omega)*, 1909

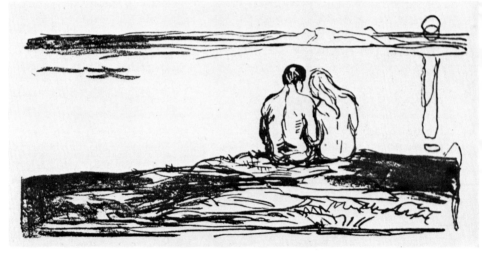

59 *Omega and the Bear,* 1909

'Omega encountered a poet-hyena with a shabby coat. Her usual words of love left him unmoved, whereupon she fashioned a laurel wreath with her small soft hands and crowned him, leaning her face against his discontented head.

'The tiger came and brought his savage head close to Omega's small, enchanting face. She was not afraid; she let her small hand rest in the tiger's jaws and stroked his teeth.

'When the tiger met the bear, he caught the scent of Omega which emanated from the pale apple blossom which Omega loved most and which she kissed every morning when the sun rose high in the heavens. The tiger and the bear fought and tore each other to pieces.

'As on a chessboard, the position of the figures suddenly changes and Omega clings fast to Alpha; curiously and without understanding, the animals crane their necks and look on.

'Omega's eyes used to change their colour. On ordinary days they were bright blue, but when she looked at her lover they turned black flecked with scarlet and then it could happen that she would conceal her mouth behind a flower. Omega's humour changed; one day Alpha noticed her sitting on the beach kissing a donkey which lay on her lap. Alpha then brought an ostrich and bent his head over the

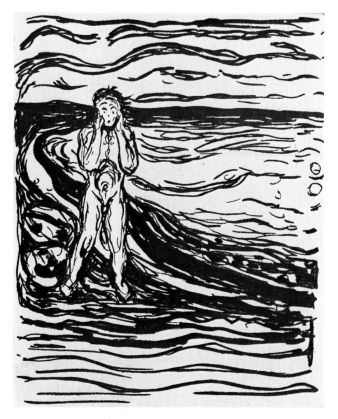

60 *Despair*
(*Alpha and Omega*),
1909

bird's neck, but Omega did not look up from her favourite pursuit of kissing. Omega felt sad because she could not possess all the animals of the island; she sat down on the grass and wept violently. Then she rose, wandered round the island in her distress, and met the pig. She knelt down and concealed her body in her long black hair and she and the pig gazed at one another.

'Omega was sorrowful and one night when the gold pillar of the moon was again reflected in the water, she fled on the back of a deer across the sea to the bright green country beyond the moon, while Alpha remained alone on the island. One day her children came to him; a new generation had grown up on the island; they called him "father". They were small pigs, small snakes, small monkeys and small wild beasts of prey and other half-human monsters. He was in despair.

'He ran beside the sea. Heaven and earth were the colour of blood. *60* He heard screams in the air and covered his ears. Earth, heaven and ocean trembled and a terrible fear possessed him.

'One day the deer brought Omega back.

'Alpha was sitting on the shore and she came towards him. Alpha felt the blood singing in his ears. The muscles of his body swelled and he struck Omega and killed her. When he bent over her body, he was shocked to see the expression on her face. It was the same expression that she had worn at that moment in the forest when he had loved her most.

'While he was engaged in contemplating her, he was attacked from behind by all her progeny and they and the animals of the island tore him to pieces. The new generation peopled the island.'

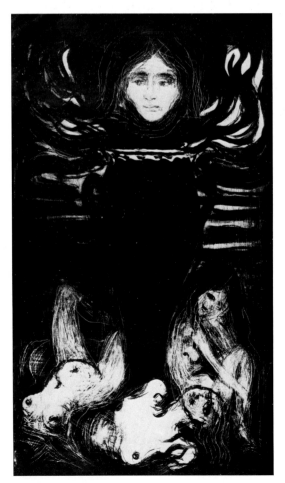

61 *The Woman and the Urn*, 1896

43 The picture entitled *Puberty* (1895) may as we have already said be regarded as part of the *Frieze*; the theme undoubtedly belongs to it. The anxious pose of the young girl, the expression in her eyes, and the heavy shadow on the wall suggest the question which disquiets her soul, the terror-filled question of love. In *The Kiss* (1892) we see two *39* figures merged into one, and in *Ashes* (1894) the despair and emptiness after fleshly union, as though nature had betrayed men and women by promising them bliss and fulfilment, while in truth the biological force that urges them together is satisfied, and as individuals they are left empty. It is as if Schopenhauer's *Metaphysics of Sexual Love* were represented in the medium of painting. Man and woman are like elements which come into contact, obsess one another but cannot

62 *Under the Yoke*, 1896

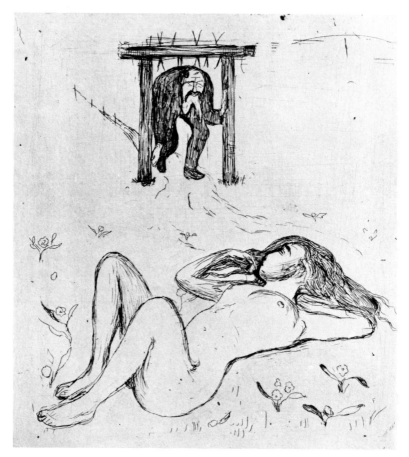

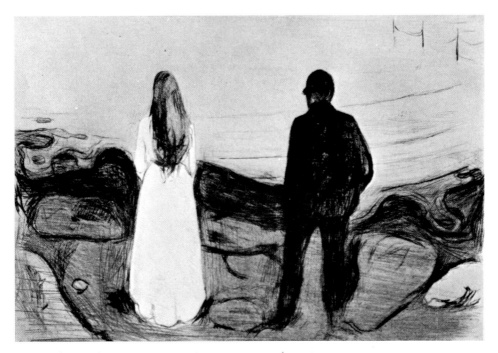

63 *The Lonely Ones (Two People)*, 1895

become united. Woman is an enigma to man, a sphinx which he must always contemplate searchingly.[9]

Munch does not hate woman, but suffers under the forces to which man is exposed, as depicted in *Attraction* and *Release* (1896) and the self-tormenting *Jealousy* (1895). In the end, there is loneliness. *The Lonely Ones (Two People)*, 1895, are depicted standing silently on the beach. What they had sought was too beautiful, too pure and too perfect. They longed for unity of soul, for deliverance from loneliness. They stand on the shore, the sea sings its eternal melody as an accompaniment to their pain-filled thoughts. No, Munch does not hate woman, for he realizes that she has to suffer as he himself suffers. *Madonna* represents the fate of the loving woman, the crown of thorns which grows from her yielding, the deep pain born of the joy of conception. Again and again Munch is attracted by the riddle of woman. *The Three Stages of Woman* (1894) exists in several versions. The girl is pure, beautiful, sensitive. She looks out musingly over the water; the magic

148–9

63

38

40

and mystery of life before her. In one of the engraved versions her expression suggests a touching simplicity. In the centre of the picture stands the mature woman who answers the strong call of life, the seductress, a Circe or a Lilith; and beside her the woman with the deep mournful hollow eyes, dressed in black, representing the mystical quality in woman, renunciation, anguish. A man leans thoughtfully against a tree, blood streaming from his heart.

72 In *The Dance of Life* (1900) the theme of love finds a new expression. Physical desire is represented in the figures in the background. In the centre of the picture the man, with eyes painfully closed, dances with the innocently expectant, trusting girl, still untouched by experience, and beginning to blossom in his arms, while to the left, ripe as an apple we see the smiling mature woman. On the right is a mournful dark figure, the symbol of the transitoriness of all feelings, of loneliness – a variation on the theme expressed by *The Three Stages of Woman*. *The Dance of Life* is one of the most beautiful scenes in the *Frieze*.

Even for the next generation love had still the quality of something hostile, threatening. So for Kokoschka, who in his thoughtful drama *Murder Hope of Women* (1907–8) expressed the problem as an eternal one, as the myth of sun and moon. Later, in his painting *The Tempest* (1914), he depicted himself experiencing the torment in the struggle between his calling as an artist and love, creativeness and sex.

Munch remained solitary all his life. Little is known about his personal relationships with women. There is the story underlying 64 the picture *Stormy Night* (1893). It was during the Bohemian period. Munch was in love with the daughter of an Oslo wine-merchant. She was rich and beautiful. His connection with the Bohemian set held a certain attraction for the young woman, although the bourgeois circles rather feared it. She clung to him but he was afraid of such a tie and anxious about his work, so he left her. One stormy night a sailing-boat came from Larkollen to Åsgårdstrand with friends of theirs on board. They had come to fetch Munch. Their story was that the young woman whom he had loved was now on the point of death and wanted to speak to him for the last time. Munch was deeply moved by the news and without question accompanied his friends, among whom was the well-known art critic Sigurd Bødtker. When he arrived he found the woman lying on a bed between two lighted candles.

88

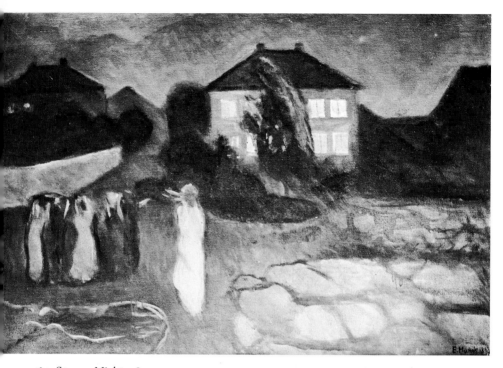

64 *Stormy Night*, 1893

As Munch entered the room she rose, and it turned out that the whole story was nothing but a hoax. She threatened to shoot herself if he left her, and drawing a revolver pointed it at her breast. Munch went to wrench the weapon away from her, convinced that this too was only part of the game. A shot went off and wounded Munch in the hand, the middle finger of which had from that time been useless. After this episode Munch's attitude towards women hardened.

Munch once mentioned that he had had the misfortune in his life of having met only women with narrow lips, and implied that they were cold and calculating creatures. Rolf Stenersen, the Norwegian collector and intimate friend of the artist relates[10] that Munch had various short-lived love-affairs but that he remembered none with special gratitude or pleasure. Munch exercised a great power over women and some of the most beautiful tried hard to win him over, but invariably he fled.

65 *Allegory*
(*Hemanthus*),
1898

When his brother Andreas died at an early age in 1895, after having been married for only six months, Munch remarked bitterly that he never should have married. From their father, so he declared, they had inherited their bad nerves, from their mother their weak lungs, and although he considered his sister-in-law to be a good person, she was too vital. It was she who wanted the marriage – his brother's health was too fragile. Munch was against marriage. He was lonely because he had experienced too often the loss of those whom he loved most. He developed a strong suspicion of any sign of affection. And then he was afraid that his work would suffer. Woman wanted the whole man. Sexual intercourse he considered a mating with death. A man who lived with a woman killed something in himself. The theme of the *Death of Marat* is to him the murder of man by woman. Even when Munch drew or painted scenes from brothels, it became

90

for him the expression of anxiety and horror, blood and murder. Rolf Stenersen says that Munch's pictures rarely seem to have sexual themes. Nevertheless, they are choked with imprisoned sex. Was his art incapable of satisfying the needs of his heart? The answer may be found in one of his graphic works (*Allegory* or *Hemanthus*, a woodcut 65 of 1898) where the naked body of a man is seen buried in the earth up to his thighs. His left hand grasps his head which is convulsively thrown back, while the right grips his breast, from a wound in which the blood wells over his hand and drips down on to the earth. In front of the figure a lily grows out of his blood: it is the symbol of art.

As love is the perpetual beginning of life, so death is the obliteration of the individual. The only means of overcoming this obliteration was the work which survives its creator. For Munch's generation death no longer appeared as a transition to a new life; for Munch himself it remained the unknown, the threatening and unanswered question. *The Scream* of 1893 and *Fear* of 1894 express the anguish of the seeker, the despair of the forsaken, our fear of death and alienation from nature. Death is the pain of the bereaved, as we see it in the picture *By the Deathbed*, or *Death Struggle* (1895). It is the question posed in the picture *Death in the Sick Chamber* (1892). In this painting neither 67 death nor the dying man are visible; only detached groups of brooding mourners are to be seen. This picture is painted in casein colours, with crayon, and from the use of these materials it appears somewhat strange among the other paintings of the *Frieze of Life*. *The Dead Mother and the Child* depicts the anguish and despair of the child after 66 its mother's death, the sudden silence spreading in unearthly fashion. In all these pictures Munch has expressed man's utter helplessness in the face of death, and accordingly they aroused the hostility of his generation, which did not wish to be made aware of its innermost weaknesses. Man has become too mechanically minded; the modern rationalist-scientific attitude no longer permits the confidence in the forces of creation, nor a life in harmony with them, that former generations knew.

Munch found an escape from this oppressive despair; he became reconciled, discovering the idea which was to become his means of deliverance. A lithograph *Life and Death* of 1897, conveys the message of biological immortality, the eternal renewal of life. Buried in the earth is a woman from whom plants and flower-like shapes arise, and bubbles in the form of faces. On the left of the picture, beneath

a tree growing out of a skull and spreading its fruit-laden branches towards the sun, is seen the youthful figure of a pregnant woman. The tree draws its nourishment from mortal remains, while between its branches the sun sends forth its rejuvenating rays in all directions. 'I find it difficult', Munch said to his friend Christian Gierlöff in 1913, 'to imagine an after-life, such as Christians, or at any rate many religious people, conceive it, believing that the conversations with relatives and friends interrupted here on earth will be continued in the hereafter. "Hello. Good morning. Do you remember Åsgård- strand? Do you remember the time when we shot at one another in Morocco?" But I do believe that there is a mysterious force that continues, so that we repeat ourselves like crystals that are dissolved and then re-crystallize again.'

66 *The Dead Mother and the Child*, 1899–1900

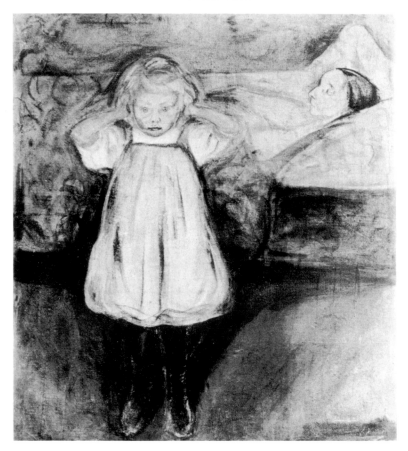

67 *Death in the Sick Chamber*, 1892

Munch did not want to think of his body decaying after death. Once he said: 'Death is pitch dark, but colours are light. To be a painter is to work with rays of light. To die is as if one's eyes had been put out and one cannot see anything any more. Perhaps it is like being shut in a cellar. One is abandoned by all. They have slammed the door and are gone. One does not see anything and notices only the damp smell of putrefaction.'

It is on the basis of such statements that two psychoanalysts, Stanley Steinberg and Joseph Weiss of San Francisco, tried to analyse Munch's psyche.[11] Here we can read that 'Munch's pictures were in

93

a sense between himself and the outside world and part of each.' The authors speak of the artist's intense fears of destructive incorporation of objects and of abandonment or loss. His fear of over-stimulation by the environment was a manifestation of his fear of the incorporation of objects through the senses. He feared losing part of himself or part of his environment. By painting such external objects Munch reassured himself that they were not really lost. His castration anxiety was an aspect of his fear of loss. He defended himself against it by repeated inclusion of phallic symbols in his paintings. Munch's dilemma was, as they point out, that 'if he became too close to people he was in danger of being incorporated by them, but if he kept at a distance he felt alone and abandoned'. Finally, he started to copy his old paintings (as he could not be without them, when they were sold, and spoke of them as his children), his pictures having become his main love objects.

It would take us too long to go into this analysis in detail. Nothing basically new about Munch's inner condition came out of it, it is an interpretation like any other.

There is always the question as to whether genius can be seen as an illness as Balzac expressed it: 'Who will win, the illness over the man or the man over the illness?' or whether it should more adequately be conceived as a heightening of the faculties of perception, mental combination or intuition and an immense urge for and ability to work. As to illness – and Munch himself, as we already know was often assailed by it from his earliest childhood – let us remember what Nietzsche said: 'There is no profound wisdom without experience of sickness, and all higher healthiness must be achieved through its means.' A similar idea was expressed by Diderot, who said: 'I suppose that reserved and melancholy men have had some temporary dislocation of their personal mechanism to thank for that extraordinary and indeed divine acuteness of perception which was to be noticed in them on occasion, and which brought them sometimes to madness and sometimes to higher reaches of thought.' Bergson, Freud and Proust all ascribe a similar constructive role to illness.

Dr K. E. Schreiner, who was Munch's physician and wanted to heal Munch of his neurosis and sleeplessness, found the artist opposing him in the most determined manner. He was afraid of losing the impetus behind his artistic will. That was impermissible. Munch made a drawing of himself as a corpse lying with an open chest on a dis-

68 *Dr Schreiner and
Munch*, 1930

secting table in front of Dr Schreiner, an 'anatomy lesson', so to speak,
but also a sign of mental grandeur, for how many people have the
courage not only to see the truth but also the strength to depict it?

Another attempt has been made to interpret Munch's art, this time
on the depth-psychological basis of C. G. Jung. Seeing Munch as a
painter of problems, G. W. Digby[12] considers them to be essentially
personal, psychological ones. Painting was for Munch an obsession
which discharged the tensions and problems of his life, a sort of auto-
biography. It is impossible to deny the neurotic element in Munch's
art, the introverted attitude. Many of his problems are ours. Munch
belonged to the feeling-intuitive type, both being dominant psycho-
logical functions. As stylistic features characteristic of introverted

artists, the author points out the tendency to simplification, the stripping of the image to its essentials, the importance of outline. Colour, for the introverted, works as a symbol, i.e. it has a psychological value. Analysing several works of Munch's the author indulges in the application of Jungian symbolism which too often proves superfluous. That Munch all through his life was subject to moments of panic fear (or irruptions of the unconscious) is true. But is it not also true that the consciousness of the forces of nature can fill any human being with anxiety? In the Jungian language, *The Scream* represents a regressive longing in conflict with the resistant figure of the 'Terrible Mother' and also with the father figure (or super ego) indicated in the eye of heaven. *Spring Evening on Karl Johan* shows another aspect of the same problem. Jung has pointed out that the

28

69 *Self-portrait with Wine Bottle*, 1906

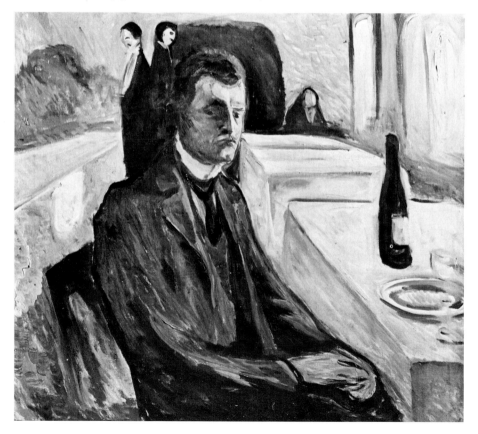

70 *Virginia Creeper*, 1898

crowd is generally a symbol of fear and anxiety. Observe the un-
relatedness of the figures to each other. The *Self-portrait with Wine* 69
Bottle is a record of the feeling of inner division and warfare. At the
end of the table sits a forbidding female. 'She is impersonating some
mysterious negative.' The analysis is more detailed but this may
suffice here. To one who is not familiar with Jungian notions the
picture reveals an empty restaurant. Munch turns his back on it,

97

on the two waiters and on the only guest as an expression of his loneliness and despair at a time which was critical in his life. The contrast between the two figures, the one dark and the one light, in *Mason and Mechanic* (1908) and in *The Duel* (1935) stand for the positive and negative aspects in Munch's life, i.e. the man and his 'shadow', in Jungian terms. The shadow side of Munch's own life was something which always threatened him. But it can also be seen as a purely painterly element, that of colour contrast.

88, 134

G. W. Digby asks: 'Why cannot Munch love, give himself up to the love of woman, to physical passion without remorse, to the ideal of woman without the loss of his own soul?' The root of this lies in his relationship with his mother, his fixation on the mother figure. 'It is as though in the infantile depth of Munch's consciousness he felt that the mother had denied him, failed him, frustrated his love-longing, cheated him by becoming a putrefying corpse.' 'Analytical psychology finds this negative mother theme widely expressed in mythology: the Devouring Mother, the Sphinx, the Lamia, the witch or sorceress.' The way of healing, a 'reconciling attitude which can lead towards a solution is a theme reoccurring in mythology and in art.' The redeeming symbol is 'a highway, a way upon which life can move forward without torment and compulsion' (Jung). The author, speaking of the picture *The Three Stages of Woman* interprets it thus: firstly, there is the mother figure, which in Munch's case is negative, inhibitory. Secondly, there is physical woman, the object of sexual desire. Thirdly, there is the anima or soul figure; for woman also has an ideal aspect for man. She wears for him the aspect of the *femme inspiratrice*, and psychologically this figure stands for him as the mistress of his inner psychic life, his relationship with it as the source of the spiritual waters of life. These three aspects of woman Munch cannot integrate although they should live together in harmony. Unfortunately, an unsatisfactory relationship with the mother figure casts its shadow over the anima, on which so much depends for man. The author goes so far as to say that 'the maiden figure who holds such promise and expectation . . . always bears the mask-like featureless face of the dead mother.' Finally the author claims: from the point of view of the understanding of art, the archetypal symbols have to be known.

40

What is of importance to note is that Munch's dilemma was also the dilemma of a whole age, and it seems improbable that in every

case (Strindberg, Nietzsche, Schopenhauer, Félicien Rops, Baude-laire) the elements of such a personal analysis could be the same.

Munch depicted the spirit of his age; he portrayed the conflicts of modern man and held before him a mirror in which he could recognize himself, even if only after long years of obstinate resistance; he did this not through antiquated symbols, but in a manner intrin-sically his own, representing in a novel way the eternal in the present. If there seemed to be some febrile, burning, disquieting element about these first efforts in which he told the story of the problems of the human soul, it was perhaps only because modern man at first resisted the recognition of his inner disharmony. Munch himself suffered when laying bare those forces which exercise so merciless an influence on man's life, shattering a happiness which is but an illusion. F. X. Šalda, the Czech critic, described Munch in 1905 as 'a dispeller of dreams, a painter in terror-inspiring colours ravaged by all the sufferings of life, a man possessed by ashen horror and gloom, a coarse barbarian and a subtle decadent in whose work both the old world and the new inferno play their parts, in whose pictures objects literally shed the blood of their colours and shriek out their sufferings and the mystery of their being; a painter whose colours are no objective manifestation but a lyrical fate. He might perhaps as well have been a criminal as an artist, and the hand which applied colours to the canvas in this way might have been equally capable of wielding a knife or throwing a bomb. And yet; there is a series of pictures that shows that while this man . . . is obsessed by vampire-like dreams, he is not only a painter of creative power with purely and simply a painter's vision and sense of values, the witness of a glowing eruption of dark forces from the interior of man, but also a delicate lyricist with a rare and fragile magic, a poet and artist of charm with a melancholy understanding insight that caresses and enchants.'

Long before any Freudian or Jungian terminologies were used we find an interpretation of great poetic value and truthfulness in the writings of Munch's friend Przybyszewski.

'The old art and the old psychology had been an art and a psycho-logy of the conscious personality, whereas the new art was the art of the individual. Men dreamed, and their dreams opened up to them vistas of a new world; they seemed to perceive with the ears and eyes of their minds things which they had not physically heard and seen.

What the personality was unable to discern was revealed to them by the individuality—something that lived a life of its own apart from that of which they were conscious. . . .

'All that is profound and obscure, everything for which the medium of language has as yet devised no system of definition, and which manifests itself only as a dim compulsion, finds expression in the colours of Munch, and so enters into our consciousness.'

If we replace Przybyszewski's 'personality' and 'individuality' with the terminology of Freud, we stand on the threshold of psycho-analytical exploration.

One of the causes of the enormous excitement which greeted Munch's art was the fact that he discovered a new world in man and afforded unlooked-for glimpses into the life of the psyche. At the

71 *Mother and Daughter*, 1897

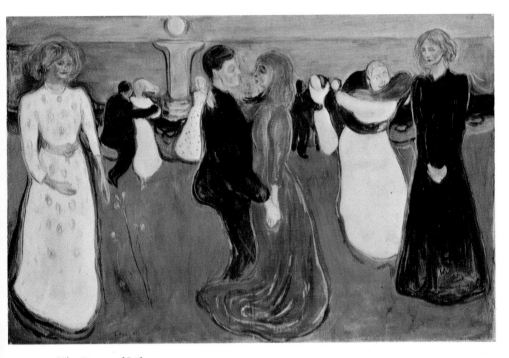

72 *The Dance of Life*, 1900

same time Munch's art radiated an unconscious moral influence, arising from his seriousness and his uncompromising commitment. Yet without his power as a painter, his supreme mastery of form, he could never have achieved such effects.

In Munch, the thinker, the poet and the painter are in equilibrium. He is no mere formalist. Art, as the realm of human imagination and creativity, found again in Munch that unity peculiar to the great artists of past ages: Giorgione, Rembrandt, Tintoretto, Goya. No one can draw a distinction between the technique of their work and its content, between the content and the man. They are one.

Munch strove for the expression of a new humanity. When he started out on his wanderings through Europe, he found the ground was already prepared by the conflict of ideas to receive his message. His personal fate, the sorrow he had experienced, the doubts with which he had wrestled, his attitude towards life gave a universal validity to what he had to impart to the world of his time.

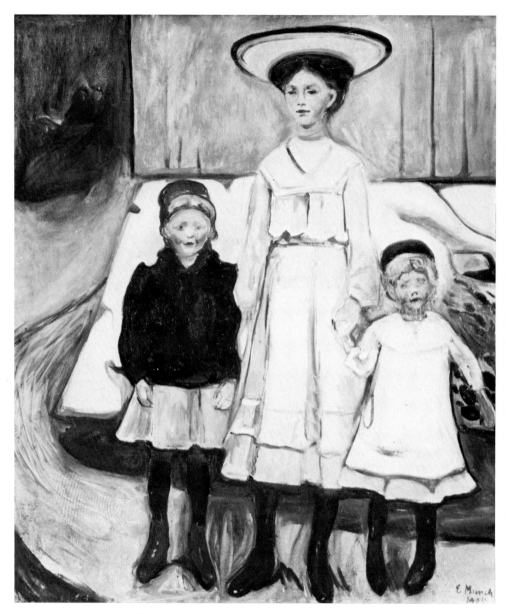

73 *Three Children*, 1905

Years of restlessness

In 1899 the Berlin Sezession held their first exhibition on their own premises, but Munch was not invited to exhibit. He was considered an eccentric, 'a slightly undesirable interloper', and it was not until 1902, after the more conservative-minded elements had been weeded out of the Sezession, that he was able to exhibit the twenty-two pictures from the *Frieze of Life* with the series on love and the series on death, on which he had been working since 1892. This exhibition marked the beginning of Munch's success in Germany. Supported by the painters Leistikow and Ludwig von Hoffman, and helped by the influence of Albert Kollmann, he was eventually able to win the admiration of even Paul Cassirer, then Secretary of the Sezession. At this period Munch was restlessly wandering in Europe, now in Norway, now in Germany. A short stay in Paris was followed by journeys to the south of France (Nice), Italy, and Switzerland. He was suffering from the effects of overwork and alcohol, quarrelled with his friends and fellow painters and had perhaps not recovered from the aftermath of the strange romantic involvement which has been described in detail in the foregoing chapter and in which he had had the joint of a finger on his left hand shot off. His previous encounters with Strindberg and his relationship with Albert Kollmann, whom he called his Mephistopheles, had helped to give his mind a brooding, restless cast. 'He was in a state of great emotional exhaustion during this time,' wrote Thiis. 'The summer of 1902 in Åsgårdstand, too, was an extremely difficult and distressing time for him.'

In the autumn of 1902 Munch went to stay with Dr Max Linde for a few quiet, restful months in which he made the 'Linde Portfolio' of fourteen engravings and two lithographs, depicting Dr Linde's house and garden and the members of the Linde family. After having refused Munch's small *Frieze* because it had been painted in the open and did not harmonize with the nursery for which it was intended, Dr Linde commissioned several other pictures from the artist. Munch's painting of Dr Linde's four sons (1903) is one of his finest 76
portraits of children, in which the artist seems to have competed with

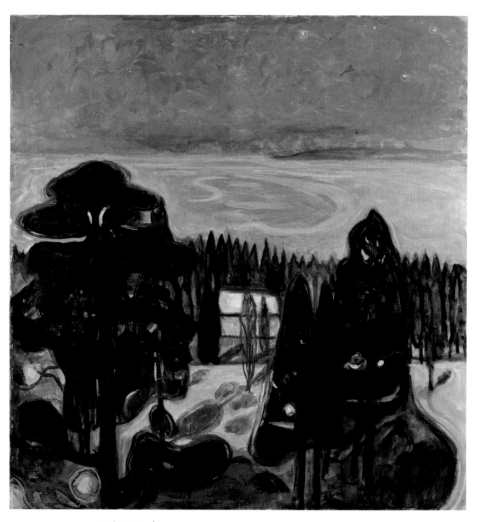

74 *White Night*, 1901

Velazquez. Munch also made a picture of Mme Marie Linde and the Lindes' son Lothar in a red jacket, standing in the garden (1903). The year after he produced the two portraits of Dr Linde himself.[13]

In 1904 Munch stayed with Count Harry Kessler in Weimar and painted his portrait. Ernest Thiel, the Swedish collector, who gave the money for the foundation of the Nietzsche archives at Weimar,

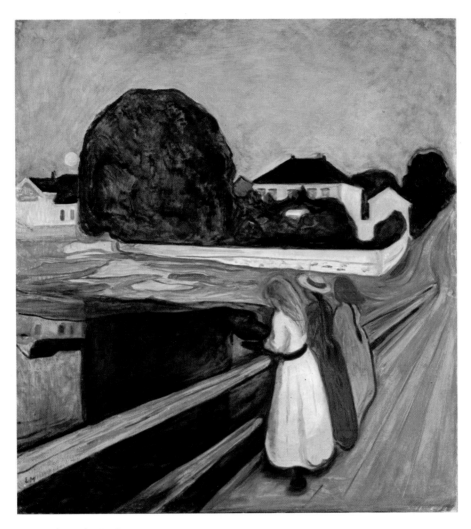

75 *Girls on the Bridge*, 1899

commissioned a portrait of Nietzsche painted from a photograph. There are two versions of it, both from 1906, the one in the Thielska Gallery in Stockholm, the other in the Munch Museum in Oslo. The portrait in Sweden seems to be the final version of this difficult task. There is also a fine drawing of 1905 showing Nietzsche sitting in an interior near a window, a quick sketch made from memory

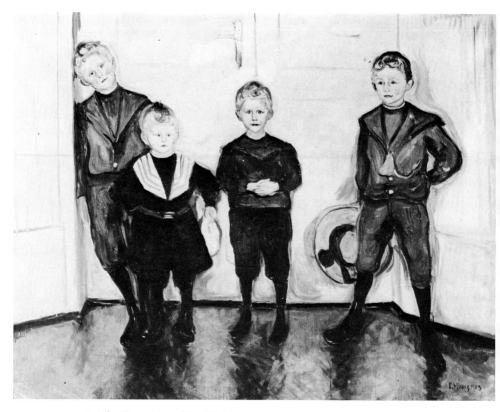

76 *The Four Sons of Dr Linde*, 1903

and more alive than the paintings, which have a stiffness unusual
for Munch.

As already mentioned, Nietzsche, Dostoevsky, Kierkegaard, Ibsen
and Strindberg were all writers with whom Munch had an affinity.
He wrote in 1924 to Dr Hoppe in Stockholm, gratified that his art
was thought to express the spirit of the North, 'Here we have Strind-
berg, Ibsen, Søren Kierkegaard and Hans Jaeger, whilst Russia has
Dostoevsky. . . . It is only during the last few years that I have made
the acquaintance of Kierkegaard, and there are some remarkable
parallels. I understand now why my works have so often been com-
pared with his. Well, I too have plans for a great work in text and
pictures.' He then goes on to speak of his memoirs: 'The notes I have
made are not a diary in the ordinary sense, but partly lengthy records

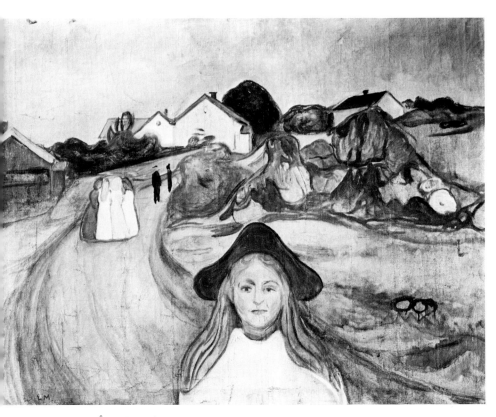

77 *Road in Åsgårdstrand*, 1902

of my spiritual experiences, and partly poems in prose. It is a difficult task to arrange it all, and I doubt whether I shall be able to do more than just make a small extract from it.'[14]

It may be of interest here to note that among the books which were found in Munch's library after his death, it was only the writings of Bjørnson, Nietzsche and of Kierkegaard that were represented in collected works. Munch is said to have been particularly interested in Kierkegaard's *The Concept of Dread*. There was Elisabeth Förster-Nietzsche's story of her famous brother's life, a few volumes of Strindberg, single volumes only of Ibsen's works, some writings by Georg Brandes (his book on Goethe and the first volume of his Michelangelo study). André Gide seems to have been Munch's favourite French author. There were some works by Dickens, Mark

Twain, poems by Sigbjørn Obstfelder, one book by Hans Jaeger. The majority of books and reviews were on art, among them Goya's *Tauromaquia*.[15]

There is no other modern artist who has travelled so extensively as Munch did between the years 1892 and 1909, always working and producing masterpieces and exhibiting them in various countries. It is a record of superhuman will power and determination, of an urge stronger than any ordinary talent can ever experience. Munch was one of the most prolific and most exhibited artists of his time. It would be tedious to list all his exhibitions here, they can be found in a useful volume containing the bare facts on the life and work of this artist.[16] What interests us is the crescendo of an artist's life,

78 *Bathing Men*, 1907–8

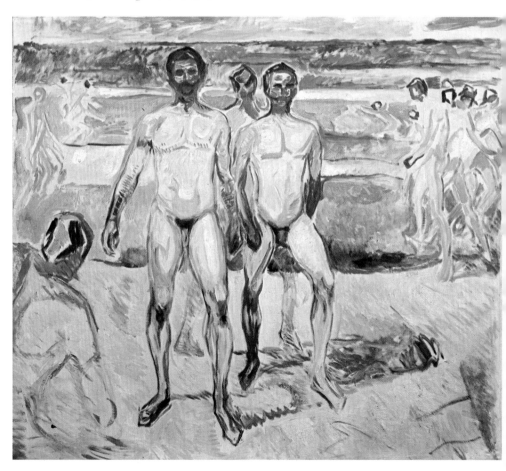

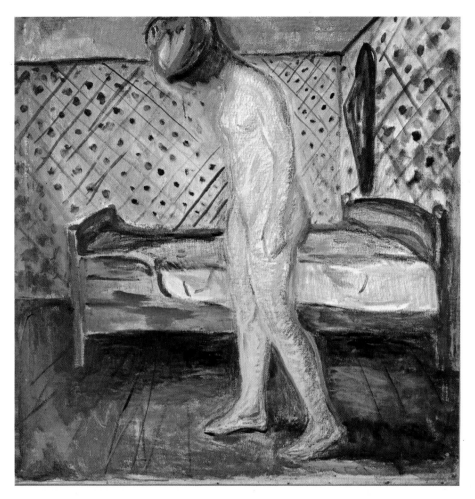

79 *Nude near the Bed, c.* 1907

haunted by his own genius, by adverse criticism in his home country, by an inner fever which brought his health to the brink of disaster. An excess of alcohol completed the devastating effects. Between 1892 and 1909 Munch exhibited one hundred and six times in Scandinavia, Germany, France, Belgium, Austria, in Italy, Russia, Czechoslovakia and twice in the United States (once in Chicago and once in New York). Of all the towns, Berlin had the most exhibitions. There were sixteen altogether, followed by Oslo with ten, Copenhagen with nine,

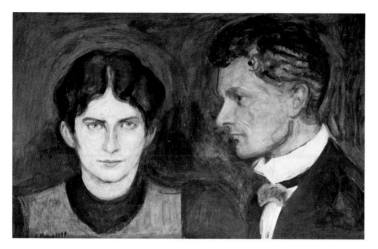

80 *Aase and Harald Nørregaard*, 1899

81, 82 *The Frenchman (M. Archinard)* and *The German (Hermann Schlittgen)*, 1901

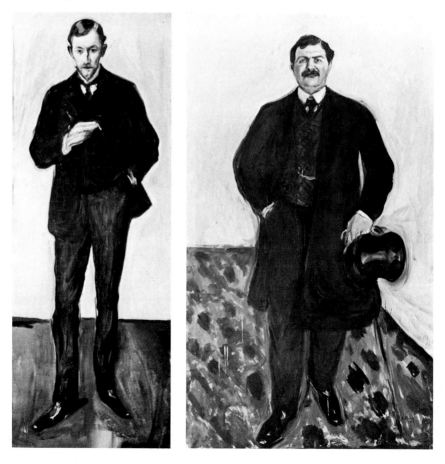

Paris, Hamburg and Dresden with seven each, Munich with five, Vienna with four, etc.

After Munch's visit to Weimar in 1904, we find him painting in Hamburg, Berlin and Lübeck under great emotional strain. He felt that he was being persecuted and spied upon. The Norwegian Press continued to display hostility to his work, though he had by now won recognition abroad as one of the great modern masters. The National Gallery in Oslo had purchased two of his pictures in 1899; but when in 1904 he sent ninety pictures there, of which eighteen were subjects from *The Modern Life of the Soul*, some lithographs and drawings, and his friends Jappe Nilssen and Jens Thiis arranged an exhibition in the Diorama Hall, attendance was poor because it had

83 *Melancholy*, 1900

received no critical notices. Jens Thiis delivered a lecture on Munch in front of empty seats.

During these years one event particularly gladdened Munch's heart: his exhibition in Prague, in March–April 1905. This included seventy-five paintings and forty-six graphic works; its nucleus was twenty-two compositions from the *Frieze of Life*. Munch went in person to Prague, and when I visited him in the summer of 1938 he said to me: 'Do you know, that was my first real retrospective exhibition abroad?' In a letter addressed to me and dictated to the painter Pola Gauguin, the son of Paul Gauguin, who lived in Oslo as an artist, teacher and writer on art, Munch recalled in answer to some of my questions that his largest exhibitions were those in the Kronprinzenpalais in Berlin and the National Gallery in Oslo in 1927, and more particularly the one in Zürich in 1922. 'The best one-man show I ever had.' He went on to say that this exhibition, and the one in Prague in 1905, were among his most memorable experiences.

In 1905 Munch carried out a portrait commission in Chemnitz (*The Two Children of Dr Esche*), in 1906 he was in Jena and again in Weimar, where he was introduced at the Court. While in Weimar he painted a self-portrait of which we have already spoken and which tells us more about his anguished state of mind than a score of words would do (the *Self-portrait with Wine Bottle*, 1906). After short visits to the spas of Elgersburg in Thuringia, near Weimar (1905), Kösen and Ilmenau, also in Thuringia (1906), where he sought in vain to tranquillize his nervous condition, Munch went several times to Berlin. In 1907 he worked on the portrait of Walter Rathenau there. The summer and autumn months of 1907 and the spring of 1908 he spent in Warnemünde. It is related that one day there when he was putting up his canvas to start a painting, the wind blew down the easel. 'That's Strindberg, he does not want it,' Munch remarked in a disturbed manner.

As well as paintings belonging to the *Frieze of Life* and the many graphic works, Munch's production during these years showed a great variety of themes. There are self-portraits. (Altogether seventy-two were executed in various techniques during the years between 1880 and 1943: paintings, drawings, watercolours, some mere sketches, graphic works, some again part of compositions. Only a limited number of them are truly important works, but all are of extreme interest for the psychological penetration of Munch's personality.[17])

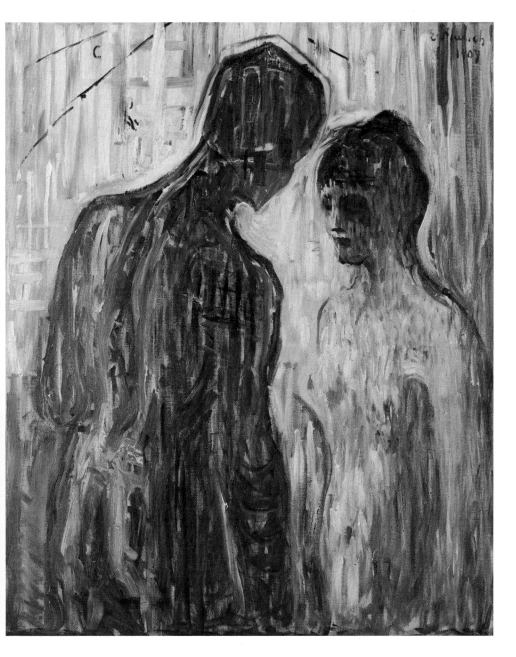

84 *Amor and Psyche*, 1907

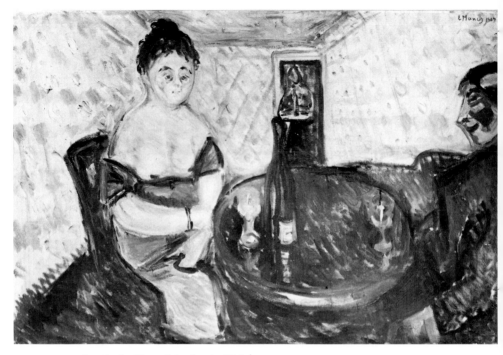

85 *At the Sign of the Sweet Girl*, 1907

There are portraits: *Ibsen in the Grand Café* in Oslo, 1898, *Albert Kollmann* (1901), *Gustav Schiefler* (1905), the author of the *catalogue raisonné* of Munch's graphic works,[18] the portrait of Miss Warburg, of the painter Ludwig Karsten (both 1905), the only Norwegian contemporary of Munch's to approach his Expressionist style. In an

89 episode depicted in the painting *Uninvited Guests* (c. 1905) we see Munch shooting at him.

82 The portraits of Hermann Schlittgen, called *The German*, and

81 M. Archinard, called *The Frenchman*, both of 1901, characterize different types: the jovial, somewhat clumsy German and the elegant, aristocratic Frenchman. There are the double portraits like that of the painter Paul Herrmann and the writer Paul Contard (1897), painted in Paris, also contrasting types as in the previous portraits, but here represented together. One of the most beautiful double portraits is

80 that of Aase and Harold Nørregaard (1899), and one in which the tension between the sexes is indicated is the later portrait of Christian Gierlöff and his wife (1912).

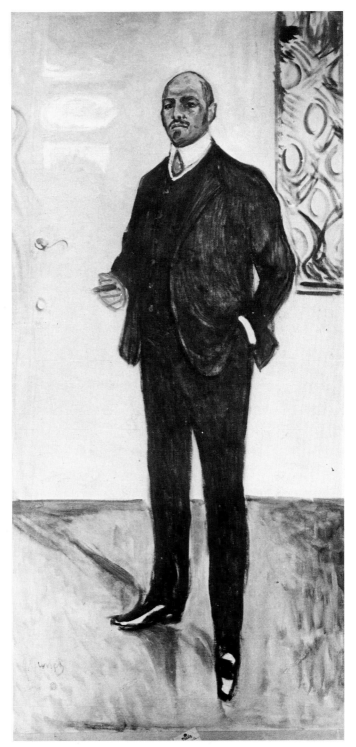

86
Walter Rathenau,
1907

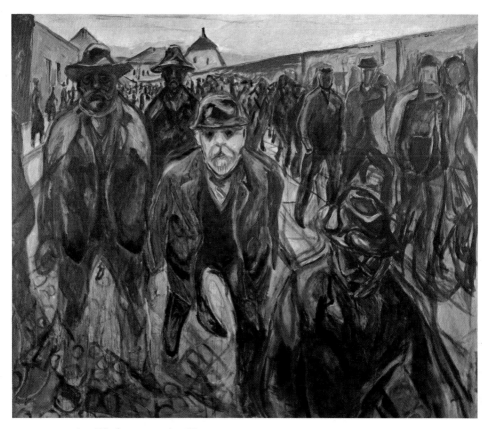

87 *Workers returning Home*, 1915

There are pictures of children such as Dr Linde's sons, *Road in*
76, 77 *Åsgårdstrand* (1902), *Four Girls from Åsgårdstrand* (1902), *Young Girl in the Garden* (1904), *Two Young Girls in the Garden* (1905) and *Three*
73 *Children*, of the same year. There is a landscape called *Winter* (1899)
74 or again *Country Lane* (1903), and *White Night* (1901). Some of Munch's finest paintings, filled with an irresistible lyricism which only he could produce, are night pictures: *Moonlight over Oslo Fjord* (1891), *Starry Night* (1893), *The Evening Star* (1894), *House in Moonlight* (1895)
70 and many others. There are landscapes such as *Virginia Creeper* (1898), the face of a panic-stricken man in the foreground, or *Country Lane with Burning House* (1903), with a touch of the uncanny. Similarly *The Drowned Boy* (1908).

116

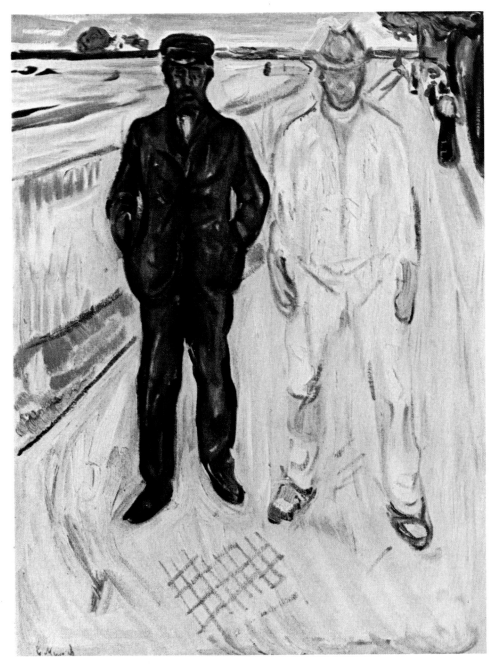

88 *Mason and Mechanic*, 1908

75 *Girls on the Bridge* (1899) is one of Munch's great masterpieces. This
 theme was repeated, in a somewhat different manner, in the picture
163 *Women on the Bridge* (1903), with one of the group facing us as if
 leaving the others behind. Munch returned to this theme, one of his
 most beautiful, many times—there are sixteen versions altogether
 produced between 1899 and as late as 1930.[19] The clear colours, the
 beautiful Northern types of women and girls, the mood, always
 pensive, even mysterious, although serene, the reflection in the water,
 the closed group of buildings with tree shapes and a surrounding wall,
 the bridge which lends emphasis to the perspective, all this was
 resolved in a supremely painterly manner. The picture *Mother and*
71 *Daughter* of 1897 too has this slightly sad quality of Northern beauty
 and nostalgia. There is the picture *On the Verandah* (1902), with its
83 evening mood and there is the oppressive *Melancholy* (1900), a portrait
 of his sister Laura in an interior with two windows. In *The Four Stages*
 of Life (1902), and *The Three Stages of Life* (1908), we feel again the
84 pulse of Munch's thoughtful nature. There is the *Amor and Psyche* of

89 *Uninvited Guests, c.* 1905

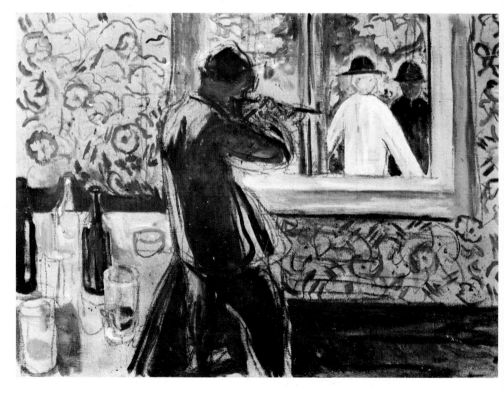

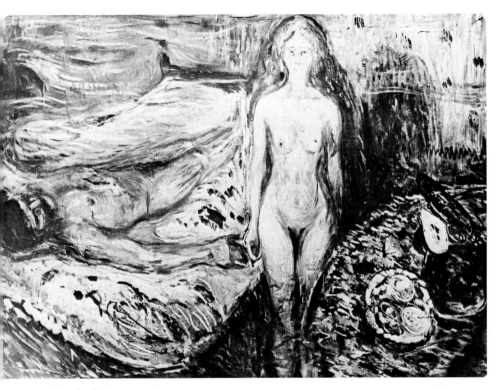

90 *Death of Marat*, 1906

1907, depicting the confrontation of man and woman in an idealized
sense. The firm brush strokes form a pattern of colour components
out of which the picture surface is built up. As a counterpoise we find
the picture *Zum Süssen Mädel* (*At the Sign of the Sweet Girl*), a brothel *85*
scene from the same year. *Adam and Eve* (1902), and *Adam and Eve
under the Apple Tree* (1904), have again the sombre symbolic quality
so typical of Munch's representation of the sexes. *Dance on the Beach*,
1900–2, combines the movement of figures with the wavy line of the
shore in moonlight. It depicts the charm of the midsummer night in
which the people of Norway dance on the beaches, dreamy, young
and full of desire. A new theme now makes its entry – the worker.
Mason and Mechanic of 1908 shows how open Munch was to im- *88*
pressions from the new world of industrial endeavour. There were
many other pictures of this kind to follow, particularly in his later life.

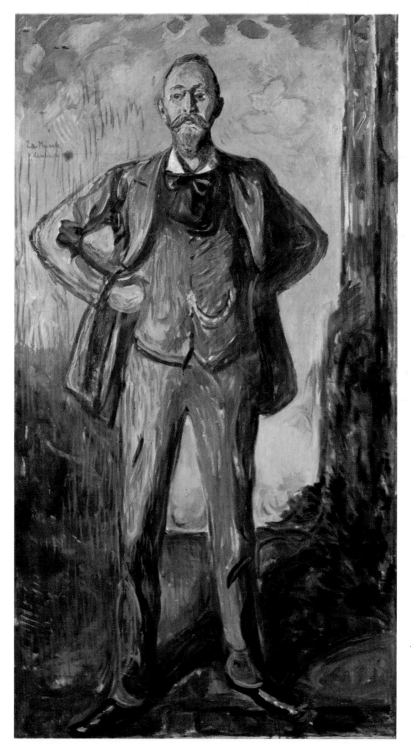

91
*Dr Daniel
Jacobsen,*
1909

Crisis and homecoming

In the autumn of 1908 Munch travelled via Hamburg and Stockholm to Copenhagen where on 23 November an exhibition of his was to open in the Kunstforeningen. As we have already seen, he suffered a nervous breakdown there. This short period of his life has been called by psychiatrists 'Munch's psychotic episode'.[20] On approximately 1 December the artist was admitted to Dr Daniel Jacobson's clinic where he underwent a combined treatment (electric shock, massage, etc., as depicted by Munch himself in one of his drawings and described in a letter to his aunt Karen Bjølstad, on 27 October 1908).[21] This 'breakdown' was the culmination of tense inner states which had lasted for years and had led through an excess of work and consumption of alcohol to a psychic and physical exhaustion. Dark thoughts amounting to a psychosis had finally broken his mind. The artist was under treatment in the hospital for eight months. He was, however, allowed to leave the premises at an early stage, and even to resume his work. After this treatment Munch felt recovered and he never touched alcohol again. I remember his saying to me in 1938, when he offered me a glass of port without taking one himself: 'I enjoy alcohol only in its most distilled form – watching my friends drinking.'

As if haunted he had travelled for seventeen years from place to place, pursuing his gigantic work, building his reputation, and at the same time fleeing from his own inner torments. Now he had had enough. After his friend Jappe Nilssen had urged him countless times to end this restless life and to return to Norway, he finally did so, as this had always been his innermost wish. Munch loved Norway, its people, its landscape, and in May 1909 we find him on his way home.[22]

The time spent in Copenhagen had not only calmed Munch's nerves and abated his dark premonitions, the enforced period of convalescence had been his salvation. He emerged from it with renewed strength and a new vision. The gloomy aspects of life began to recede, his preoccupation with the problems rooted in the negative

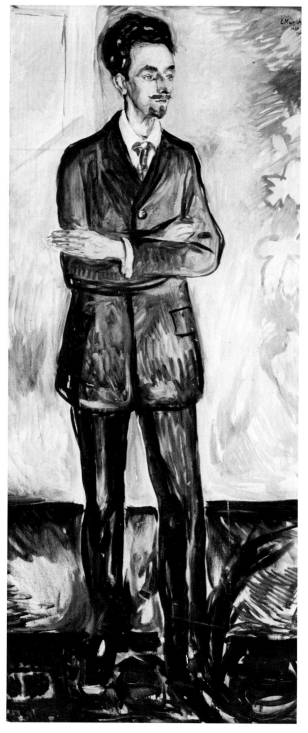

92 *Helge Rode*, 1909

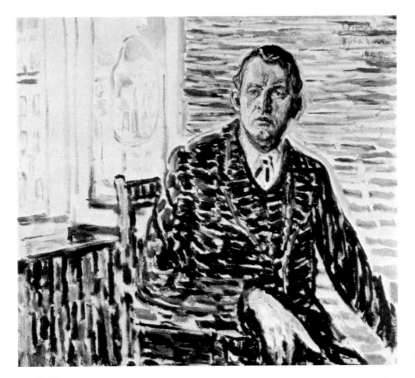

93 *Self-portrait*, 1909

aspects of eros and death faded away and only now and then, in his later paintings and graphic works, do we find sombre and violent motifs like a memory, a faint reverberation from his early experiences. His longing to be at peace with life, to immerse himself in it had already found expression before his breakdown. It is in this light that we have to see the significance of the picture *Bathing Men* of 78 1907–8 which depicts man's harmony with the elements.

In Copenhagen Munch painted the full-length portrait of Dr 91 Jacobson and of his friend, the poet Helge Rode (1909). Here he 92 painted himself, too, as a convalescent with firm and forceful brush 93 strokes. It is like an inexorable self-examination, like an intensive search for the demons which had gained possession of him. Life flows back into him like sunlight streaming in through a window. The strong indigo-blue of his garments is expressive of his confidence in recovery, while the reddish-violet tints remind us of the retreating

95 *Thanks to Society*, 1899

94 *The Rich Man,*
1911

96 *The Critic,* 1911

shadows from which he had triumphantly emerged. Yet it is here, too, that Munch wrote and illustrated his prose-poem *Alpha and Omega,* 58–60 and that he drew some of his most satirical caricatures of society and the artist facing it.

When in 1946 after the war, I visited Copenhagen, I met there the printer O. Wennerberg, who was an apprentice at the firm where in 1909 Munch used to print his lithographs, the Dansk Reproduktions-anstalt. He described the artist as always elegant, friendly, and wearing a top hat. On his walls I found prints of many lithographs produced in those days in Copenhagen. Of particular interest to me were the many caricatures. There was the portrait of Munch's friend Emanuel Goldstein (1909), in a straw hat, and there was also a caricature of him as a panther. There was the lithograph *Thanks to Society,* and his 95 biting comment on the rich man: 'The rich man who gives, steals twice 94 over. First he steals the money and then the hearts of men.' Munch captioned the caricature of a critic: 'After all his literary efforts had 96 come to nought and he had to wear dark glasses, he became an art critic.' His most amusing attack was a print to which he gave the title: *Manuring my Garden.* It shows a number of men relieving themselves on small flowers. In the foreground to the left squats a hunched–up figure behind which is a poster bearing the words 'Döbbell Rotary Press'.

Tired and disappointed with people, Munch made a series of animal drawings in Copenhagen's zoo, masterpieces of observation, which he continued later on in Norway, depicting domestic animals on his own farm, Ramme – chicken and ducks, horses and dogs. One of his engravings gives an almost anecdotal version of his own head and those of his two dogs. Behind the humour of the picture lies the understanding – all is nature.

In Norway Munch had rented the Skrubben estate at Kragerø, with its stony coast, its rough character and hardy fishermen. Here he retired and painted for a time in solitude. In 1910 he bought the Ramme estate at Hvitsten to ensure better and less crowded working conditions. It was a peaceful, idyllic spot with roses and fruit trees, although situated in the middle of the busy Oslo fjord. Gierlöff suggested that Munch's stay there was brief because it was too peaceful and relaxing for his ascetic nature. But he did not sell it, and as Gierlöff wrote: 'He went there occasionally in a hired boat . . . on a visit to himself.'

97 *Tiger*, 1909

98 *Flamingoes*, 1908–9

In 1913 Munch had rented Grimsrød Manor at Jeløya, as he needed ever more room to work. In these three houses situated in landscapes of totally different characters, Munch lived in turn. Each had its importance because he not only painted these landscapes but used them as the background and *milieu* for his monumental works.

A new life had opened out before him, free of the need for agonizing struggle. He now lived surrounded by simple, unassuming people who never found themselves at odds with nature and whose trust and confidence in its powers were henceforth to reassure him when doubts assailed him. Only his nearest friends were allowed to visit him. Those friends, already before and while he was a convalescent in Copenhagen had combated the public hostility to his work which had flourished on anonymous criticism and equally anonymous letters to the Press.

Jens Thiis, as Director of the Oslo National Gallery, had already in 1908 bought five of Munch's most important works for the State collections, works which would otherwise have been sold abroad, namely *The Day After*, *Puberty*, *Ashes*, *Two Girls on the Verandah*, and *The Frenchman*. Shortly afterwards, the collector Olof Schou presented to the National Gallery the pictures *Madonna, The Sick*

Child, Mother and Daughter, Girls on the Bridge, and in the following years he added *The Scream, Death in the Sick Chamber, The Dance of Life, Girl at her Toilet, Moonlight in Nice* and *Betsy,* a portrait of the red-haired girl who sat for *The Sick Child.*[23] In March 1909 Jappe Nilssen arranged an exhibition at Blomqvist's Gallery in Oslo (one hundred paintings and two hundred graphic works).

As a tribute to their friendship, Munch painted life-size portraits of the critic Jappe Nilssen, Jens Thiis, and the lawyer Torvald Stang, all in 1909, and in the year after that of the writer Christian Gierlöff. During the years 1909–10, Munch also produced lithograph portraits of Emanuel Goldstein, Helge Rode, Dr Jacobson and Christian Gierlöff. In his pictures Munch intensified the characteristics of these men by isolating them from the background in the paintings, and the forceful brushwork in some of them is reminiscent of Van Gogh and, going further back, of Frans Hals. Munch felt close to Van Gogh at this period; like the Dutchman he had faced the abyss of mental breakdown; and Munch too knew how to paint the sun. Munch's *90* self-portrait made in Copenhagen and the *Death of Marat* show how close his painting technique could come to that of Van Gogh. His full-length portraits followed the tradition of Velazquez, Rubens and Goya, and in his own lifetime, of Manet, Renoir and Whistler, applying at times the Impressionist idiom of expressing light through colour (for instance the portrait of Christian Gierlöff, 1910, in the Museum of Gothenburg). Manet and Munch were the most accomplished modern exponents of this genre. However, even his portraits seem to have provoked antagonism, as he himself remarked: 'When I paint a person, his enemies always find the portrait a good likeness. He himself believes, however, that all the other portraits are good likenesses except the one of himself.'

The bright strong colours of the works executed by Munch during his period of convalescence suggest that his recovery was indeed complete. 'Come here,' he wrote to Christian Gierlöff, 'a vigorous, active young man will meet you at the landing-stage – myself.'

It was in Kragerø that Munch began work on the murals for Oslo University (see Chapter Eleven). Just as Åsgårdstrand had supplied the landscape for the *Frieze of Life,* Kragerø and Hvitsten appear in the paintings for the University Great Hall.

In 1916 Munch bought the estate of Ekely in Skøyen, and there he *166* built the fireproof studio to house his *Frieze,* and an open-air studio.

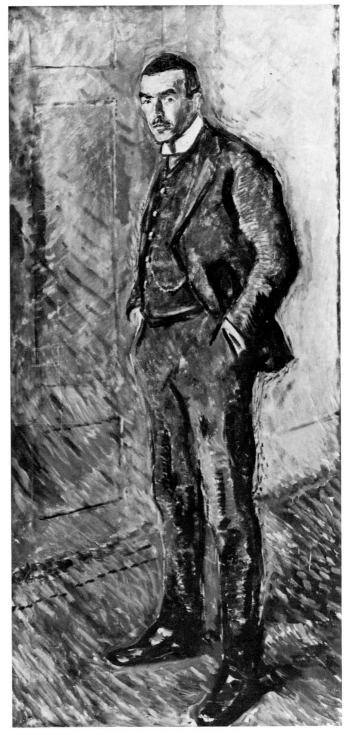

99 *Jappe Nilssen*, 1909

100 *Workers in the Snow,*
1912

101 *Snow Shovellers,*
1913

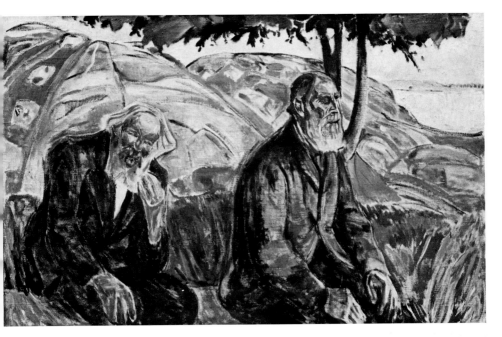

102 *Two Old Men*, 1910

The artist lived at Ekely for the rest of his life, except for short journeys abroad during his last decades. His restlessness of spirit, however, did not altogether abate, and in 1938 he complained to me of the impossibility of realizing his new monumental projects in Norway. 'Norway is a poor country', he said, and added: 'I would prefer to live in a big city.' These words refer to his plans to decorate the Council Chamber in the new Town Hall at Oslo, which were abandoned. The town of Oslo later acquired his painting *Life* of 1910 for this purpose.

Besides his murals, Munch produced in the years after 1909 paintings with subjects unconnected with his monumental task, as well as graphic works: in 1912 the painting *Workers in the Snow* and in 1913 *100* *Snow Shovellers*, two different compositions on the theme of work. *101* One of these paintings shows three workers with shovels moving to or from their work, the other depicts two men back to back, shovelling snow. The contrast of the dark figures in the snow must have attracted the particular interest of the painter. There is the picture *Two Old Men* *102*

(1910), depicting the angular figures of Kragerø fishermen, and also the composition *Fisherman in Kragerø* of 1911. An old fisherman appears

110 on one of the main panels for Oslo University, the one entitled *History*.
87 In 1915 there followed the magnificent and dynamic painting *Workers returning Home*, perhaps the finest on this subject. We may recall that already in 1908 Munch had produced a painting depicting a mason and a mechanic, the worker who works in a traditional craft and the worker who is the representative of the modern industrial age. From then on the theme of work and the worker was to appear regularly in Munch's œuvre. In 1916, at Ekely, Munch discovered a new subject-matter – agricultural life, the farmer who tills the soil and reaps. There are no sentimental overtones or scenes reminiscent of Millet in these pictures. Munch simply painted man in relation to the soil, and his companions, the animals, who aided him in his work:

104, 103 *Man in the Cabbage Field* (1916), or *Ploughing*, sometimes called *Two*

103 *Ploughing (Two Horse Team)*, 1919

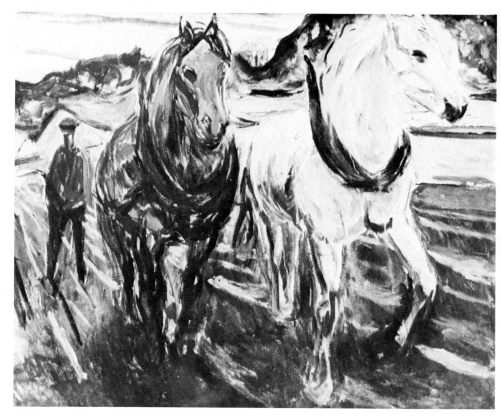

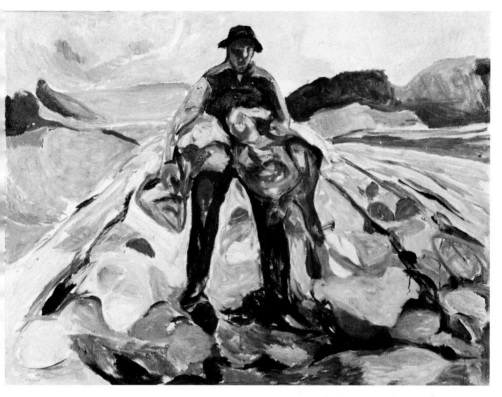

104 *Man in the Cabbage Field*, 1916

Horse Team. Similar motifs continue as late as 1943, only a year before his death. Munch wrote in a letter in 1929: 'The day of the workers is at hand. Shall not art belong to everyone and find its way on to the wide walls of public buildings?'

The themes *Galloping Horse* of 1912, *Passion* of 1913 and *Death Struggle* of 1915 are connected with those ideas of the artist which dominated the first half of his life. The *Galloping Horse* can be seen as a pendant to *The Scream* of 1893. It is a panic-stricken depiction of the terrifyingly elemental force expressed in the animal with the small helpless man behind the horse, supposedly controlling it. There is a depth-psychological interpretation of these pictures referring to the 'lack of integration between a man's conscious and unconscious life'.[24] *Passion* is a new variation of *Jealousy* painted in 1895. In 1916

105

Munch produced the fourth version of *The Sick Child*. (The first version was painted in 1886, the second in 1896, the third in 1906–7. A fifth version followed in 1926.)

As we have seen, whenever Munch sold a picture which was particularly close to his personal experience he felt compelled to repaint it for himself, so as not to miss its company. A self-portrait of 1916 from Bergen with the new church in the background still shows a harassed face. Until the end Munch would always have to fight for the balance of his emotional life.

In 1913 Munch painted two portraits of women: Elsa Glaser, the wife of the German art historian who in 1917 published a monograph on the artist, and Kaethe Perls. There are landscapes such as *Fir Tree, Kragerø* (1912), *Winter, Kragerø* (1915) and other similar motifs. The *Bathing Men* of 1914–15, the second version of the picture from 1907–8 is a most vigorous composition of vertical lines (the male nudes) and horizontal lines (the sea), powerfully drawn and painted in cool tones (yellows, blues). It reiterated the theme of the *Bathing Boys* of *c*. 1904. Munch's preoccupation with the ages of man here came again to the fore, and in the Munch Museum at Oslo we find the *Bathing Men* as the middle panel of a triptych composition showing on the left a young boy (1913–14) and on the right an old man (1907–8).

114

During the years between 1910 and 1918 Munch exhibited in Berlin eleven times, in Oslo eight times, in Stockholm six times, in Gothenburg four times, in Copenhagen three times, in Paris twice. The war years restricted to some extent the possibility of his exhibiting on the Continent. There were, however, exhibitions in Vienna, Munich and Rome, Hamburg, Dresden, Breslau, Barmen, Jena, Düsseldorf, Leipzig, Bergen, Trondheim and Kragerø.

The international Sonderbund exhibition in Cologne, from May to September 1912, was of the utmost importance for Munch's position in Germany. Here his work could be compared with the production of many European countries, particularly of France. Munch also showed some works in a mixed exhibition of Scandinavian art in New York in 1912, and graphic works at the famous Armory Show in 1913, which also went to Boston and Chicago.

The artist received his first official recognition in Norway in 1908 when he was made a Knight of the Royal Norwegian Order of St Olav. Many tributes were paid to him in December 1913, on the occasion of his fiftieth birthday.

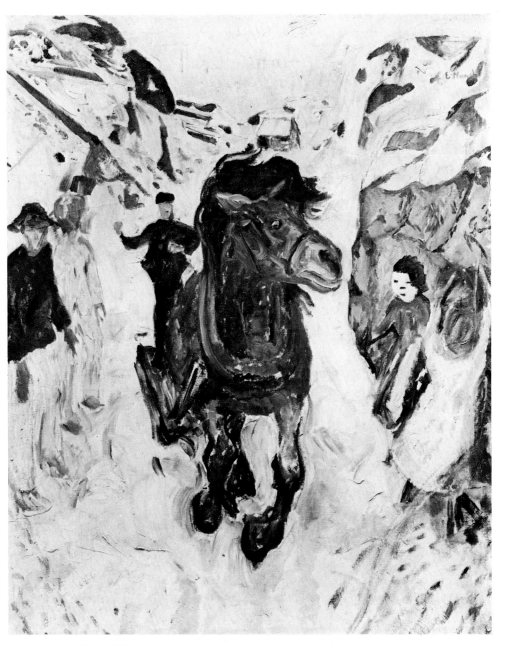

105 *Galloping Horse*, 1912

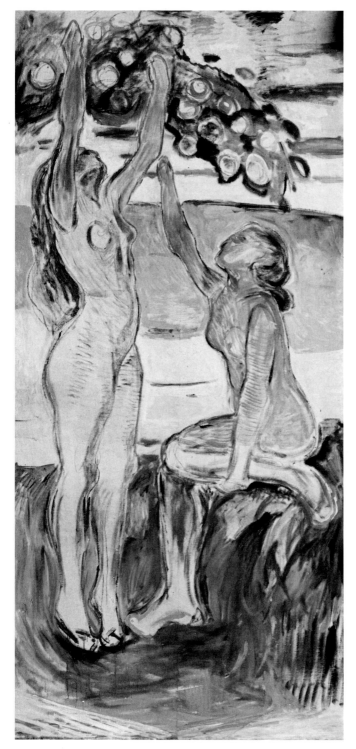

106 Panel for
the Great Hall,
Oslo University,
1909–11

The Oslo University murals

For the centenary of Oslo University in 1911 a new Great Hall was
to be built and decorated with murals. A competition was announced
in 1909. Twenty-two painters, among them Munch, and three
sculptors declared their willingness to take part in it. There were
difficulties and disagreements between the Building Committee and
the jury which proved insurmountable even after eighteen meetings.[25]
Edvard Munch was one of six painters who were finally invited to
participate. Work on the Aula murals occupied him from May 1909
and throughout 1910, and they were in fact not finished until 1914.

The painting *Life* (1910), a resumption of the 'Stages of Life' theme,
is said to have been conceived originally for the centre panel, but was
not submitted in the first limited competition which took place in
March 1910. Two other designs were submitted on this occasion:
History, which was finally used for the large left-hand-side panel, and
The Human Mountain, which was not used at all. *The Human* *108*
Mountain, or as Munch also called it, *The Human Pillar* or *Towards*
Light, is a motif which is formally related to an allegorical lithograph
of Munch's from 1897 entitled *Funeral March*. There we see against *107*
the background of a landscape a pyramid of bodies growing out of
a ground sown with skulls. The outstretched arms and hands of the
figures hold an open coffin against the sky. *The Human Mountain* is
an abortive literary idea which was more characteristic of Klinger or
Böcklin. Only rarely did Munch move in this direction of literary
allegory. In the one sketch we see a mountain of figures rising from a
plain full of people. On the top of this mountain or pillar is a figure
stretching its arms towards the sun. The other sketch is nearer to the
Funeral March in that there are skulls at the base of the composition.
There is no figure on the top of the mountain. Above it, how-
ever, we find the moon, so dominant in the compositions of the
Frieze of Life. It has been suggested that this composition has some
connection with Böcklin's *Toteninsel* (The Island of the Dead),
whereas the first sketch may be nearer to Nietzsche's *Thus Spoke
Zarathustra*, a book which Munch admired.[26] There is no direct

stylistic connection with the first-named picture and the literary connection can only be a guess. Munch himself spoke only of a number of naked people striving towards the light. For the side panel to this central one, Munch designed compositions called *The Storm* and *The Rainbow*, depicting on the one side man fleeing from a natural catastrophy, and on the other man resting in hope of peace. Munch in fact produced several sketches with different ideas which were finally all discarded by him. Eventually he decided on a composition without figures for the central panel, having the sun as its subject. The entire decoration was divided into two main themes: Natural Forces and Humanity. These are linked by the themes of the beauty of nature, knowledge and science.

A second competition was held in August 1911. The jury decided in favour of Munch. The battle of opinions raged bitterly round his project, however, and ended with the Building Committee of the Senate refusing to approve Munch's paintings for the commission.

107 *Funeral March*, 1897

108 Study for *The Human Mountain, c.* 1910

Munch continued to work on the decorations and at the instigation of Jens Thiis, a private subscription committee was formed to raise the question of the University murals relentlessly until the day was won. Finally, in 1914, the Senate decided to accept Munch's decorations as a private gift. They were unveiled only in September 1916.

Munch's solitude and the lack of harmony in his life before his nervous breakdown, his conception of love and death as a biological tragedy, might have accomplished his ruin but for his ability to turn again to nature. In the University murals he represented the eternal life-forces: *Sun, History* and the *Alma Mater*, the all-nourishing and procreating Mother, the symbol of life's continuity. The *Sun* has definitely a male quality, just as *Alma Mater* (and the moon) has a female one. The sunlight of Bonnard with its lyrical orange glow has but one purpose, to illuminate the beauty of life, the security of the family circle. Painting the sun drove Van Gogh into insanity. To

*113, 110
112*

Munch the sun is a cosmic body, the source of light, the eternal principle of fertilization.

The three main panels of the murals, *Sun, History* and *Alma Mater* are linked by eight narrow panels with the theme of man's thirst for beauty and knowledge – the adventure of science.

110 The left-hand panel, *History*, shows an old man and a boy under an ancient oak tree. It is the most realistic in style of all the three major compositions of the murals. To express objectivity Munch needed the detailed rendering and the sharp outlines. The oak may also be seen as a symbol, the tree of life, a motif which occurs in Munch's *œuvre* in different versions. (*Life*, 1910, depicts the ages of

109 man under a tree; *The Tree*, a lithograph of 1915, draws its strength from the putrifying bodies buried underneath it, life–death; *Fertility*, 1898, represents a man and a woman, under a tree – he seated, she standing with a basket full of fruit.)

109 *The Tree*, 1915

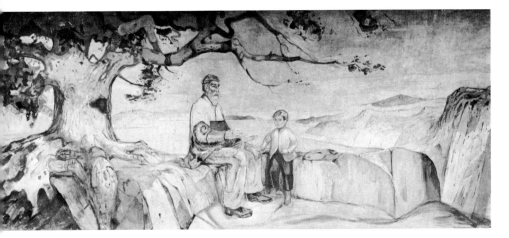

110 *History*, 1909–11

The decision to represent an old man as the bearer of tradition was the final outcome of a process in which other variations of the theme were tested for their suitability. One can say that during this time the main idea not only changed but took shape. We see both a work in progress and also the primary cell of the idea for *History* in *The Old Man and the Seer*. The old man, a bulky body, heavy with age, weighed down by experience, makes a movement of his right arm, as if just awakening. The Seer standing behind him – or is it just a thinker, as the gesture of the hand raised to the forehead might suggest? – in the shape of an aged hermaphrodite (beard and breasts) allows interpretations of a philosophical kind at will. Another sketch of *c*. 1910 shows a seated old man with a beard, the one we know from the final version of *History*, with a young naked woman lying with outstretched body over his knees. A child, pressing his hand to his eyes, as if crying, appears in the background on the left. The scene was called *Pietà*.[27]

The large right-hand panel of the mural began as the *Researchers*, but developed into the *Alma Mater*. The emphasis was shifted from the idea of youth, eager to explore and learn from nature, to the theme of the Great Mother, the eternal rebirth. This picture is more lyrical than *History*, and painted in summer colours. Although the central figure of the mother feeding her baby with an older child standing on her left has changed little (except that in the *Alma Mater* her

112

141

expression seems gentler, gayer, while in the *Researchers* it is more stylized and stern), the surroundings, both landscape and figures, *111* have been altered considerably. In the *Researchers* we see a group of five children on the left, four bending down, one prostrate on the ground, and another child seated on the right of the mother; on the right-hand side of the canvas an older boy seems to be explaining something to a younger girl. The landscape is poor, restrained, with a few groups of trees against the horizon on the right-hand side and the open fjord on the left, with three boys turned towards the water about to bathe. In the *Alma Mater* picture the children's group has disappeared, the central figure of the mother and the two children attract all the attention. There are two other small children on the right of the central group but not dominant, rather melting into the landscape which reveals a more serene character than that of the *Researchers*, with a large fir tree in the right foreground and behind it, a group of birch trees with their decorative white trunks against a blue hillock. On the left a gentle coastline and the surface of the water reflecting trees and hills, and a high sky above it with white clouds.

111 *The Researchers*, 1909–11

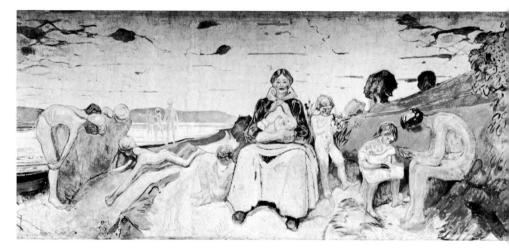

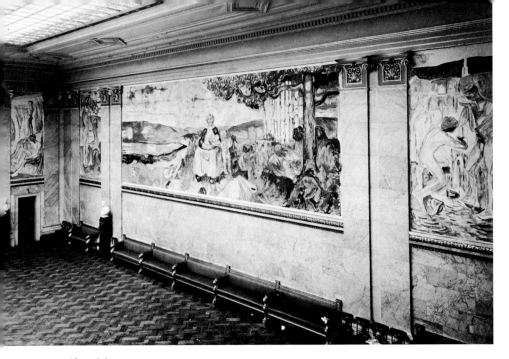

112 *Alma Mater*, 1909–11

At the time of the competition Munch wrote: 'I mean the decorations to be an autonomous world of ideas, expressing both Norwegian qualities and human life generally. I think the neo-classical style of the Hall and the style of my paintings have features in common, in particular simplicity, and that they will go well together although the pictures are Norwegian. The three panels, the *Sun, History*, and *Alma Mater* are meant to produce a grand and imposing effect, but those around are lighter and brighter in keeping with the style of the hall and as a framework.' Munch painted feverishly on the cartoons, making no less than twenty-two versions plus some variations in different sizes. He intended at first that there should be, nearest the *Sun* on the left-hand side, the picture of a sower, and on the right-hand side the picture of a man hewing a path through the forest. In the final version of the decorations, however, these subjects were replaced by others. On the left of the *Sun* there is a composition with three men at a waterfall, one standing, stretching his arms to the light, the other sitting with one outstretched arm, the third lying and resting. On the right of the *Sun* we find a composition in which the rays of the sun

106

continue from the main panel. In these rays light-spirits in the shape of *putti* dance in the air, while in the lower part two men lie outstretched, resting and meditating.

113 Munch's sun, the sun of the North, rises over the coast of the Kragerø fjord. Composed in the upper third and the centre of the canvas, the rays of the sun, as represented by Munch, form the traditional triangle of the Renaissance composition. The lower third of the picture surface is covered by the land and the coastline, rising at both ends to reach the middle of the canvas. With the cool harmonies of its colours, the large circular and cross-shaped radiations, the curving outlines of the coast and the hillocks studded with jewel-like patches of colour and underneath the main body of the sun another small sun lying like a yolk – in the grandeur of its conception it is a peak of achievement of Munch's rare genius, and at the same time one of the most important paintings produced in the first half of the twentieth century. By avoiding a figurative motif Munch was able also to avoid all allegorical allusions. When we compare the preparatory sketches for this monumental work we realize the maturing of a great painterly idea. From a realistic scene with some elements of decorative stylization, it developed into an absolute statement with the quality of a Platonic dialogue or a Canto from Dante.

These murals are overwhelming in the subtlety, the simplicity and the power of their compositions. They give the hall the dignity of a cathedral.

Munch's pictures in the Great Hall are painted in oil on canvas, hence their fresh, strong colours. Their style is the consummation of the union of idea and form. For what is style, if not the fullest expression of a creative will, the crystallization of a personality and of a period, when all questions of form and content have found their harmonious solution? Style is the living atmosphere of an age, its efforts and its ideals expressed in form. Therefore Munch's murals can also be claimed as representative of the style of his generation.

Munch has referred to the association between his *Frieze of Life* and the murals in the University Great Hall. The *Frieze of Life*, he wrote, 'must be seen in connection with the University decorations, for which in many respects it was a forerunner. Without it they might not have been achieved. The *Frieze of Life*, that is the sorrow and the joy of the individual human seen from close at hand. The University decorations are the great eternal forces.'

144

113 *The Sun*, 1909–11

114 *Winter, Kragerø*, 1915

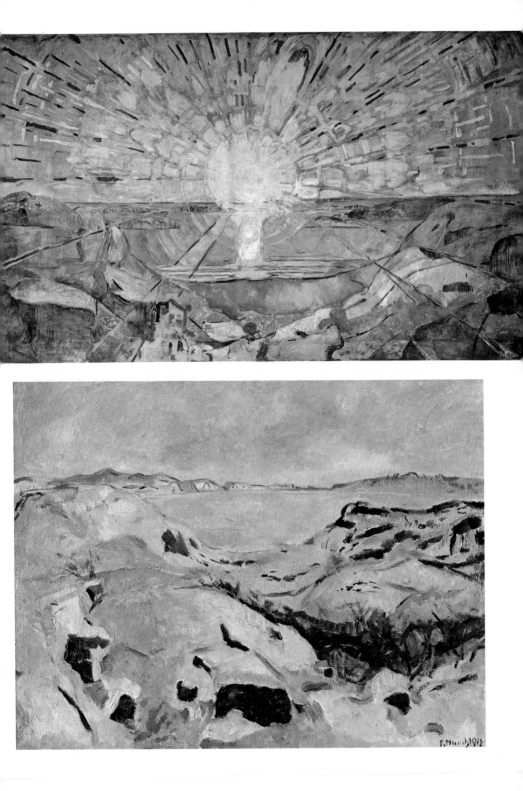

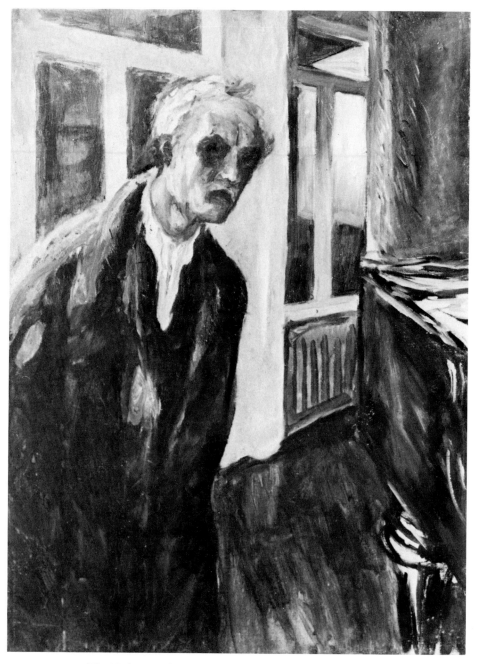

115 *The Night Wanderer (Peer Gynt)*, 1939

Reminiscences and premonitions

Munch's paintings after his return to Norway had, as we have seen, acquired a fresh character. They became more colourful, and consequently the formal values seem to have taken precedence over the content. But this is true only to a certain degree. There are paintings from the first half of his career with a high key of colour values, produced particularly after the impact on Munch of Impressionism. And there are paintings in this period which do not suggest any preoccupation with the human fate or the darker side of existence. Although Munch was saved from becoming a victim of his melancholy and lonely nature, there nevertheless remained a residue of past experiences which clamoured now and again for expression. And so we encounter in 1918 the picture *The Death of the Bohemian*, of which Munch in 1926 produced a second version, followed in the same year by *The Bohemian's Wedding*. How strong these reminiscences *116* were can be seen from the fact that even in 1943, before he died, Munch produced a new portrait, this time a lithograph of Hans Jaeger, the leading spirit of Oslo's Bohemia. These late Bohemian scenes are lyrical, the wedding picture showing the fatal triangle, the Bohemian, his bride and a friend, sitting at a table covered with a white cloth, with food, wine and small bunches of flowers on it, in an interior which, seemingly calm and civilized, is filled with tension. Munch's mind must have wandered back to those days in Berlin when he and Strindberg were both in love with Dagny, Przybyszewski's wife, and Munch often wondered whether the eccentric Przybyszewski noticed it. Munch had painted him in the *Jealousy* of *48* 1895 with a green face on the right-hand, dark side of the picture. (Two variations of this theme are called *Passion*, 1913.)

In 1919 Munch again took up work on motifs related to the *Frieze of Life*, after having in 1915 painted a new version of the *Death Struggle* of 1895, with a group of people standing on one side of a bed in which the dying person is lying. In the middle of them is a bearded man, with his hands folded as if in prayer. (It is the same man who appears in the picture *History*, Munch's factotum Børre Eriksen.)

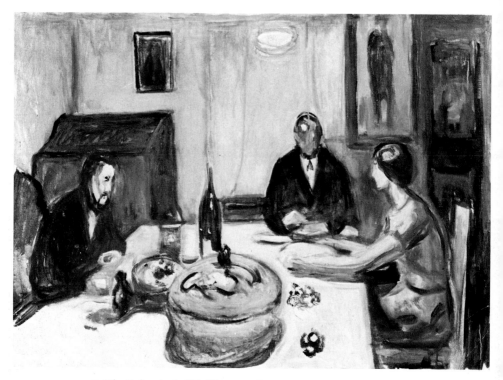

116 *The Bohemian's Wedding*, 1926

In 1919 Munch contracted the Spanish 'flu which after the First World War claimed more victims than the war itself. A famous self-portrait shows him sitting in a cane chair, convalescing after this exhausting illness which brought him near to death. In the background is the open bed. What a contrast to the powerful self-portrait painted in Copenhagen in 1909! In the self-portraits we can follow the ups and downs, the ebb and flow of the restrained emotionalism which was the *leit-motif* of the second part of Munch's life. Again, when we compare the self-portrait from Ekely of 1926, with Munch surrounded by the exuberant splendour of a Norwegian summer, and the self-portrait of 1939 called *The Night Wanderer* (or sometimes *Peer Gynt*) depicting the artist walking sleeplessly through his house, with deep-sunk shadowy eyes, we encounter the same opposites. When we consider the date, 1939, we can easily connect this picture of distress with the political developments of those days. On 1 September the

148

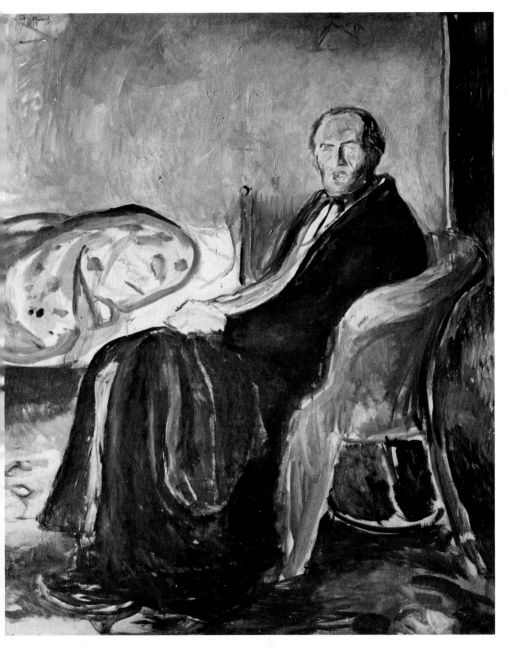

117 *Self-portrait*, 1919

118 *Self-portrait in Ekely, 1926*

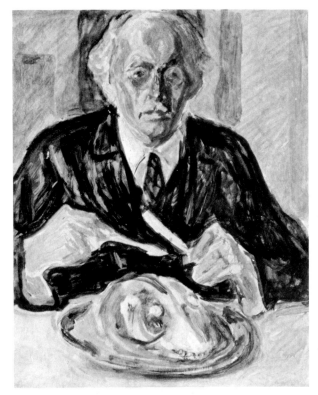

119 *Cod Lunch*, 1940

German Army marched into Poland, and on 3 September Great Britain declared war on Germany. Seven months later Norway was occupied by the enemy.

Munch was the type of artist who from time to time had to look searchingly at himself, to scrutinize his innermost being. In this he resembled Rembrandt. And even when ill or assailed by torturing experiences he, like Rembrandt, had the strength to look truth in the eyes. A new element appeared in the later self-portraits in that Munch became increasingly conscious of old age. How strangely he looks at us through his pince-nez when eating, or rather when about to dissect a cod's head, a great speciality for the connoisseur. But the eyes of the fish, the skull and even the suggestion of the teeth speak another language. And then, the resemblance between them – the artist's and the cod's head! (*Cod Lunch*, 1940). In the same year the allusion to mortality is pursued still further in another self-portrait.

119

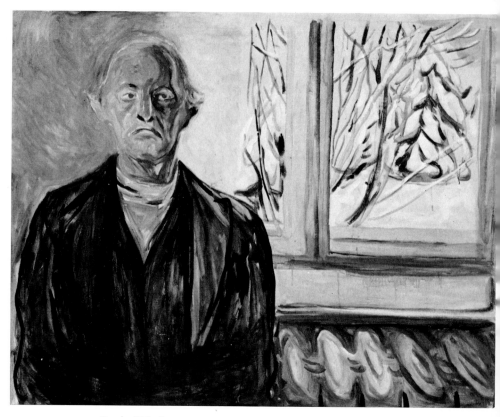

120 *By the Window*, 1942

121 Munch is standing upright in his bedroom, beside a tall grandfather-clock. The hour has struck. The artist's hands, which have completed their great work hang helplessly, heavily. His neck is thin, his face emaciated, his eyes almost lifeless. Here is depicted the transitoriness of life, as the preacher knew it, in all its bitterness. The bedspread with its vivid stripes makes one think of a catafalque, the picture of a nude which hangs on the wall, of a mummy (*Between Clock and Bed*, 1940). Or again, there is the self-portrait *By the Window* of 1942: winter outside, winter inside. The expression of the eyes and the mouth drooping at the corners all tell us of what he once said to a friend: 'It is no fun to grow old, neither is it to die. We have really no great choice.'

120

152

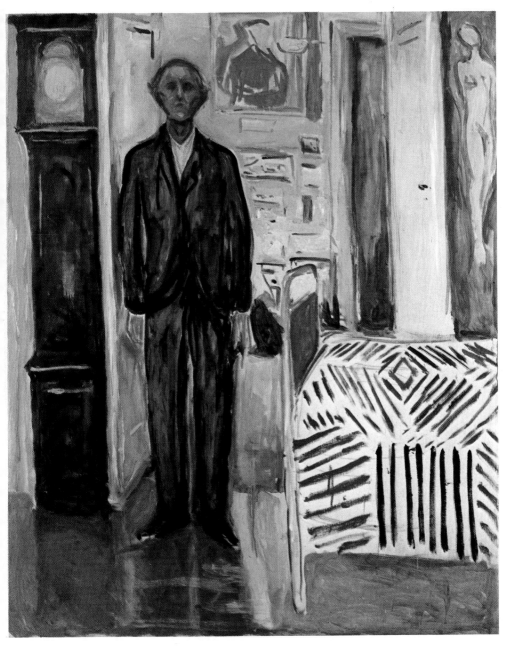

121 *Between Clock and Bed*, 1940

During these years Munch painted incessantly and also produced
many graphic works. There are portraits such as *The Gothic Girl* of
123 1924 and the *Model on the Sofa* of 1928 in which a girl in a blouse and
long skirt sits on a sofa with her right arm on her knee and her left arm
resting on the edge of the sofa. A colourful interior with furniture,
books and pictures surrounds her. All Munch's series continued also.
His full-length portraits such as *Mrs Mustad* of 1922 or *Mrs Thomas
Olsen* of 1932 are airy and gay, with a French lightness and *joie de
122 vivre*. Then again, double portraits such as the friends *Lucien Dedichen
and Jappe Nilssen* of 1926, the doctor and his patient, continue the
series of contrasting personalities from previous years. Munch also
added to his series of compositions with motifs from the life of the

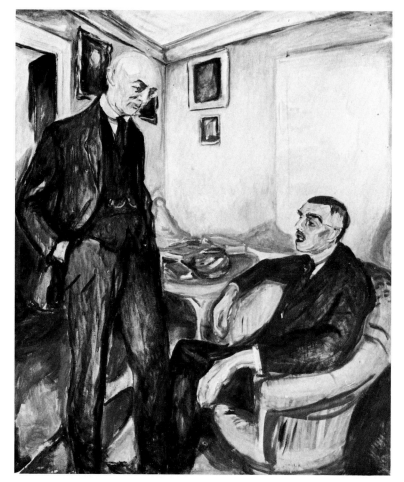

123 *Model
on the Sofa*,
1928

122
*Lucien
Dedichen
and Jappe
Nilssen*,
1926

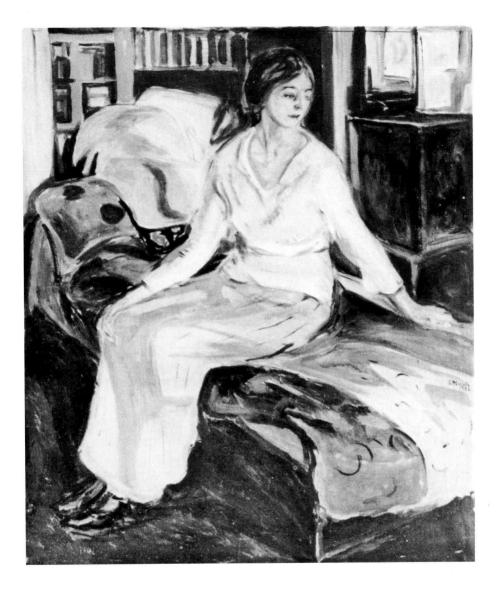

workers and farmers: *Spring Ploughing* (1916), or *Horse Team* (1919), *126*
Horse Team in Snow (1923), or *Man with Cart and Horse* of the same
year; also *Washerwoman* (1920–30), *Sowing, Hay Harvest* and simi-
lar pictures. Some of his earlier paintings with labourers Munch

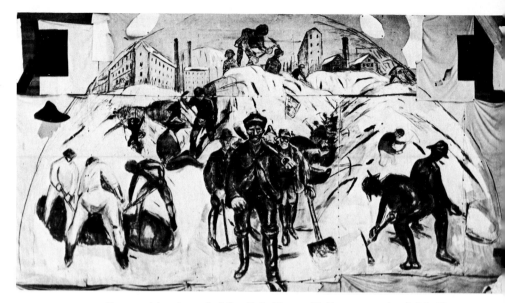

124 Composition intended for Oslo Town Hall, 1935–44 (unfinished)

124 combined in a monumental composition on which he worked in 1936. It was meant as an apotheosis of labour, using the pictures *Workers in the Snow, Snow Shovellers* and two other groups. This composition was planned to decorate the Council Chamber in Oslo's new Town Hall. The painting *St Hans* (c. 1939) also seemed to have been sketched in connection with the new Town Hall, to decorate the Central Hall.[28]

 A major work of these years are the twelve oil-paintings made in 1922, a small *Frieze of Life* to decorate the workers' canteen in the Freia chocolate factory in Oslo. In all these pictures we find the sea as a compositional element, also the curving coastline with a path

129 leading along it. In the picture with the two girls watering plants in a garden the sea is only faintly indicated in the top left-hand corner. Some of the panels have the sea as their main motif, for instance the

128 picture with the boy and his sailing-boat and the tramp wandering by, carrying his earthly belongings on his back. It is the same figure that

127 we recognize in Munch's picture *The Tramp* (1908–9), an Ahasuerus type having, it is thought, some connection with Zarathustra's *Night Wanderer*.[29] Then there is the *Farewell* picture: a woman with a child on her arm, and a girl standing beside her, waving good-bye to a schooner which sails into the moonlit night. We also find here the

156

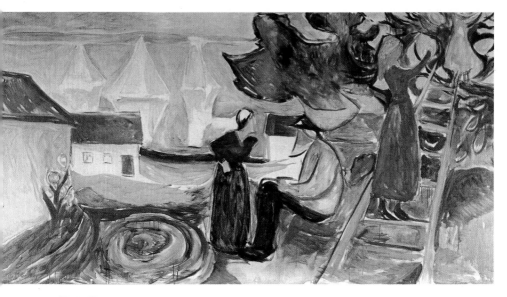

125 *Freia Frieze*, 1922

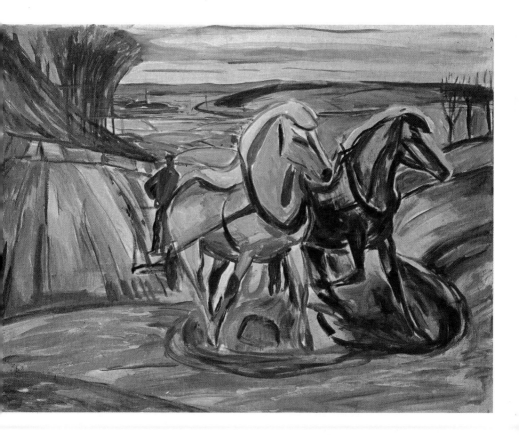

picture of a group of fishermen walking towards a landing-stage, where a fishing-boat is being prepared for sailing. Other shore motifs take up the subject-matter of the main *Frieze of Life*: a man and a woman sitting on the beach, with two other figures in the background, reminiscent of *The Lonely Ones*, then *The Dance on the Beach*, with several couples dancing among the fir trees, one couple sitting in the left-hand lower corner, and on the sea a ship in full sail, and again the moon with its reflection in the water, called by psycho-analysts a phallic symbol. Then there is another similar composition without the dancers. There are two paintings with children: *Four Children on their Walk into the Forest*, a variation of the subject-matter of an earlier picture *The Wood of Adventure* of *c.* 1898 (probably a reminiscence from Munch's own childhood), and *Four Girls* facing us in the land-scape, taken from the painting *Four Little Girls from Åsgårdstrand* of 1905. Three other pictures show garden scenes. In one apples are being harvested while a yellow steamship is seen on the water approaching a landing-stage – a theme reminiscent of one of the pictures in the Reinhardt *Frieze* – in another there are two old people under a tree, a similar motif to the painting *Fertility (Under the Tree)*

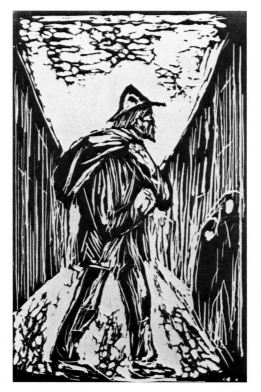

127 *The Tramp*, 1908–9

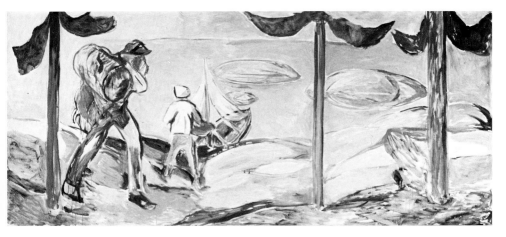

128 *Freia Frieze*, 1922

of *c.* 1910. Finally, there is a combined sea and garden view with three *125*
yellow sailing-boats, and in the foreground a girl in a red dress on a
ladder picking fruit and two old people conversing with each other.
All these pictures are light and serene.

129 *Freia Frieze*, 1922

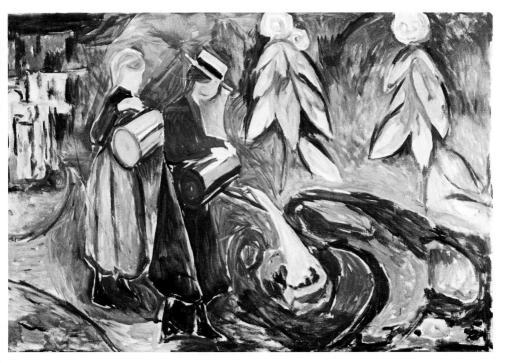

Munch was very attached to these paintings and I remember that he was pleased when I gave expression to my appreciation at having found them painted in oils. Most of the public buildings in Oslo had at that time and later been decorated by painters of the generation following Munch – Per Krohg (Christian Krohg's son), Henrik Sörensen, Axel Revold, Alf Rolfsen and others – predominantly in the fresco technique. Munch said to me: 'Youth must go ahead and prosper too. These young painters are all very talented people, but they all paint frescoes and have all been talking for years about frescoes. Books are being written about this. But why frescoes? Fresco-painting is an antiquated technique. It isn't satisfying. It often gives a greyish impression and the colours are not brought out properly. Oil-painting is a more developed technique. Why go backwards, then?'

'Have you ever painted frescoes?' I asked him.

'No, not yet,' he replied, 'but I think I could. It is just like water-colour painting. It has also something attractive and mystical about it like dry-point work. It always turns out differently from how one had imagined it. One has surprises. If I had to paint frescoes, I would attempt something new. . . .'

Munch painted several nudes during these years. There is the *Girl seated on the Edge of her Bed* (*c.* 1917), with a predominantly warm colouring (reds and yellows). It reminds us in its technique of the earlier walking *Nude near the Bed* (*c.* 1907), with its cold colouring – a yellow in the nude and predominantly blue tones on the floor, bed and ceiling and mauve round the bedside. There is the melancholy standing nude *Krotkaia* of 1920, painted in green and blue tones with a touch of red on the lips. There is the *Model beside the Armchair* of 1929, a powerful picture with all the colour concentrated on the red cover of the chair, the walls in yellow and blue round the female body which seems ice cold in its complexion – and other nudes. Even Munch's nudes tended to arrange themselves into a series. So *Morning, Noon, Evening* and *Night* represent the course of a day in the life of a model (1925).

There are landscapes such as *Apple Tree* of 1921, *Winter Night at Kragerø* of 1923, another *Starry Night* of 1924 and *The Red House* of 1926. In 1927 Munch painted in Rome the grave of his uncle Peter Andreas Munch, the historian. *Summer on Karl Johan* of 1933 also repeats a well-known motif.

79

130

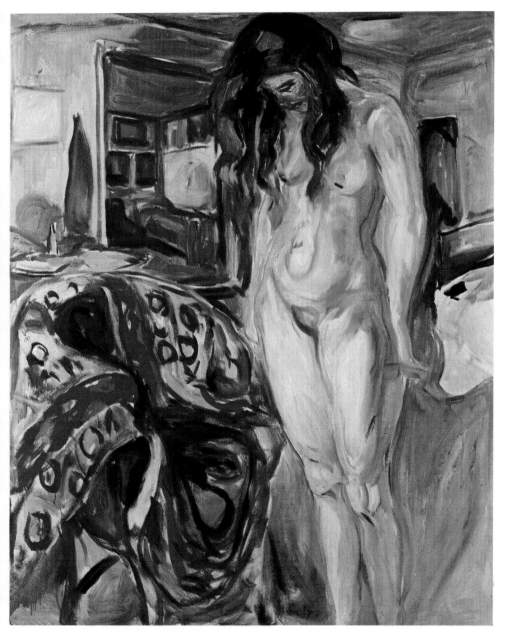

130 *Model beside the Armchair*, 1929

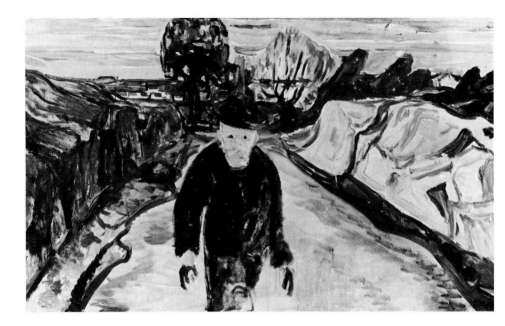

133 *Mephistopheles II. Split Personality*, 1935

Two pictures of 1935 are important contributions to Munch's thematic paintings. The aged artist took up the theme of Dr Faust. We see a youngish man walking proudly along a village street, his *133* hand on his hip, elegant and with a hat, passing a girl who turns round to look at him. In the background two groups of people stand exchanging views. Beside the walking figure, and arm in arm with him, there is another figure of exactly the same shape but shadowy, like a ghost. Between them appears the dark suspicious face of a woman. Another woman standing slightly behind her looks curious and astonished. I interpreted this painting, when I saw it at Munch's

163

131 *The Murderer, c.* 1910

132 *The Brawl, c.* 1905

studio – it was the first interpretation of this composition – as the scene depicting the meeting with Margaretha, and gave it this title. In the ghostlike figure I saw Mephisto. This interpretation was accepted and the picture was officially called *Mephistopheles II. Split Personality*. Mephisto is part of Faust, that power in the individual which works for the evil but achieves the good. In the case of Munch, who defended his art against Eros, one could interpret Mephisto as the inner voice which impelled the artist to a task of superhuman proportions, to a work which must be paid for with his life. The temptation is –

134 Margaretha. *The Duel* – it has been called officially *Mephistopheles I, The Fight* – if connected with the Faust story would be the duel between Faust and Gretchen's brother, the soldier, who intended to defend her honour and was killed. No Mephisto is in this picture – in Goethe's play, however, his presence is essential. It may be said that this picture represents a fight in which the one figure is dark, the other, wounded figure is white. (The face of the latter is strongly reminiscent

132 of the face of the white figure in the painting and etching *The Brawl* of *c*. 1905, which referred to Munch's quarrel and fight with the painter Karsten.) The duel takes place at the same spot in the street where 'Faust' met 'Margaretha'. Munch had also painted a picture called

131 *The Murderer* showing a man running along a lane, with mad eyes, his hands red with blood.

Munch exhibited in many countries from 1919 onwards but not later than 1942. During the Second World War only five exhibitions took place: four in Scandinavia (Norway and Sweden) and one in New York (graphic works). There were ninety exhibitions altogether, not taking into account those held in Great Britain and the United States, thirty-five of which were in Scandinavia (Oslo had seventeen exhibitions), Germany forty and Switzerland six. Of the German exhibitions the most important was the international exhibition in Dresden in 1926, where as in the Sonderbund exhibition at Cologne in 1912, one could see Munch's work confronted with the whole generation of painters in every European country. The Zürich exhibition of 1922, which also went to Bern and Basel, was very impressive: seventy-three paintings, three hundred and eighty-nine graphic works, the 'Linde Portfolio' and *Alpha and Omega*.

In 1919 New York saw Munch's graphic works, and in 1935 some of his paintings, in an exhibition of Norwegian art. In San Francisco in 1928, Munch was represented in an international exhibition, in

134 *The Duel (Mephistopheles I)*, 1935

Detroit in 1931 by graphic works. The Carnegie Institute in Pittsburgh showed pictures of Munch four times, in 1926, 1927, 1933 and 1934.

Five Munch paintings were seen for the first time in Great Britain at the Royal Society in London in 1928. In 1931 Munch was invited by the Society of Scottish Artists to exhibit in Edinburgh (twelve paintings). In 1932 the National Gallery of Scotland organized a Munch exhibition in Glasgow. The London Gallery showed some works of the artist in 1936.

Munch's last journey abroad took place in the autumn of 1937 when he visited Gothenburg. The international situation was too

tense and during the war there was no opportunity. Since he had been permanently established in Norway Munch had travelled, but not as nervously or as extensively as before. He had for instance attended the international exhibition in Munich in 1926 where he was represented by seventeen paintings, three watercolours, five drawings and thirty graphic works; also his exhibition in the Kunsthalle of Mannheim, in 1926 (seventy-four paintings, three watercolours, six drawings and one hundred and forty-eight graphic works). In 1927 he was in Berlin to attend the large exhibition of his works in the Kronprinzen-palais (two hundred and twenty-three paintings, twenty-one water-colours and drawings).

In 1930 Munch began to suffer from an eye complaint, which recurred in 1938 when he was in danger of becoming completely blind. In 1940 he was still troubled by this illness which made it difficult for him to work. For a painter this must have been a great strain and I remember his extreme nervousness in those years.

In 1926 Munch's sister Laura died. There was only his sister Inger left for whom Munch cared until her end. In 1931 Munch's aunt Karen Bjølstad died, the aunt who had encouraged him when he was young.

In 1933, to celebrate his seventieth birthday, his old friend Jens Thiis and Pola Gauguin, the son of Paul Gauguin who lived in Oslo, each published a monograph on the artist, the first detailed accounts of his life and work. The French honoured him with the Cross of Commander of the Légion d'Honneur, and Norway with the Grand Cross of the Norwegian Order of St Olav. The last tributes from Norway and foreign countries were received when he was eighty. Some of these were later collected and published.[30]

In 1937 eighty-two works by Munch in various public and private collections in Germany were branded as 'degenerate', confiscated and many of them sold in Switzerland in a public sale. Unlike Hamsun, Munch refused during the occupation of Norway to have any contact with the German invaders and the Norwegian collaborators. This is remarkable, as it was in Germany, after all, that Munch's international reputation had first been established. As early as 1923 he had been honoured with membership of the German Academy and in 1925 he was elected an honorary member of the Bavarian Academy in Munich. He not only supported German artists particularly in 1922 and 1924, but in 1937 gave monetary help to the young German

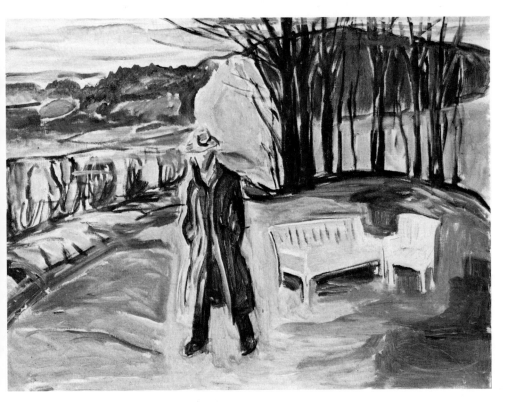

135 *Explosion in the Neighbourhood*, 1944

painter Ernst Wilhelm Nay to enable him to stay in Norway. It was during the war also (in 1941) that Munch organized the large-scale growing of potatoes, vegetables and fruit at Ekely and Hvitsten to counter the wartime scarcity of foodstuffs. When on 19 December 1943, just after his eightieth birthday, the Filipstad Quay in Oslo was blown up as an act of sabotage, the windows at Ekely burst from the air pressure. Munch left the house and, as he depicted himself in one of his last self-portraits (1944), walked restlessly up and down in his garden. He caught a cold which through his tendency to bronchitis he was unable to shake off. In the afternoon of 23 January 1944 Munch died at Ekely. In his will he bequeathed to his home-town of Oslo all the works which were in his possession, approximately one thousand paintings, 15,400 prints, 450 watercolours and drawings as well as six sculptures.[31]

135

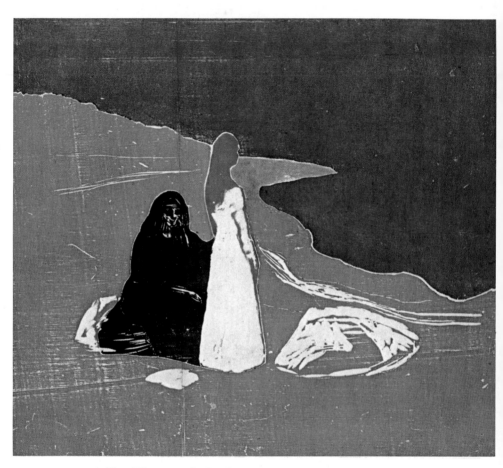

136 *Two Women on the Beach*, 1898

Munch's graphic works

In 1894, when he was in Berlin, Munch produced his first etchings, and in 1896 he printed in Paris in the workshop of the famous Auguste Clot, his first colour lithographs and woodcuts. If we recall that Toulouse-Lautrec produced his first colour prints in 1892 these dates acquire a particular significance for the history of modern print-making.

In his graphic works Munch did more than transfer the major themes of his *Frieze of Life* and other compositions into a graphic technique, though this had been the original aim. Soon the new manner of expression, the material itself and the technical side involved, fascinated the artist, and numerous variations were produced in composition, in the change of colour schemes, in the paper used for the prints, the application of mixed techniques, etc. The experimental side of his graphic adventure and its surprising results account for the fact that Munch, who was an indefatigable worker, left behind not only an imposing but a quite exceptionally large *œuvre* of graphic works, of which sometimes not even he himself possessed documentary prints. For this reason even the very large collection which is to be found in the Munch Museum in Oslo does not contain all the editions or variations of Munch's graphic works.

Although great artists worked in graphic techniques during Munch's lifetime and some of them such as Daumier, Toulouse-Lautrec, Odilon Redon, as well as Félicien Rops and Félix Vallotton, to name only a few, exercised a certain amount of influence on Munch, both stylistically and technically (Degas and Rodin also produced fine etchings, as did Manet), what seems to be established beyond all doubt is the fact that Munch developed into a master of *all* the graphic techniques. This is quite unique. Rembrandt and Goya were primarily etchers. It was only in his old age that Goya took up the new technique of lithography and produced outstanding works in the medium. Toulouse-Lautrec produced mainly lithographs, Dürer and Hokusai mainly woodcuts. For Kokoschka, who produced a large body of lithographic works and only a few etchings in his early career, as well

as dry-point prints during his later years, the woodcut technique was unacceptable. The process was too slow for his temperament. Munch, on the other hand, though he embarked on the woodcut technique as the latest of his graphic ventures, used it in a new manner. With its tradition of some five hundred years, this technique had for Munch – who was thirty-two years old when he produced his first woodcut *Vampire* (based on the painting of the same title) – a specific significance. The large and simple form which the woodcut technique proper entails emphasized the monumental character of his subject-matter (whereas in Munch's lithographs the lyrical and intimate character is predominant). It came about that by 1900 Munch had produced thirty-two wood blocks, among them motifs from the *Frieze of Life* which were created first as paintings (with preparatory

137 *Melancholy (Evening)*, 1896

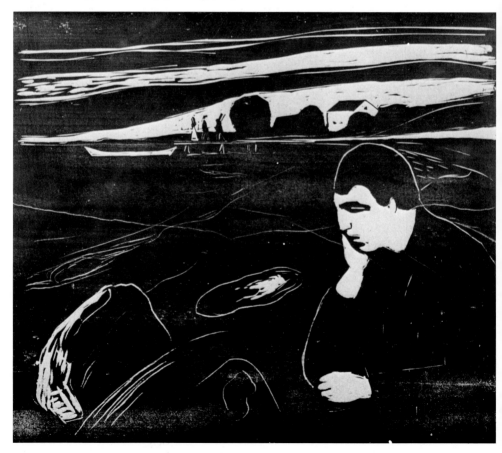

138 *The Kiss*, 1902

drawings or sketches), later as etchings and lithographs, and found their final shape in the woodcuts. *The Kiss*, for example, was painted for the first time in 1892, and later on variations appeared, from the etching of 1895 to lithographs. Then between 1897 and 1902 Munch used this subject for woodcuts which show an increasing concentration, a great severity and closeness of form.[32]

54

138

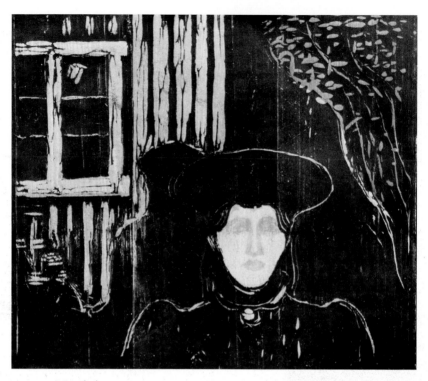

139 *Moonlight*, 1895

Soon Munch discovered that the structure of wood asserted its own rights, and he subordinated the subject-matter to this, so the expressiveness latent in this particular material was emphasized. Not only was the pattern produced by the wood fibre itself used in a decorative manner, but cutting the wood against the grain brought out new possibilities of effect. Munch's woodcuts exercised a strong influence on the generation of German Expressionists in the first half of the twentieth century. It is in this field particularly that German Expressionism has produced some of its most original works. After 1900 Munch made no less than one hundred and thirteen woodcuts, pioneering new ways to exploit wood's expressive possibilities. The Munch Museum has one hundred and forty-three woodcuts and one lino plate (*Two Women on the Beach*) in its collections. Some of Munch's woodcuts are multi-coloured.

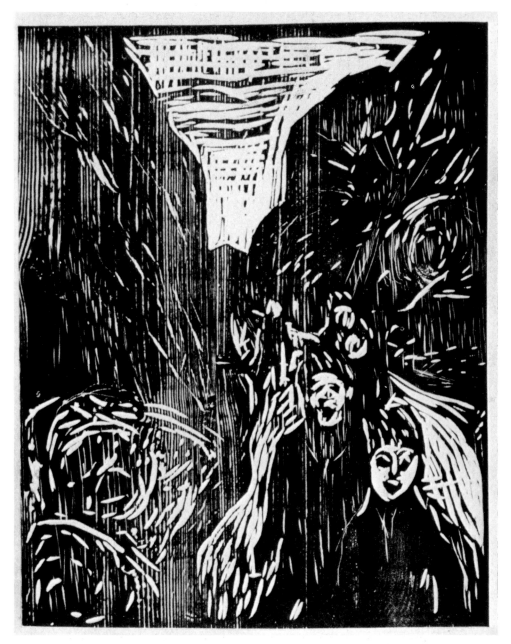

140 *The Mountain Path*, 1910

Christian Gierlöff reported that Munch 'never felt as fine, he was never as gay at work as when etching'.

Munch's engraved work, apart from his etchings, consists of aquatints, mezzotints, dry-point engravings and mixed techniques. The etchings are so far the only section of the artist's graphic work of which there is a complete printed record.[33] They consist of one hundred and ninety-eight plates covering the years from 1894 to 1926. To give an account of the prints in mixed techniques is impossible at the moment as the prints in the Munch Museum have not yet been checked from this point of view.

The year 1916 was the last year in which Munch concentrated on the particular technique of etching. Afterwards he worked only occasionally with copper or zinc plates, and then in small formats. His first work was the portrait of Mr Mengelberg (who belonged to Munch's circle of friends in Berlin) in dry-point, 'alert, wide awake, as if caught during a pause in the conversation'. The last masterpiece in this technique is *Ecstasy*, a reclining half-length nude of 1916.

The range of expression and the application of various techniques is large. We encounter in this *œuvre* quick, spontaneous sketches, in which the detailed method of etching is not applied. It was said that Munch, carried away with enthusiasm for his new medium, went about with a little plate in his pocket so as to have it at hand, like a sketchbook. Dr Max Linde records that Munch's plates were often executed in a café or even in the street. Then again we have the *141* masterpieces, such as *Death and the Maiden* or *The Sick Child*, both of 1894. The first takes up the main themes of the *Frieze of Life*, love and death, in these two figures embracing. A symbolic border surrounds the grand composition suggesting in the human sperm and embryonic shapes the fatal connection of love and death. The second shows the mastery with which Munch could translate the effects of colour and chiaroscuro into a black and white medium. One of the *63* most famous dry-point etchings is *Two People* of 1895, taking up the subject of the painting *Summer Night* of 1891 with the whole impact of Munch's lyricism, depicting melancholy and loneliness. *The Kiss* *54* of the same year (etching, dry-point and aquatint) is a climax both historically and graphically. Munch, as we have said before, incorporated most of the motifs from the *Frieze of Life* in his graphic *œuvre*. They not only speak of the obsession with which he pursued certain themes, but also of his urge to deepen their impact. We can speak of

174

141 *Death and the Maiden*, 1894

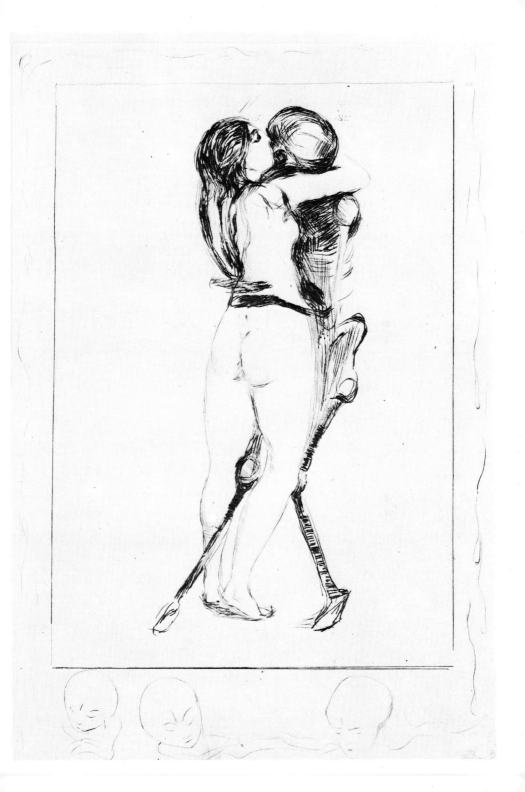

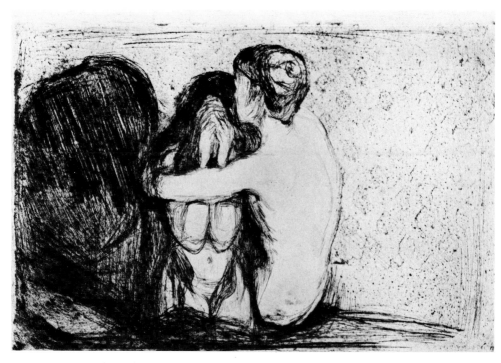

142 *Consolation*, 1894

significant variations. The imagination and the skill involved are admirable. There are works of an intensity of disharmony and tragic grimness and even masochism such as *Vampire* (1894), *Woman I* (1895), a variation of the painting *Three Stages of Woman* with the dark woman holding the severed head of a man in her hands. *The Maiden and the Heart* (1896) combines the lyrical and the cruel, as does *Life and Death*, or *Interplay of Matter* (1902), showing how a tree sucks its sap out of the dead body of a man. *Dead Lovers* (1901), a double suicide motif, *The Dead Mother and Child* (1901), *Salome I* (1905), and a variation on the same theme entitled *Cruelty* (1905), *The Bite* (1913–14), *The Seducer* (1913) are produced in the same vein. There are other works displaying an intensity of feeling and lyricism expressed through tonal values: *Girl in a Nightgown near the Window* (1894) or *Young Woman on the Beach* (1896), *Man and Woman* (1913), depicting the tragic relationship of the sexes, and many others. That Munch was able to express so supremely both the aggressive and the

56

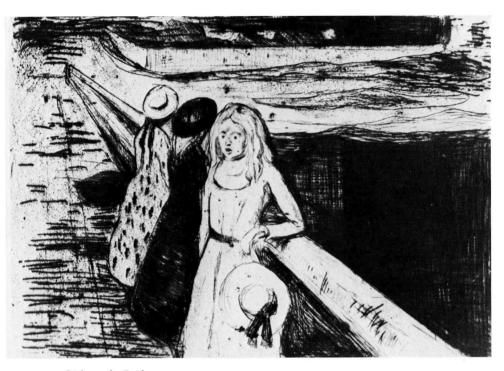

143 *Girls on the Bridge*, 1903

tragic elements on the one hand, and the lyrical on the other, makes him an artist of extraordinary stature.

There are picture compositions translated into etchings such as *Christiania Bohème I and II* (1895), or *Moonlight* (1895) based on the paintings with the same subjects, *Jealousy* (1913–14), *Galloping Horse* (1915), etc. Then there are portraits of friends and people whom the artist knew well, such as *Knut Hamsun* (1896), *Stéphane Mallarmé* (1896), *Sigbjørn Obstfelder* (1897), *Helge Rode* (1898), *Albert Kollmann* (1902), *Dr Max Linde* (1902). *Emanuel Goldstein* (1906), *The Countess* (1907), *Christian Gierlöff* (1913), *Hieronymus Heyerdahl* (1916), etc. There are subjects too, from the worker's life, landscapes and townscapes, animals, female nudes, and then again pure caricatures.

The etching technique is the most direct and exact manner of using the primarily linear element. It is above all a means of multiplying a drawing. Like a drawing too, it has often a personal and intimate character, but in the case of the dry-point engraving it remains cool,

177

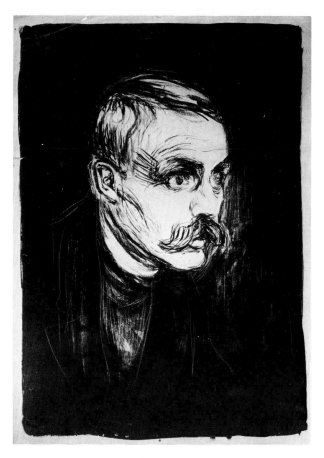

144 *Sighjørn Obstfelder,* 1896

even detached, whatever it may represent. The lithograph on the other hand, particularly the colour lithograph, stands nearer to painting. Even the line drawn with a crayon, chalk or india ink on the stone has a painterly and generous character in Munch's work. The lithographic output in Munch's graphic *œuvre* is the largest. The Munch Museum alone has three hundred and ninety-one lithographic compositions in its collections. The changing colour-scheme offers greater possibilities than any other graphic technique for the expression of different moods through varied harmonies and disharmonies of colours. A strong musical element is involved both in colour and line in many of Munch's lithographs. In the great variety of his colour

lithographs Munch appears to us like a composer using his talent to create endless variations on a theme.

What has been said about the subject-matter of Munch's etchings applies also and to an even greater extent to his lithographs. The technical ease with which a lithograph can be produced, as compared with a woodcut or an etching, makes possible a more playful application of both colour and line. The line in the lithographic work of Munch is fluent, undulating in those compositions which are akin to Art Nouveau, and always rhythmical and expressive.

Although Munch had started his career as a graphic artist in Berlin, there was little he could learn from the work of Max Klinger or Max Liebermann, although both were good etchers. Munch received advice of a purely technical nature from Karl Köpping, an artist known for his outstanding reproductions of the old masters. The situation in Paris was quite different, and it is here that most of Munch's

145 *Jens Thiis*, 1913

lithographs were produced. The elegant use of colour is characteristic of these prints. Apart from Toulouse-Lautrec, Forain, Steinlen and Willette were also well versed in this technique. The printer Clot who experimented largely with the possibilities of colour lithography, used in those days also for posters of theatres, variety shows, etc., was a master from whom Munch was able to learn a great deal. Munch developed his lithographic art during the years between 1895 and 1897. The variations in Munch's lithographic work depend not

146 *The Dance of Death*, 1915

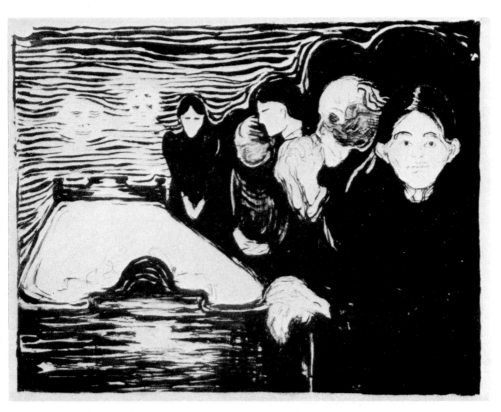

147 *Death Struggle*, 1896

only on the colours or versions of the motifs involved but also on the different thickness, tone, etc. of paper used. One of the first works produced in this technique is the *Self-portrait with Skeleton Arm.* 57 It was printed in 1895. With the full name of the artist and the year of production on top, and on the base the skeleton arm like a border, it has a solemn character. The beautiful face of the artist, then thirty-two years old, appears in the dark surfaces like a vision. A self-portrait of 1915 takes up the same idea but in a different composition: the *Dance of Death* shows him in profile, already marked by age, touching 146 with a trustful hand the bony chest of a grinning skeleton. One of Munch's most popular lithographs is *The Sick Child*, printed at Clot 44 in 1896. Drawn with crayon on stone it was combined with touches of india ink on up to three stones and printed in various colours and

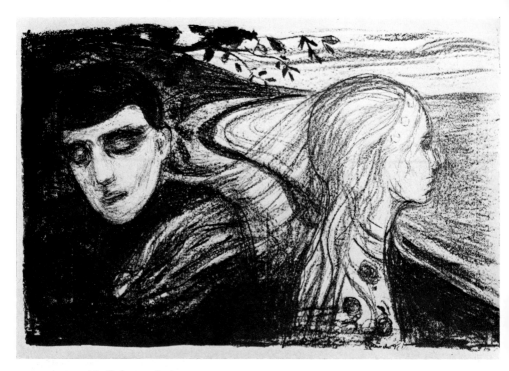

148 *Release*, 1896

tones. Among the scenes depicting the relationship of man and woman
149 is the lyrical *Attraction* of 1896. This lithograph depicts a night scene
with two heads, the man and the woman facing each other. The
woman's hair is so composed that it seems almost imperceptibly to
draw the man towards her, a poetic and melancholy vision. The hair
148 appears again, this time more obviously, in the composition *Release*
of 1896. It is one of Munch's most appealing works. The girl in a
flowery dress is facing the sea and the curving coastline, the man's
head in the dark left-hand side of the composition, with his eyes shut,
is suffering the agony of separation. The girl's hair seems to flow
51 towards his heart, symbolizing her power over him. *Madonna* is one
of Munch's great graphic works and a favourite among collectors
(printed in 1895 and in 1902). The colour prints of this subject are
produced on paper of different tones and also on white paper, with
Paris blue or vermilion, then again with deep cobalt and carmine.

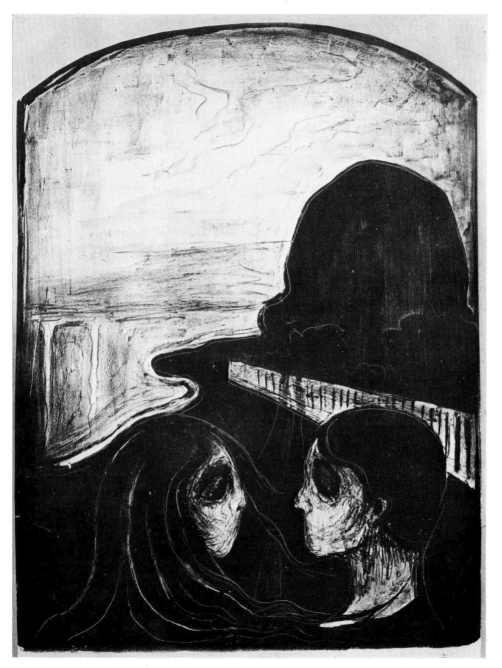

149 *Attraction*, 1896

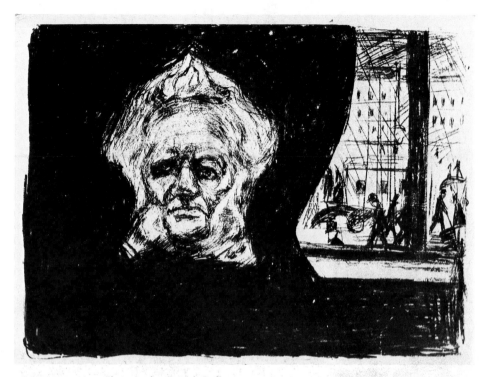

150 *Ibsen in the Grand Café*, 1902

The frame with sperm and an embryo symbolizes the moment when a new life is conceived. The wavy lines round the Madonna's hair are expressive of the connection of this happening with the life-forces of the universe. *The Lady with the Brooch* (1903) is the portrait of the violinist Eva Mudocci to whom Munch was attracted. It is a noble likeness and one of the most beautiful produced by the artist. The problematic nature of Munch's relationship to her is revealed in a lithograph *Salome* (1903), which shows the head of the lady with a brooch, surrounded by her hair, and somewhat lower the emaciated face of the artist himself. The price for the art of the woman is the head of John the Baptist claimed by Salome. In another lithograph *The Violin Concert* (1903) we see Eva Mudocci, violin in her hand, awaiting the first chords from her accompanist at the piano. There are versions of *The Death of the Bohemian* in lithographic technique (1927) and also the *Alpha and Omega* series.

151

184

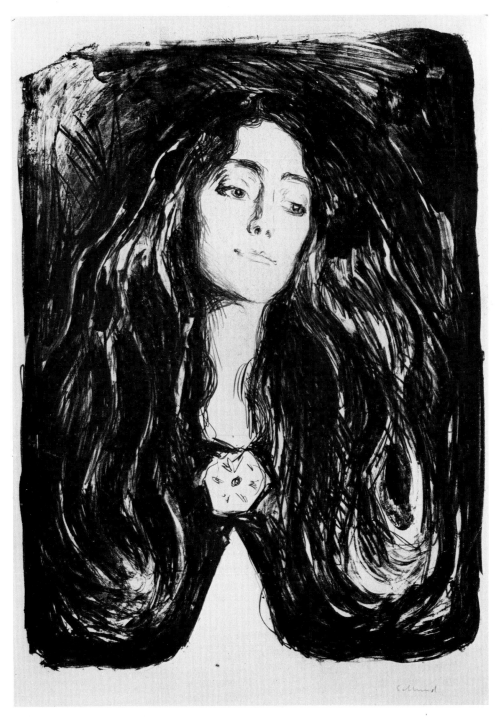

151 *The Lady with the Brooch*, 1903

As often in Munch's work, the lithographs are not mirror-images of the paintings, but rather a series of variations on the original theme. Among the scenes from the *Frieze of Life* we find *Ashes* (1896), from the painting of 1894, showing a couple in a forest after love-making, the woman with both arms raised to her head, expressing despair, *Vampire, Jealousy, Death Struggle* (both 1896) and many others. *The Death Chamber* of 1896 shows a great simplification of the dark figures contrasting strongly with the surrounding room. There are many portraits in Munch's lithographic *œuvre* of men and women, heads, heads and shoulders, etc. There are nudes, scenes from Ibsen's plays produced for Max Reinhardt, animals and caricatures, symbolic compositions, landscapes, townscapes – a microcosmos of a visionary imagination.

When I visited Munch in 1938 I found the whole first floor of the house at Ekely serving him as a huge graphic printing studio with several printing-presses standing about, also lithographic stones, copper and zinc plates and a great number of printed works lying in heaps on the ground. The whole impression was of an intense activity now suspended. Munch had by this time accomplished the major body of his graphic *œuvre*. In 1928 he wrote to Dr Ragnar Hoppe in Stockholm: 'I decided long ago not to print any more because I found that too many have been printed already. Instead I will do as Rembrandt did – would that I resembled him in other respects too – I shall soon make an *auto-da-fé* of all my graphic work.' It may be of interest also to mention here that in his will, Munch made certain that none of the graphic works bequeathed to the town of Oslo should be sold.

In Munch we recognize one of the greatest graphic artists of his time, comparable to a Dürer, a Rembrandt, a Goya, a Hokusai, continually seeking new means of expression. His development as a graphic artist is linked with the revival of this genre at the end of the nineteenth century. In the beginning it was one of Munch's aims not only to find a simplified and condensed form of expression but also to make possible the replication of his pictorial ideas so as to reach a larger audience than his paintings could ever hope to do. In this respect too he was like Dürer. Later on this aspect was of lesser importance to him, and the purely creative and aesthetic side of this activity became predominant.

152 *Vampire*, 1895

153 *The Death Chamber*, 1896

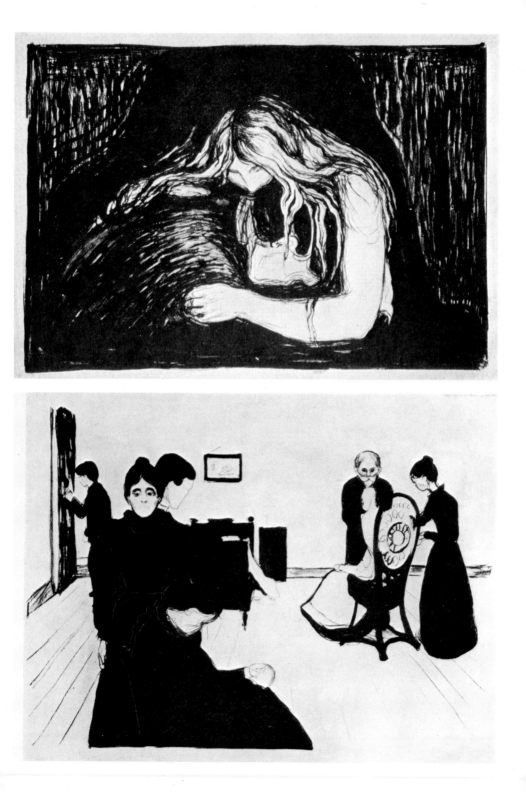

154 *Starry Night*, 1923

How Munch worked. His style. The draughtsman

When we study Munch's drawings – and Munch left behind thous-
ands of drawings – we realize that from the very beginning the basis
of his art was thorough observation. He drew everything he saw –
landscapes, portraits, figures and animals – naturalistically sometimes
and sometimes in a distorted manner, and also as caricatures, from
memory. He made notes of all his visual experiences and often
preliminary sketches for his paintings and graphic works. From the
changes in composition and expression, from the many variations
and versions of a theme, we can draw conclusions on the working of
his mind, on the development and application of his techniques.
His drawings were a little-known area of the artist's activities and it
is only now through researches undertaken in the Munch Museum in
Oslo, that both scholars and connoisseurs can form for themselves a
more comprehensive idea of this side of his work.[34] Munch himself
once said: 'In common with Michelangelo and Rembrandt I am
more interested in the line, its rise and fall, than in colour. One can
easily tell that the creator of the paintings in the Sistine Chapel was
above all a sculptor.' This statement, though surprising in such a
fine colourist as Munch, supports the art-historical view of the
Expressionists, which is that the nature of their subject-matter and the
emphasis placed on outline are two reasons for the important part
played by Expressionism in graphic art. Apart from the thorough
nature studies and nudes from Munch's early years, including those
in the Bonnat studio, there are sketches of an expressive kind fore-
shadowing future developments, and it is interesting to see that even
late in his career an ordinary naturalistic sketch will provide a sig-
nificant figure in a complex composition. The naturalistic interior
Adieu of 1892, for instance, contains the basic elements of the well- *155*
known painting *Kiss by the Window* of 1892, and variations on the *54, 138*
theme. What an enormous step from the simple study for *Madonna*, *157*
a pencil drawing, to the expressiveness of one of Munch's most
intense paintings of womanhood, *Madonna* of the same year, and its *38*
translation into graphic techniques. The same is true of the many

155 *Adieu*, 1892

156 Study for *Death in the Sick Chamber, c.* 1892

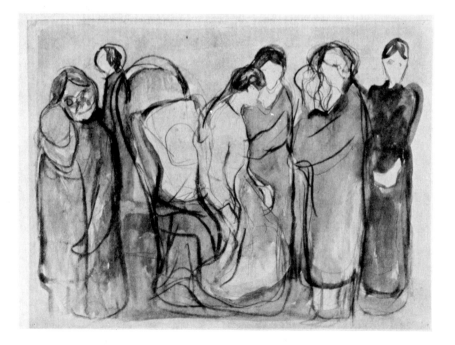

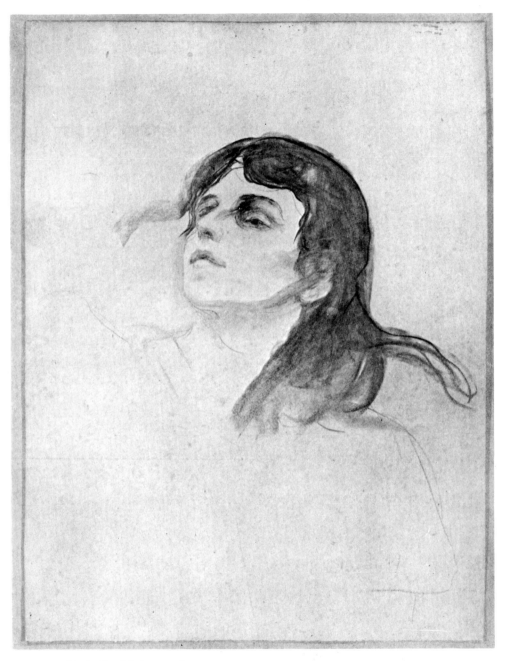

157 Study for *Madonna*, 1894

158 studies for *Death Struggle* of 1895, successively in pencil, charcoal, ink
159 and watercolours, with their changes of emphasis in gesture and
placement of the figures until the maximum intensity of expression
147 is arrived at in the final work. Munch's naturalistic studies of boys
160 bathing (*c.* 1895) in a swimming-pool or the studies of male nudes
from a bathing establishment (1907) are the first impressions leading
161 up to the picture *Boys Bathing* of 1895, and to several of the panels of
the Aula decorations (1909–14). A quick watercolour sketch of a
scene in a harbour, *On the Quay* (*c.* 1907), provides the subject-matter
for one of the panels for the *Freia Frieze* of 1922. Between a simple
pencil drawing *From Kragerø* (*c.* 1910), to a later painting in which
that landscape was used as background, lies the whole process of
artistic intensification. What was purely topographical and typical
becomes a vehicle of expression and meaning. Munch will make
detailed studies of a landscape, for instance the shore of Åsgårdstrand
with its undulating line and its boulders, and of a figure, and later
combined the two to express a certain mood and finally to provide
the elements of an important painting.

158 Study for *Death Struggle*, 1895

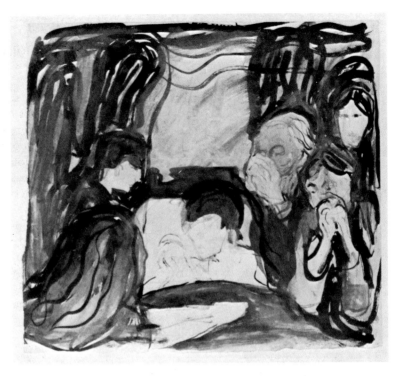

159 Study for
Death Struggle,
1895

Even late sketches for pictures loaded with emotional qualities show a simplicity and straightforwardness which is surprising. If we compare them with those of the early period, when these sketches were the final results of the artist's observations, we see how much the artist had matured in his ability to express the various states of his mind. Although there is a marked difference in the drawings of his introspective period and those of a later date, where external reality seems to preoccupy him more and more – this is true particularly of his compositional sketches – what has never changed are the basic aspects of the visual experiences retained throughout his entire career as indispensable. The perpetual exercise in drawing made Munch the master of a controlled technique, both in the quick appraisal of first impressions and in the working out of emotionally inspired compositions. Whether his form is at times detailed (particularly at the beginning of his career) or again summary, descriptive and analytical, it is never a question of routine or pure formalism which we encounter, but always drawing as a medium for expression.

160 *Boys Bathing* (sketch), *c.* 1895

161 *Boys Bathing*, 1895

162 *Model Undressing*, *c.* 1918

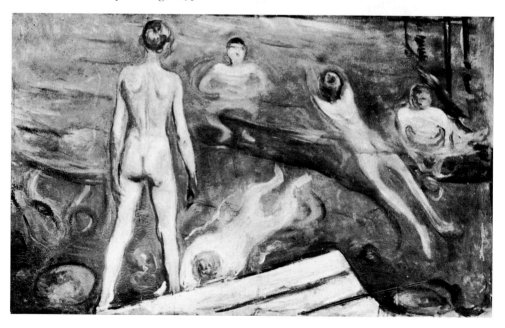

Munch's art, although characterized as Expressionism (at least in the first half of his career) has never used inorganic distortions as did the German Expressionists. It never sacrificed beauty to expressiveness, and though some of his most important works from the *Frieze of Life* are of a melancholy or even depressing nature, they never make any concession to ugliness. In other words ugliness is not necessary to depict a desperate view of the world, as preached from the time of the Realists onwards. Munch has chosen beautiful people to express the sufferings and sorrows and torments of mankind, and even in the wildest compositions such as *The Scream*, where the red in the sky is not the red of the setting sun but coagulated blood, there is still a beauty in the scenery and the vibrations of the lines, as there is in the figures. To achieve his impact Munch did not need the emphasis on the ugly. He used it only in the beginning in pictures such as the realistic painting *The Heritage* of 1897–9 in which the fatal consequences of one of the scourges of the age, syphilis, are illustrated.

The beauty in Munch's pictures as well as their idea-content has a cathartic effect, and in the second half of his career Munch achieved that *conjunctio oppositorum*—the acceptance of light as well as darkness, life as well as death, joy and pleasure as well as suffering, the two sides that together are life and unity and truth–which enabled him to realize the absolute communion of his being with existence. Such an achievement was not easy in an epoch of Existentialist philosophy, without confidence either in the powers of nature or in the social order, and which did not allow of harmony, but only a balance of opposite forces. Through his very being and his work Munch rendered his time a great service.

In using pure geometric elements for his compositions (for instance

163 the building up in a pyramidal form of *Women on the Bridge* of 1903, or the rhomboid form of the group of boys in the picture *Village*
164 *Street* of 1905), or again in his stressing of the horizontal and the vertical
90 (standing and lying) in the *Death of Marat* of 1907 (a second version of the picture of 1906), and in his contrasts of light and dark (both
134 visually and psychologically) as for instance in *The Duel* of 1935, and of warm and cold–Munch achieves a structure which gives the picture the character of a definite statement, as we find it in major works of any great style. In Munch, who is a modern man, it is modified by an element of improvisation which has its roots in Impressionism but is controlled by strong outlines. When we study

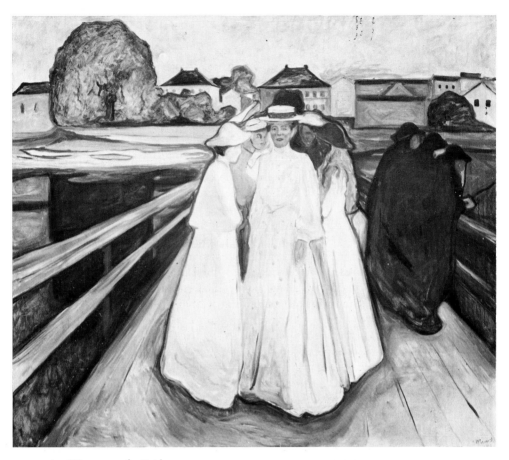

163 *Women on the Bridge*, 1903

the collection of pictures in the Munch Museum, we can discern that the achievement of a final masterly statement is the result of trial and error. There are pictures which can be seen as stages in this process, and it is open to doubt whether certain of these paintings, not necessarily the unfinished ones, would have received Munch's final approval.

Frontality is one of the elements of the primitive styles and Munch used it consistently in his efforts to achieve the most direct psychological impact on the beholder. It is as if he wished to force him to look the challenge straight in the face; as if he attacked him, leaving him no

197

escape from the intensity of his experience. Frontality is also one of the devices used in portraiture. In most of Munch's portraits it is applied, particularly in his full-length life-size portraits which can be compared to Velazquez's *Portrait of Philippe IV* of 1628 or Manet's *The Absinthe Drinker* of 1859, Seurat's *Poseuses* of 1887 or Whistler's *Portrait of Th. Duret*, or again, Bonnard's *Portrait of G. Besson* of 1911. Munch often combined *en face* with profile representations. He also made use of an exaggerated perspective by placing figures in a large size as *repoussoir* in the foreground of a picture to elaborate the depth, and then accentuating it further by very small figures or objects deep in the picture. This method was applied by him not only for pictorial but also for psychological reasons. Munch's application of a lyrical undulating line and of harmonious colours, then again of abrupt lines and violent colours, often emphasized by a forceful and broad brush-work, are all basic 'formulae' of his art. It is as if Munch had created for himself a vocabulary capable of giving expression to the emotional content that he wished to convey.[35]

From early in his career Munch painted large pictures. Only his first works were small. Later on he had no use for small canvases, which allowed no scope to the monumental quality of his art. On the occasion of the large exhibition of his graphic work in the National Museum in Stockholm, in 1929, he wrote to the Keeper of Prints, Dr Ragnar Hoppe: 'Almost everywhere the new Realism has come to the fore with its detailed treatment, smooth execution and small format. I think I can understand the good points about it, and changes there must always be, but I believe that this sort of art will change again soon. Perhaps the tendency towards a small format will decline? This kind of paintings with its large frames is, in any case, a bourgeois drawing-room art. It is an art dealer's art – and that came in after the civil wars following the French Revolution.' This preference of Munch's for large-scale paintings was to find its final fulfilment in the Oslo University murals. Munch himself said that to execute paintings on surfaces like those Michelangelo filled with figures in the Sistine Chapel was a task worthy of an artist.

Christian Gierlöff wrote of Munch in 1913: 'He has no less than forty-three studios altogether in his four houses at Kragerø, Ramme, Åsgårdstrand and Grimsrød on Jeløya: all his rooms are studios. He does not possess very much more furniture than he had twenty years ago, when he was a penniless young artist; a few cane chairs

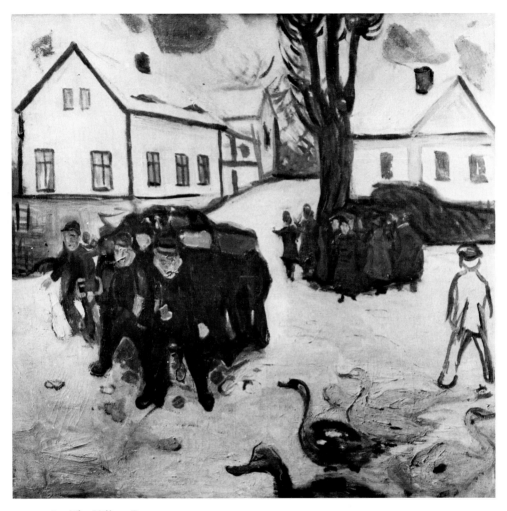

164 *The Village Street*, 1905

are the most luxurious items. His rooms are his workshops, for pictures, easels, portfolios, lithographic presses, etching tools and electric furnaces are to be found scattered in every room in a chaos of which he himself has but a hazy idea.

'Tubes of paint and turpentine, brushes and palettes lie scattered about on the floor, on packing-cases and chairs. Munch places the canvas on the easel while he glances towards his model. "Ah, yes,

painting, that's quite a business," he observes as he takes a couple of steps to the side, gazes at the model for a few moments half wrapped in thought, glances again, and then with arm outstretched draws the first strokes with a stick of charcoal. . . . Often too he does not say a word, and an oppressive silence fills the room while he continues to draw with deepening concentration. He then looks less and less often at the model, until it seems as though the canvas is absorbing his entire attention. He forgets completely that the model needs to relax a little. After twenty minutes of drawing he starts painting straight away. . . . He paints steadily, a little here, a little there with increased absorption in his work. Now and again he will take the picture from the easel, place it in another room, contemplate it awhile from a distance, replace it on the easel and set to work painting again with intensified energy. . . . All that can be heard is the soft scraping sound of the brush on the canvas, accompanied by the intermittent rattle of the loose frame beneath the force of his powerful and at times almost violent brush strokes.

'I particularly recollect the case of one of his very large portraits – one of the most celebrated, now in the possession of a Swedish collector, which was painted in this fashion at a single sitting lasting only a few hours. It resulted in a splendid picture, but the unhappy model was almost in a state of collapse by the time it was completed.

'Or again: "Why do you talk such a terrible lot when you paint?" asked Elisabeth Förster-Nietzsche when she was sitting for him, for he can also talk as he works, especially with models whom he does not know. "In self-defence," answered Munch with his frank, almost childlike smile. "I build a kind of wall between myself and the model, so that I can paint in peace behind it. Otherwise, she might say something that confuses and distracts me."

'Munch often paints two pictures with the same subject or the same model, a large picture and a small one: he passes from one to the other and the two supplement each other. He does not paint every day, or even every week. In fact, many weeks and often months may elapse between spells of painting. He generally likes to go about for a long time considering a subject and meditating on it until one day he suddenly plunges feverishly into the work of painting it. He is eager to paint every minute, every second that he feels the inspiration working within him. There is no power in heaven or earth that could ever make him paint without this.

165 Munch in his studio at Ekely in 1938, when he was seventy-five

'When he has finished at last, he sets up the picture on the wall and looks at it with narrowed eyes. "Oh well," he will comment, "that will be all right when it has stood there for a while and has had time to mature. The colours live a remarkable life of their own after they have been applied to the canvas. Some reconcile themselves to one another, others just clash, and then they go together either to per-dition or to eternal life. Just wait until they have weathered a few showers of rain, a few scratches with nails, or something of the sort, and have knocked about all over the world in every kind of miserable, battered, and far from air- or water-tight packing case. Oh yes, that will turn out all right . . . when it has developed a few slight flaws it will be quite presentable."'

Visiting Munch in Norway in 1938 I was taken to his open-air studio. We came to a wooden palisade with a door. Munch opened it, using a very large key, and I found myself inside an enclosure with a narrow roof along its walls. Munch called it his 'invention', as it allowed him to work on his compositions out of doors undisturbed in the middle of his garden. Here he painted both in summer and winter, and the pictures went on hanging there year after year. It was Munch's opinion that they could only improve by the treatment, and he used to study them under diverse conditions of light and shade and in various seasons as though they were strange and remote creatures with a life of their own.

Buffon's statement, *'Le style c'est l'homme même'*, acquires in the context of the Expressionists a particular significance. Munch is one of those artists whose life it is difficult to separate from his work. Most of his work has an autobiographical character. Although we can define style as an intensely personal quality for the artist, subcon-sciously determined and instinctive, an inherent organic form of expression, we nevertheless have to consider that the process of maturing, of finding oneself is a long one. Munch discovered the essence of his own style at the time of his *Diary* entry in Saint-Cloud in 1889 (page 50).

We have followed the line of unfolding of this style through all its phases, from the naturalistic, *plein-airist* first attempts, with some allusions even to current trends in Academic art; to Realism with a sociological tendency in some pictures during the eighties; to the side-step into Impressionism which came after his 'blue period', when he painted the early night pictures in the south of France – a romantic

166 The open-air studio at Ekely

intermezzo of the nineties; until we reached the Synthetic and Expressionist styles which were most fully compatible with Munch's direction of mind. It was here that his artistic personality found its form. Although affiliated to certain trends in modern French art, as we have suggested previously, Munch's personality was of such power, his message so urgent, that he was able to achieve in his style an authority and strength which influenced other artists of his own and later generations. Being an artist who genuinely worked 'from inside out', he might go astray in a formal sense but he would always find himself again. It is precisely the autobiographical element, the themes based on personal emotional experiences, which guaranteed the genuineness of his art. This is also the source of his style. The spontaneity deeply rooted in his unconscious, the fundamental cast of his mind, the severity of his technique, all combined to save him from exaggerations which often endangered the works of German Expressionists. The fact that he kept his identity as a man and as an artist enabled Munch to achieve that climax of his expressive powers which placed him as a source of influence on the same level as the leading artists of the first French *avant-garde*.

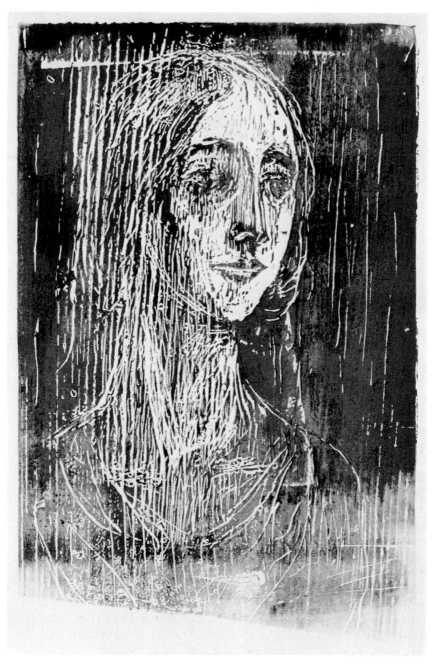

167 *The Gothic Girl,* 1931

Epilogue

The romantic sense, deeply rooted in the Northern spirit in the nineteenth century and counteracting the impact of rationalism and utilitarianism, was personified in figures such as Jens Peter Jacobsen's Nils Lyhne, or Knut Hamsun's Johan Nagel, who asked the question: 'Of what real profit is it to us, to deprive life of all its poetry, of all its dreams, of all its beautiful mysticism and of all its lies? What is truth – do you know? We move forward only by the aid of symbols, and we change those symbols as we move forward.' The line in Ibsen's *The Wild Duck*: 'Deprive the average human being of his life-lie and you rob him of his happiness,' seemed like a revelation. In *The Gothic Chambers* Strindberg characterized the crisis of the nineties in the words: 'The human spirit awoke from its solitude and felt itself to be without power, because it had lost contact with the transcendental.'

The time in which Munch lived was intellectually disturbed and restless in the extreme. Everywhere was tension. Dostoevsky wrote: 'Never before has Europe been ravaged by conflict as it is today. It is as if it were totally undermined, like a gigantic powder-magazine awaiting only a spark to ignite it.' As the interpreter of his time, Munch originated the weird emotional intensity (*das unheimliche Pathos*) of which Wilhelm Worringer speaks. For Central Europe, the North meant the rebirth of fantasy. The untouched Northern forests seemed filled with melancholy, the fjords appeared as witnesses of long-forgotten ages of earth's history. Even the colours of the North were a revelation, the blond and blue-eyed type of people of a particular beauty and appeal, the deep cold blue of the sea and sky and the pristine purity of the shimmering snow, its sparkling hoary whiteness, its mysterious shades of violet. The green is sharp, in the North, for it breaks out with sudden impulse in the vivid spring which follows upon the long winter. In autumn the colours are more brilliant than in the South, and in the crystal-clear air, the foliage shines like cold fire. The white nights, the unforgettable twilight which is at the same time an early dawn, the bright darkness, the mysterious contours and shapes that merge into each other – all combine to make up the story

of light in the North. Dreams attend it like living shadows. Then there are the violent contrasts: the days of unceasing light are followed by months shrouded in deepest night, broken only by the pale glimmer of the Northern Lights, burning like feverish fancy with a chilly flame.

Europeans who were captivated by the lyricism of the North, by its purity, and the spectacle of its peoples' proud solitude amid the silent melancholy of the scene, found their way back to the very sources of the inner life. Munch succeeded in reproducing clearly and deeply the note sounded by the land of his forefathers, and taught others to discover the essence and beauty of their own lands.

He was, too, a living demonstration of the fact that it was possible to paint well elsewhere than in Paris at a time when the influence of Paris was overwhelming. Emile Filla, the leading Czech painter of this generation, later a post-Cubist Expressionist, wrote in 1938 when referring to the Munch exhibition in the art society Mánes, in Prague, 1905: 'In the beginning of our brave search for our own modes of expression we had the good fortune to meet with such a one as Edvard Munch. For us Munch became our ineluctable fate. So it was when Donatello came to Padua, Rembrandt to Amsterdam; when Michelangelo appeared in Florence or Caravaggio in Rome. Munch afforded an example to his generation of how man should stand free and fearless in his environment.'[36]

Oskar Kokoschka, the only artist to carry the style of Munch a step further in its development, also wrote a moving tribute to his art.[37]

The impact which Munch made on the young Kokoschka has been analysed in his biography.[38] The international exhibition of 1904 organized by the Vienna Sezession showed the public twenty paintings by Munch, and even before 1904, single works had been exhibited by the Sezession when Klimt was its President. Austria was well aware of his importance. Kokoschka's early portraits such as *Father Hirsch* of 1907, or *The Tranceplayer* of 1908, left both the idealizing tendency and the decorative Art Nouveau style behind, as did Schiele and Gerstl. A connection with the work of Munch is obvious.[39]

On the work of the German Expressionists the influence of Munch is direct. Not only did he create the spiritual climate in which German Expressionism could flourish, but in some works his influence on the subject-matter and execution is easily traceable.[40]

168 *Old Man*
(*Primitive Man*),
1905

Max Deri[41] was among the first to name Karl Schmidt-Rottluff, Erich Heckel, Emil Nolde, Otto Mueller, Ernst Ludwig Kirchner, as well as Beckmann, Kokoschka, Pechstein and Ludwig Meidner and some minor masters, as among those standing nearest to Munch. Johan H. Langaard and Reidar Revold, some forty years later, were more explicit. They recognized Munch's influence in the landscape paintings of Schmidt-Rottluff, Pechstein and Heckel, in the figure compositions of Kirchner and Nolde; they also mention Polish artists such as Wojtkiewicz and Slevinski (a friend of Kokoschka's from his Paris time), and some Scandinavian painters. Not so certain is the statement that even the French Fauvists, particularly Rouault, received impulses from Munch.[42] The young Picasso may well have done so, but this is of no great significance, as Picasso's sources were many and fluctuating and his 'Expressionist' period in Barcelona was very short.

In Czech painting Munch's influence is obvious in the early work of Emil Filla and Antonin Procházka, as also in that of Jan Preisler, V.H. Brunner, Josef Čapek, and in the drawings of Zdeněk Kratochvil.[43] Ludwig Justi, Director of the National Gallery in Berlin, when writing in 1919 about the Expressionists[44] spoke of Munch and Van Gogh as masters whose work was still connected with present-day developments.

Deri[45] attributed to Munch a place in the development of modern German art like that held by Cézanne in France, at the turning-point from subjective Naturalism (Impressionism) to Expressionism. Through certain stylistic formulae which Munch used for the first time in Germany he became of extraordinary importance for art east of the Rhine. Historically Munch is to be seen as the master painter of this transition period.

The direct influence of Munch has been potent even in a third generation. In the twenties and thirties paintings of Kokoschka's pupils Friedrich-Karl Gotsch from northern Germany, the Prague-born Paul Berger-Bergner, the Stuttgart-born Erich Kahn, and the Polish painter Z. Ruszkowski, who now lives in England, to name but a few, showed clear indications of his influence.

Of Munch, the master, we can say what Cézanne said one day to Gasquet: '*Bien peindre, c'est . . . exprimer son époque dans ce qu'elle a de plus avancé, être au sommet du monde, de l'échelle des hommes.*' To paint well is to express one's own time where it is most progressive, to stand on the summit of the world, on the heights of humanity.

The memorial exhibitions held in various countries from 1944 onwards, the exhibitions of the Munch Bequest in the National Gallery of Oslo in 1946, and the large international exhibitions organized by Oslo Kommunes Kunstsamlinger in practically all the countries of Europe, the United States, the Near East, the Soviet Union, South America, and even in Japan and China have spread the knowledge of Munch's work throughout the world, where by its content no less than by its grandeur it now commands universal respect and admiration.

Notes on the Text

Short Bibliography

List of Illustrations

Index

Notes on the Text

1 Oskar Kokoschka, 'Edvard Munch's Expressionism', *College Art Journal*, Vol. XII, No. 4; Vol. XIII, No. 1. New York 1953/54.

2 Peter and Linda Murray, *Dictionary of Art and Artists*, London 1965.

3 K.E. Schreiner, 'Minner Fra Ekely', *Edvard Munch, Som Vi Kjente Ham. Vennene Forteller.* Oslo 1946.

4 Edvard Munch, *The Frieze of Life*, a pamphlet published in connection with an exhibition at Blomqvist's Gallery in Oslo, 1918.

5 Quoted from Johan H. Langaard and Reidar Revold, *Edvard Munch*, Stuttgart 1963.

6 Edvard Munch, op. cit.

7 See: Jean Cassou, 'Munch en France', *Oslo Kommunes Kunstsamlinger, Årbøker* 1963.

8 In 1889, 1903, 1904, 1905, 1908, 1910 and finally in 1912.

9 Munch painted a strange picture in 1925, *The Sphinx*, as the central figure of *The Human Mountain* which was intended for the murals of the Great Hall of Oslo University. It shows a creature with Munch's own traits and female breasts.

10 *Naerbilde av et geni*, Oslo 1946.

11 'The Art of Edvard Munch and its Function in his Mental Life', *The Psychoanalytical Quarterly*, Vol. XXIII, No. 3. New York 1954.

12 'Edvard Munch', in: *Meaning and Symbol in Three Modern Artists, Edvard Munch, Henry Moore, Paul Nash*, London 1955.

13 Details of these works are given in: Dr Linde's letters to the artist (*Edvard Munch, brev. fra Dr. Med. Max Linde*, Oslo 1954); and Carl Georg Heise: *Edvard Munch, Die vier Söhne des Dr. Max Linde*, Stuttgart 1956.

14 Some of these notes have been published in Langaard and Revold, *Edvard Munch*, op. cit.

15 See: Olav Myre, 'Edvard Munch og Hans Boksamling' in *Oslo Kommunes Kunstsamlinger, Årbøk 1946–1951*, Oslo 1951.

16 Langaard and Revold: *Edvard Munch. Fra År Til År (A Year by Year Record of Edvard Munch's Life)*, Oslo 1961.

17 See: Langaard, *Edvard Munchs Selvportretter*, Oslo 1947.

18 Two volumes (see Bibliography); and *Edvard Munch's graphische Kunst*, Dresden 1923.

19 See: Reidar Revold, 'Omkring en motivgruppe hos Edvard Munch', in *Oslo Kommunes Kunstsamlinger, Årbøk 1952–1959*, Oslo 1960.

20 See: Steinberg and Weiss, 'The Art of Edvard Munch and its Function in his Mental Life', op. cit.

21 *Edvard Munchs brev. Familien*, Oslo 1949.

22 *Edvard Munchs Kriseår*, ed. Erna Homboe-Bang, Oslo 1963.

23 In 1970 the collectors Charlotte and Christian Mustad gave ten important paintings to the National Gallery, which now owns fifty-eight pictures by Munch.

24 G.W. Digby, *Meaning and Symbol*, op. cit.

25 Otto Lous Mohr, *Edvard Munchs Auladekorasjoner I Lys av Ukjente Utkast og Sakens Akter*, Oslo 1960.

26 Gösta Svenaeus, *Idé och Innehåll i Edvard Munchs Konst*, Oslo 1953.

27 Ibid.

28 See: N. Rygg, 'Noen Timmer med Edvard Munch', in: *Edvard Munch, Mennesket og Kunstneren*, Oslo 1946.

29 Svenaeus, op. cit.

30 *Edvard Munch, Mennesket og Kunstneren*, op. cit.; *Edvard Munch Som Vi Kjente Ham. Vennene Forteller*, Oslo 1946; *Edvard Munch og Jappe Nilssen. Etterlatte brev og kritikker*, Oslo 1946.

31 See the preface by Johan H. Langaard (the first director of the Munch Museum) to the catalogue of the opening exhibition of the Museum in Oslo on 29 May 1963 (the centenary year of Munch's birth).

32 See: Eli Ingebretsen Greve's preface to the catalogue of the exhibition: 'Edvard Munchs Tresnitt', March/April 1946, National Gallery, Oslo.

33 Sigurd Willoch, 'Edvard Munch Etchings' in: *The City of Oslo Art Collections*, Munch Museum Series No. 11, Oslo 1950.

34 See: Langaard and Revold, *The Drawings of Edvard Munch*, Oslo 1963.

35 See: Carl Nordenfalk on the Munch exhibition of 1947 in the Swedish periodical *Konstperspektiv*, No. 1, Year 3, appreciated in John H. Langaard's study: 'Edvard Munch's Formler', in *Samtiden*, No. 1, Oslo 1949.

36 Emile Filla, 'Edvard Munch a naše generace' (E.M. and our Generation) in: *Volné Směry*, 1–2, Prague 1938–9.

37 Oskar Kokoschka, 'Edvard Munch's Expressionism', College Art Journal, Vol. XII, No. 1. New York 1953/54.

38 J.P. Hodin, *Oskar Kokoschka, the Artist and his Time*, London 1966.

39 Hans Bisanz, 'Edvard Munch und die Wiener Porträtmalerei nach 1900' in: *Edvard Munch 100 år.* Oslo Kommunes Kunstsamlinger, Årbøk 1963

40 As, for instance, in Kirchner's *Erich Heckel and Model in the Studio* (1905), *Street* (1908–19), *Tavern* (1909), *Marcella* (1909–10), etc; or in graphic works such as *Self-portrait with Pipe* (dry-point, 1908), or *Street in Dresden* (lithograph, 1908), *Nude Dancers* (woodcut, 1904), Schmidt-Rottluff's *Love Scene* (woodcut, 1909) or Nolde's *Sombre Head of a Man* (self-portrait, lithograph, 1907), *The Prophet* (woodcut, 1912), etc; or again, Paula Modersohn-Becker's *The Old Woman* (etching, 1906) or Erich Heckel's *Two Men at the Table* (woodcut, 1913).

41 *Die Malerei im XIX Jahrhundert. Entwicklungsgeschichtliche Darstellung auf Psychologischer Grundlage*, Berlin 1919.

42 Langaard and Revold, *Edvard Munch, Masterpieces from the Artist's Collection in the Munch Museum in Oslo*, Oslo 1964.

43 See: Jaromír Pečírka. *Edvard Munch*, Prague 1939.

44 *Neue Kunst*, Berlin 1921.

45 Max Deri, *Die Malerei im XIX Jahrhundert. Entwicklungsgeschichtliche Darstellung auf Psychologischer Grundlage*, Berlin 1919.

The literature on Edvard Munch, particularly in Norwegian and German, is vast. This short bibliography contains only the most important monographs. A detailed bibliography of books, articles and references to important contributions is contained in: *Oslo Kommunes Kunstsamlinger, Årbøk* 1946–1951, Oslo 1951; in the *Årbøk* 1952–1959, Oslo 1960, and in Ingrid Langaard's *Edvard Munch, Modningsår*, Oslo 1960.

The first pamphlet on the artist, *Das Werk des Edvard Munch*, containing essays by STANISLAW PRZYBYSZEWSKI, FRANZ SERVAES, WILLI PASTOR and JULIUS MEIER-GRAEFE, was published in Berlin in 1894; the first monograph by HERMANN ESSWEIN, followed in 1905 (*Moderne Illustratoren*, VII, Munich and Leipzig); the second by CURT GLASER in 1917 (Berlin). Indispensable for any student of Munch's graphic work are the two volumes by GUSTAV SCHIEFLER: *Verzeichnis des graphischen Werks Edvard Munchs bis 1906* (Berlin, 1907), and: *Edvard Munch, Das graphische Werk, 1906–1926* (Berlin 1928). POLA GAUGUIN published in 1946 an important book on Munch's graphic work: *Grafikeren Edvard Munch. I Lithografier, II Tresnitt og Raderinger* (Trondheim). See also, OLE SARVIG, *Edvard Munchs Grafikk*, Copenhagen 1948 (also German edition) and WERNER TIMM, *Edvard Munch Graphik*, Berlin 1969

(English edition, *The Graphic Art of Edvard Munch*, London 1969).

Two major biographies were published in Norway to celebrate Munch's seventieth birthday: JENS THIIS: *Edvard Munch og hans samtid* (shortened German edition, Berlin 1934), and POLA GAUGUIN: *Edvard Munch* (both Oslo 1933). J.P. HODIN, *Edvard Munch. Der Genius des Nordens* (with extensive bibliography) was published in Stockholm 1948 (Swedish edition *Edvard Munch. Nordens Genius*, revised German edition, Mainz 1963). HANS EGON GERLACH published in 1955 the monograph: *Edvard Munch. Sein Leben und sein Werk* (Hamburg). ROLF STENERSEN's *Edvard Munch, Naerbild av ett geni* (Stockholm, 1944, Copenhagen, 1945, Oslo 1945/6). English edition: *Close-up of a Genius*, Oslo 1954) contains personal reminiscences. So do the following volumes: *Edvard Munch, Som Vi Kjente Ham. Vennene forteller*, Oslo 1946; *Edvard Munch og Jappe Nilssen. Etterlatte brev og kritikker*, Oslo 1946 and *Edvard Munchs brev. Familien*, Oslo 1949.

Important single aspects of Munch's art are dealt with in: JOHAN H. LANGAARD, *Edvard Munchs Selvportretter*, Oslo 1947; SIGURD WILLOCH, *Edvard Munchs raderinger*, Oslo 1950 (English edition: *Edvard Munch, Etchings*, Oslo 1950); GÖSTA SVENAEUS, *Idé och innehåll i Edvard Munchs Konst. En analys av Aulamålningarna*, Oslo 1953; GEORGE WINGFIELD DIGBY, *Meaning and Symbol in Three Modern Artists. Edvard Munch, Henry Moore, Paul Nash*, London 1955; JOHAN H. LANGAARD and REIDAR REVOLD, *Edvard Munch som tegner* (*The Drawings of Edvard Munch*), Oslo 1958, and INGRID LANGAARD, *Edvard Munch Modningsår*, a study of his early Expressionist and Symbolist work, Oslo 1960.

The first book published on Munch in English is FREDERICK B. DEKNATEL'S *Edvard Munch*, London and New York 1950. It is the study for the catalogue of the first large travelling exhibition of Munch's work in the United States after the war. ARVE MOEN published his three volumes *Edvard Munch, Graphic Art and Paintings* (*Age and Milieu, Woman and Eros, Nature and Animals*) in Oslo in 1956–8. STEPHAN TSCHUDI MADSEN, *An Introduction to Edvard Munch's Wall Paintings in the Oslo University Aula* was published in Oslo, 1959. In 1960 appeared in London and Cologne *Edvard Munch* with a preface by OTTO BENESCH. JOHAN H. LANGAARD and REIDAR REVOLD: *A Year by Year Record of Edvard Munch's Life* (Oslo, 1961) is a most useful handbook for the student. The same authors published *Edvard Munch, The University Murals*, Oslo 1961, and *Edvard Munch, Masterpieces from the Artist's Collection in the Munch Museum in Oslo*, Oslo 1964 (Norwegian and German, 1963).

List of Illustrations

Measurements are in inches and centimetres, height preceding width. The abbreviation Sch. refers to Schiefler's *catalogue raisonné* of Munch's graphic work (see Bibliography).

1 *The Voice* (detail), 1893. Oil on canvas $43\frac{1}{4} \times 35\frac{5}{8}$ (110 × 88). Courtesy, Museum of Fine Arts, Boston. Ellen Kelleran Gardner Fund

2 *The Lovers*, 1896. Lithograph $12\frac{1}{4} \times 16\frac{1}{2}$ (31 × 42). Sch. 71

3 *The Sick Child* (detail), 1885–6. Oil on canvas $47\frac{1}{16} \times 46\frac{11}{16}$ (119·5 × 118·5). Oslo, National Gallery

4 *From Bygdøy*, 1881. Pencil drawing $3\frac{15}{16} \times 6\frac{3}{4}$ (10·2 × 17·1). Oslo,

Municipal Museum (Munch Museum)

5 *Karen Bjølstad*, 1884. Oil on canvas $18\frac{1}{2} \times 16\frac{1}{8}$ (47 × 41). Oslo, Private collection

6 *Self-portrait*, 1881–2. Oil on canvas $9\frac{1}{16} \times 7\frac{7}{8}$ (23·5 × 20). Oslo, Municipal Museum (Munch Museum)

7 *Girl sitting on the Edge of her Bed (Morning)*, 1884. Oil on canvas $37\frac{15}{16} \times 40\frac{11}{16}$ (96·5 × 103·5). Bergen, Collection Rasmus Meyer

8 *Family Evening*, 1884. Oil on canvas $10\frac{5}{8} \times 15\frac{9}{16}$ (27 × 39·5). Oslo, National Gallery

9 *Sister Inger*, 1884. Oil on canvas $38\frac{1}{8} \times 26\frac{3}{8}$ (97 × 67). Oslo, National Gallery

10 *Munch's father*, 1883. Oil on paper $8\frac{7}{16} \times 7\frac{1}{16}$ (21·5 × 17·5). Oslo, Municipal Museum (Munch Museum)

11 *Jørgen Sørensen*, 1885. Oil on canvas $34\frac{3}{16} \times 11\frac{3}{4}$ (56·5 × 30). Oslo, National Gallery

12 *Net Mending*, 1888. Oil on canvas $17\frac{1}{4} \times 31\frac{7}{8}$ (54 × 81). Oslo, National Gallery

13 *Landscape*, 1880. Present whereabouts unknown

211

14 *The Sick Child*, 1885–6. Oil on canvas 47$\frac{1}{16}$ × 46$\frac{11}{16}$ (119·5 × 118·5). Oslo, National Gallery

15 *Spring* (detail), 1889

16 *Spring*, 1889. Oil on canvas 66$\frac{1}{2}$ × 103$\frac{11}{16}$ (169 × 263·5). Oslo, National Gallery

17 *Afternoon at Olaf Ryes Square*, 1884. Oil on canvas 18$\frac{7}{8}$ × 9$\frac{7}{8}$ (48 × 25). Stockholm, National Museum

18 *Street Scene.* Present whereabouts unknown

19 *Sister Laura*, 1888. Oil on canvas 29$\frac{1}{8}$ × 39$\frac{3}{8}$ (74 × 100). Bergen, Collection Rasmus Meyer

20 *Inger on the Shore*, 1889. Oil on canvas 49$\frac{3}{4}$ × 63$\frac{5}{8}$ (126·4 × 161·7). Bergen, Collection Rasmus Meyer

21 *Hans Jaeger*, 1889. Oil on canvas 43 × 33$\frac{1}{8}$ (109·5 × 84). Oslo, National Gallery

22 *Tête-à-Tête*, 1885. Oil on canvas 25$\frac{13}{16}$ × 29$\frac{11}{16}$ (65·5 × 75·5). Oslo, Municipal Museum (Munch Museum)

23 *The Men of Letters*, 1887. Oil on canvas 31$\frac{7}{8}$ × 49$\frac{1}{4}$ (81 × 125). Oslo, Private collection

24 *Portrait of the Painter Jensen-Hjell*, 1885. Oil on canvas 74$\frac{3}{4}$ × 39$\frac{3}{8}$ (190 × 100). Oslo, Private collection

25 *Dansemoro*, 1885. Oil on canvas 11$\frac{3}{8}$ × 15$\frac{3}{8}$ (29 × 39). Oslo, National Gallery

26 *Music on Karl Johan Street*, 1889. Oil on canvas 40$\frac{1}{8}$ × 55$\frac{11}{16}$ (102 × 141·5). Zürich, Kunsthaus

27 *Spring Day on Karl Johan*, 1891. Oil on canvas 31$\frac{1}{2}$ × 39$\frac{3}{8}$ (80 × 100). Bergen, Billedgalleri

28 *Spring Evening on Karl Johan*, 1892. Oil on canvas 33$\frac{1}{8}$ × 47$\frac{5}{8}$ (84·5 × 121). Bergen, Collection Rasmus Meyer

29 *Eventide*, 1889. Oil on canvas 59 × 76$\frac{3}{4}$ (150 × 195). Copenhagen, State Museum of Art

30 *Self-portrait*, 1886. Oil on canvas 12$\frac{5}{8}$ × 9 (32 × 23). Oslo, National Gallery

31 *Rue Lafayette*, 1891. Oil on canvas 36$\frac{1}{4}$ × 28$\frac{3}{4}$ (92 × 73). Oslo, National Gallery

32 *Moonlit Night in Nice*, 1891. Oil on canvas 18$\frac{7}{8}$ × 21$\frac{1}{4}$ (48 × 54). Oslo, National Gallery

33 *Gambling-hall in Monte Carlo*, 1892. Oil on canvas 21$\frac{1}{4}$ × 25$\frac{5}{8}$ (54 × 65). Oslo, Municipal Museum (Munch Museum)

34 *Night in Saint-Cloud*, 1890. Oil on canvas 25$\frac{7}{16}$ × 21$\frac{1}{4}$ (64·5 × 54). Oslo, National Gallery

35 *The Day After*, 1894–5. Oil on canvas 45$\frac{1}{4}$ × 59$\frac{7}{8}$ (115 × 152). Oslo, National Gallery

36 *Evening (The Yellow Boat)*, 1891–3. Oil on canvas 25$\frac{5}{8}$ × 37$\frac{3}{4}$ (65 × 96). Oslo, National Gallery

37 *The Scream*, 1893. Oil on cardboard 35$\frac{7}{8}$ × 28$\frac{15}{16}$ (91 × 73·5). Oslo, National Gallery

38 *Madonna*, 1893. Oil on canvas 35$\frac{7}{8}$ × 27$\frac{13}{16}$ (91 × 70·5). Oslo, National Gallery

39 *Ashes*, 1894. Oil on canvas 47$\frac{7}{16}$ × 55$\frac{1}{2}$ (120·5 × 141). Oslo, National Gallery

40 *The Three Stages of Woman*, 1894. Oil on canvas 64$\frac{5}{8}$ × 98$\frac{3}{8}$ (164 × 250). Bergen, Collection Rasmus Meyer

41 *Vampire*, 1893. Oil on canvas 31$\frac{1}{2}$ × 39$\frac{3}{8}$ (80 × 100). Gothenburg, Museum of Art

42 *Death and the Maiden*, 1893. Oil on canvas 50$\frac{3}{8}$ × 33$\frac{7}{8}$ (128 × 86). Oslo, Municipal Museum (Munch Museum)

43 *Puberty*, 1895. Oil on canvas 59 × 43$\frac{3}{4}$ (150 × 111). Oslo, National Gallery

44 *The Sick Child*, 1896. Lithograph 16$\frac{1}{2}$ × 22$\frac{1}{8}$ (42 × 56·5). Sch. 59d

45 *Sister Inger*, 1892. Oil on canvas 67$\frac{3}{4}$ × 60$\frac{5}{16}$ (172 × 122·5). Oslo, National Gallery

46 *Stanislaw Przybyszewski*, 1895. Pastel 24$\frac{3}{8}$ × 21$\frac{5}{8}$ (62 × 55). Oslo, Municipal Museum (Munch Museum)

47 *Dagny Juell (Ducha)*, 1893. Oil on canvas 58$\frac{15}{16}$ × 44$\frac{1}{8}$ (149·8 × 112). Oslo, Municipal Museum (Munch Museum)

48 *Jealousy*, 1895. Oil on canvas 26$\frac{5}{16}$ × 39$\frac{3}{8}$ (66·8 × 100). Bergen, Collection Rasmus Meyer

49 *Starlit Night*, 1893. Oil on canvas 53$\frac{1}{8}$ × 55$\frac{1}{8}$ (135 × 140). Oslo, Private collection

50 *Self-portrait with Burning Cigarette*, 1895. Oil on canvas 43$\frac{1}{4}$ × 33$\frac{11}{16}$ (110 × 85·5). Oslo, National Gallery

51 *Madonna*, 1895/1902. Lithograph 35$\frac{7}{8}$ × 17$\frac{1}{2}$ (60·7 × 44·3). Sch. 33A II b

52 *August Strindberg*, 1896. Lithograph 24 × 18$\frac{1}{8}$ (61 × 46). Sch. 75 II

53 *The Scream*, 1895. Lithograph 13$\frac{3}{4}$ × 9$\frac{7}{8}$ (35 × 25·2). Sch. 32

54 *The Kiss*, 1895. Dry-point and aquatint 13$\frac{3}{8}$ × 11 (34·8 × 28). Sch. 22 b

55 Programme for Ibsen's *Peer Gynt*, Paris, 1896. Lithograph 9$\frac{7}{8}$ × 11$\frac{11}{16}$ (25 × 29·8). Sch. 74

56 *The Maiden and the Heart*, 1896. Etching 9$\frac{1}{4}$ × 9$\frac{5}{16}$ (23·6 × 23·7). Sch. 48

57 *Self-portrait with Skeleton Arm*, 1895. Lithograph 17$\frac{9}{16}$ × 12$\frac{1}{2}$ (45·5 × 31·7). Sch. 31

58 *Moonrise (Alpha and Omega)*, 1909. Lithograph 8$\frac{1}{4}$ × 17$\frac{1}{16}$ (21 × 43·5). Sch. 311

59 *Omega and the Bear*, 1909. Lithograph 7$\frac{7}{8}$ × 7$\frac{11}{16}$ (20 × 19·5). Sch. 315

60 *Despair (Alpha and Omega)*, 1909. Lithograph 16$\frac{1}{2}$ × 13 (42 × 33). Sch. 325

61 *The Woman and the Urn*, 1896. Etching 18$\frac{1}{8}$ × 10$\frac{7}{16}$ (46 × 26·5). Sch. 63

62 *Under the Yoke*, 1896. Etching 13 × 9$\frac{1}{4}$ (33 × 23·6). Sch. 42

63 *The Lonely Ones (Two People)*, 1895. Dry-point 8$\frac{7}{8}$ × 10$\frac{1}{2}$ (22·8 × 26·7). Sch. 20 V b

64 *Stormy Night*, 1893. Oil on canvas 38$\frac{5}{8}$ × 50 (98 × 127). Oslo, National Gallery

65 *Allegory (Hemanthus)*, 1898. Woodcut 18$\frac{5}{16}$ × 13 (46·5 × 33). Sch. 114

66 *The Dead Mother and the Child*, 1899–1900. Oil on canvas 39$\frac{3}{8}$ × 35$\frac{3}{8}$ (100 × 90). Bremen, Kunsthalle

67 *Death in the Sick Chamber*, 1892. Casein and crayon 59 × 65$\frac{9}{16}$

212

(150 × 167·5). Oslo, National Gallery

68 *Dr Schreiner and Munch*, 1930. Lithograph 29⅛ × 21⅝ (74 × 55). Munch Museum 551

69 *Self-portrait with Wine Bottle*, 1906. Oil on canvas 43¼ × 47¼ (110 × 120). Oslo, Municipal Museum (Munch Museum)

70 *Virginia Creeper*, 1898. Oil on canvas 47¼ × 47¼ (120 × 120). Oslo, Municipal Museum (Munch Museum)

71 *Mother and Daughter*, 1897. Oil on canvas 53⅛ × 64⅛ (135 × 163). Oslo, National Gallery

72 *The Dance of Life*, 1900 (signed and dated bottom left 1899, dated upper right 1900). Oil on canvas 49⁷⁄₁₆ × 74¹⁵⁄₁₆ (125·5 × 190·5). Oslo, National Gallery

73 *Three Children*, 1905. Oil on canvas 51⅝ × 43¾ (131 × 111). Stockholm, Thielska Gallery

74 *White Night*, 1901. Oil on canvas 45¼ × 43¼ (115 × 110). Oslo, National Gallery

75. *Girls on the Bridge*, 1899. Oil on canvas 53½ × 49⅝ (136 × 126). Oslo, National Gallery

76 *The Four Sons of Dr Linde*, 1903. Oil on canvas 56¾ × 78⁹⁄₁₆ (144 × 199·5). Lübeck Museum

77 *Road in Åsgårdstrand*, 1902. Oil on canvas 34½ × 44¾ (88 × 114). Basel, Collection Schwarz-von Spreckelsen

78 *Bathing Men*, 1907–8. Oil on canvas 79⅞ × 90½ (203 × 230). Oslo, Municipal Museum (Munch Museum)

79 *Nude near the Bed, c.* 1907. Oil on canvas 47¼ × 47⅝ (120 × 121). Oslo, Municipal Museum (Munch Museum)

80 *Aase and Harald Nørregaard*, 1899. Oil on canvas 19¼ × 29½ (49 × 75). Oslo, National Gallery

81 *The Frenchman (M. Archinard)*, 1901. Oil on canvas 72⅞ × 27⅝ (185 × 70). Oslo, National Gallery

82 *The German (Hermann Schlittgen)*, 1901. Oil on canvas 78¾ × 47¼ (200 × 120). Oslo, Municipal Museum (Munch Museum).

83 *Melancholy*, 1900. Oil on canvas 43¼ × 49⅝ (110 × 126). Oslo, Municipal Museum (Munch Museum)

84 *Amor and Psyche*, 1907. Oil on canvas 46½ × 39 (118 × 99). Oslo, Municipal Museum (Munch Museum)

85 *Zum Süssen Mädel (At the Sign of the Sweet Girl)*, 1907. Oil on canvas 33½ × 51⅛ (85 × 130). Oslo, Municipal Museum (Munch Museum)

86 *Walter Rathenau*, 1907. Oil on canvas 86⅝ × 43¼ (220 × 110). Bergen, Collection Rasmus Meyer

87 *Workers returning Home*, 1915. Oil on canvas 79½ × 90½ (202 × 230). Oslo, Municipal Museum (Munch Museum)

88 *Mason and Mechanic*, 1908. Oil on canvas 35⅜ × 26⅛ (90 × 68·5). Oslo, Municipal Museum (Munch Museum)

89 *Uninvited Guests, c.* 1905. Oil on canvas 29½ × 39¾ (75 × 101). Oslo, Municipal Museum (Munch Museum)

90 *Death of Marat I*, 1906. Oil on canvas 59 × 78¾ (150 × 200). Oslo, Municipal Museum (Munch Museum)

91 *Dr Daniel Jacobsen*, 1909. Oil on canvas 80¼ × 44⅛ (204 × 112). Oslo, Municipal Museum (Munch Museum)

92 *Helge Rode*, 1909. Oil on canvas 78 × 37¾ (198 × 96). Stockholm, National Museum

93 *Self-portrait*, 1909. Oil on canvas 23⅝ × 35⅜ (60 × 90). Bergen, Collection Rasmus Meyer

94 *The Rich Man*, 1911. Lithograph 12⅝ × 17⅛₆ (32 × 43·5). Sch. 344

95 *Thanks to Society*, 1899. Lithograph 15¾ × 20¹¹⁄₁₆ (40 × 52·5). Sch. 121

96 *The Critic*, 1911. Lithograph 8⅝ × 5½ (22 × 14). Sch. 346

97 *Tiger*, 1909. Lithograph 13¾ × 10¹⁄₁₆ (35 × 25·5). Sch. 288 b

98 *Flamingoes*, 1908–9. Lithograph 6¾ × 13¾ (17 × 35). Sch. 299

99 *Jappe Nilssen*, 1909. Oil on canvas 58 × 36⅝ (193 × 93). Oslo, Municipal Museum (Munch Museum)

100 *Workers in the Snow*, 1912. Oil on canvas 64⅛ × 78¾ (163 × 200). Oslo, Municipal Museum (Munch Museum)

101 *Snow Shovellers*, 1913. Oil on canvas 37⅜ × 29⅛ (95 × 74). Formerly Berlin, National Gallery

102 *Two Old Men*, 1910. Oil on canvas. Stockholm, Valdemarsudde (Prins Eugen)

103 *Ploughing (Two Horse Team)*, 1919. Oil on canvas 39⅜ × 49¼ (100 × 125). Oslo, Municipal Museum (Munch Museum)

104 *Man in the Cabbage Field*, 1916. Oil on canvas 53½ × 70⅞ (136 × 180). Oslo, National Gallery

105 *Galloping Horse*, 1912. Oil on canvas 58¼ × 47¼ (148 × 120). Oslo, Municipal Museum (Munch Museum)

106 Panel decorating the Great Hall, Oslo University, 1909–11. Oil on canvas 14 ft 10 in × 7 ft 5 in (4·52 × 2·26 m.).

107 *Funeral March*, 1897. Lithograph 21⅝ × 14⅝ (55·5 × 37). Sch. 94

108 Study for *The Human Mountain*, *c.* 1910. Oil on canvas 117¾ × 165 (298 × 419). Oslo, Municipal Museum (Munch Museum)

109 *The Tree*, 1915. Lithograph 8¼ × 13¹⁵⁄₁₆ (21 × 35·5). Sch. 433

110 *History*, 1909–11. Oil on canvas 14 ft 10 in × 38 ft 4¾ in (4·52 × 11·65 m.). Oslo University

111 *The Researchers*, 1909–11. Oil on canvas 14 ft 10 in × 38 ft 4¾ in (4·52 × 11·65 m.). Oslo, Municipal Museum (Munch Museum)

112 *Alma Mater*, 1909–11. Oil on canvas 14 ft 11⅛ in × 38 ft (4·55 × 11·60 m.). Oslo University

113 *The Sun*, 1909–11. Oil on canvas 14 ft 10 in × 25 ft 10¼ in (4·52 × 7·88 m.). Oslo University

114 *Winter, Kragerø*, 1915. Oil on canvas 40½ × 50⅝ (103 × 128). Oslo, National Gallery

115 *The Night Wanderer (Peer Gynt)*, 1939. Oil on canvas 35⅝ × 26¾ (90 × 68). Oslo, Municipal Museum (Munch Museum)

116 *The Bohemian's Wedding*, 1926. Oil on canvas 19¼ × 24 (49 × 61). Oslo, Municipal Museum (Munch Museum)

213

117 Self-portrait, 1919. Oil on canvas 59$\frac{1}{16}$ × 51$\frac{5}{8}$ (150·5 × 131). Oslo, National Gallery

118 Self-portrait in Ekely, 1926. Oil on canvas 35$\frac{3}{8}$ × 26$\frac{3}{4}$ (90 × 68). Hamburg, Kunsthalle

119 Cod Lunch, 1940. Oil on panel 18$\frac{1}{8}$ × 13$\frac{3}{8}$ (46 × 34). Oslo, Municipal Museum (Munch Museum)

120 By the Window, 1942. Oil on canvas 37$\frac{3}{8}$ × 43$\frac{1}{4}$ (95 × 110). Oslo, Municipal Museum (Munch Museum)

121 Between Clock and Bed, 1940. Oil on canvas 67$\frac{3}{8}$ × 47$\frac{5}{8}$ (171 × 121). Oslo, Municipal Museum (Munch Museum)

122 Lucien Dedichen and Jappe Nilssen, 1926. Oil on canvas 62$\frac{13}{16}$ × 52$\frac{15}{16}$ (159·5 × 134·5). Oslo, Municipal Museum (Munch Museum)

123 Model on the Sofa, 1928. Oil on canvas 55$\frac{1}{8}$ × 46$\frac{1}{2}$ (140 × 118). Oslo, Municipal Museum (Munch Museum)

124 Composition for the Council Chamber, Oslo Town Hall (unfinished), 1935–44. Oil on canvas, c. 11 ft 1 in × 18 ft 8 in (c. 3·40 × 5·70 m). Oslo, Municipal Museum (Munch Museum)

125 Freia Frieze, 1922. Oil on canvas 52$\frac{3}{4}$ × 96$\frac{1}{2}$ (134 × 245). Oslo, Freia Chocolade Fabrik

126 Spring Ploughing, 1916. Oil on canvas 33$\frac{1}{8}$ × 42$\frac{7}{8}$ (84 × 109). Oslo, Municipal Museum (Munch Museum)

127 The Tramp, 1908–9. Woodcut 12 × 8$\frac{7}{16}$ (33 × 21·5). Sch. 340

128 Freia Frieze, 1922. Oil on canvas 52$\frac{3}{4}$ × 126 (134 × 320). Oslo, Freia Chocolade Fabrik

129 Freia Frieze, 1922. Oil on canvas 52$\frac{3}{4}$ × 76$\frac{3}{4}$ (134 × 195). Oslo, Freia Chocolade Fabrik

130 Model beside the Armchair, 1929. Oil on canvas 47$\frac{1}{4}$ × 39$\frac{3}{8}$ (120 × 100)., Oslo, Municipal Museum (Munch Museum)

131 The Murderer, c. 1910. Oil on canvas 37$\frac{3}{16}$ × 60$\frac{5}{8}$ (94·5 × 154). Oslo, Municipal Museum (Munch Museum)

132 The Brawl, c. 1905. Etching 14$\frac{5}{8}$ × 15$\frac{3}{8}$ (37 × 39). Sigurd Willoch cat. 184

133 Mephistopheles II. Split Personality, 1935. Oil on canvas 41$\frac{3}{8}$ × 66$\frac{7}{8}$ (105 × 170). Oslo, Municipal Museum (Munch Museum)

134 The Duel (Mephistopheles I), 1935. Oil on canvas 41$\frac{3}{8}$ × 47$\frac{1}{4}$ (105 × 120). Oslo, Municipal Museum (Munch Museum)

135 Explosion in the Neighbourhood, 1944. Oil on canvas 23$\frac{5}{8}$ × 31$\frac{1}{2}$ (60 × 80). Oslo, Municipal Museum (Munch Museum)

136 Two Women on the Beach, 1898. Woodcut 17$\frac{3}{4}$ × 19$\frac{5}{8}$ (45·5 × 50·8). Sch. 117 b

137 Melancholy (Evening), 1896. Woodcut 14$\frac{7}{8}$ × 17$\frac{15}{16}$ (37·6 × 45·5). Sch. 82

138 The Kiss, 1902. Woodcut 17$\frac{1}{2}$ × 17$\frac{1}{2}$ (44·7 × 44·7). Sch. 102 D

139 Moonlight, 1895. Etching 16$\frac{3}{16}$ × 18$\frac{5}{16}$ (41·2 × 46·5). Sch. 81 Ac 2

140 The Mountain Path, 1910. Woodcut 23$\frac{5}{8}$ × 19$\frac{7}{16}$ (60 × 49·5). Sch. 349

141 Death and the Maiden, 1894. Drypoint 11$\frac{13}{16}$ × 8$\frac{5}{8}$ (30·2 × 22). Sch. 3 II b

142 Consolation, 1894. Etching 8$\frac{3}{16}$ × 12$\frac{3}{16}$ (20·8 × 30·9). Sch. 6

143 Girls on the Bridge, 1903. Etching with aquatint 7$\frac{1}{8}$ × 9$\frac{7}{8}$ (18 × 25). Sch. 200 III

144 Sighbjørn Obstfelder, 1896. Lithograph 14$\frac{1}{8}$ × 10$\frac{13}{16}$ (36 × 27·5).

145 Jens Thiis, 1913. Lithograph 11$\frac{9}{16}$ × 10$\frac{1}{16}$ (29·5 × 25·5). Sch. 410

146 The Dance of Death, 1915. Lithograph 19$\frac{1}{4}$ × 11$\frac{3}{8}$ (49 × 29). Sch. 432

147 Death Struggle, 1896. Lithograph 15$\frac{3}{4}$ × 19$\frac{5}{8}$ (40 × 50). Sch. 72

148 Release, 1896. Lithograph 16$\frac{1}{8}$ × 25$\frac{1}{4}$ (41·7 × 64·5). Sch. 68 a

149 Attraction, 1896. Lithograph 18$\frac{9}{16}$ × 13$\frac{15}{16}$ (47·2 × 35·5). Sch. 65

150 Ibsen in the Grand Café, 1902. Lithograph 16$\frac{1}{2}$ × 22$\frac{7}{8}$ (42 × 58). Sch. 171

151 The Lady with the Brooch, 1903. Lithograph 23$\frac{5}{8}$ × 18$\frac{1}{8}$ (60 × 46). Sch. 212

152 Vampire, 1895. Lithograph

153 The Death Chamber, 1896. Lithograph 15$\frac{3}{16}$ × 21$\frac{13}{16}$ (38·5 × 55). Sch. 73

154 Starry Night, 1923. Charcoal 27$\frac{5}{8}$ × 24$\frac{9}{16}$ (70 × 62·5). Oslo, Municipal Museum (Munch Museum)

155 Adieu, 1892. Pencil 10$\frac{5}{8}$ × 8$\frac{1}{8}$ (27 × 20·7). Oslo, Municipal Museum (Munch Museum)

156 Study for Death in the Sick Chamber, c. 1892. Charcoal, watercolour and pencil 14$\frac{5}{8}$ × 19$\frac{3}{8}$ (37 × 49·2). Oslo, Municipal Museum (Munch Museum)

157 Study for Madonna, 1894. Charcoal 24$\frac{3}{16}$ × 18$\frac{9}{16}$ (61·5 × 47·1). Oslo, Municipal Museum (Munch Museum)

158 Study for Death Struggle, 1895. Charcoal 16$\frac{9}{16}$ × 18$\frac{15}{16}$ (42·1 × 48·2). Oslo, Municipal Museum (Munch Museum)

159 Study for Death Struggle, 1895. Ink and watercolour 12$\frac{1}{2}$ × 13$\frac{11}{16}$ (31·6 × 34·8). Oslo, Municipal Museum (Munch Museum)

160 Sketch for Boys Bathing, c. 1895. Pencil and watercolour 13$\frac{3}{8}$ × 19$\frac{3}{4}$ (33·9 × 50·4). Oslo, Municipal Museum (Munch Museum)

161 Boys Bathing, 1895. Oil on canvas 36$\frac{1}{4}$ × 59 (92 × 150). Oslo, National Gallery

162 Model Undressing, c. 1918. Watercolour and crayon 13$\frac{7}{8}$ × 10$\frac{1}{16}$ (35·3 × 25·7). Oslo, Municipal Museum (Munch Museum)

163 Women on the Bridge, 1903. Oil on canvas 79$\frac{7}{8}$ × 88$\frac{1}{2}$ (203 × 230). Stockholm, Thielska Gallery

164 The Village Street, 1905. Oil on canvas 39$\frac{3}{8}$ × 41$\frac{3}{4}$ (100 × 106). Oslo, Municipal Museum (Munch Museum)

165 Munch in his studio at Ekely, 1938. Photo O. Væring

166 The open-air studio, Ekely. Photo O. Væring

167 The Gothic Girl, 1931. Colour woodcut 23$\frac{5}{8}$ × 12$\frac{5}{8}$ (60 × 32·2). Munch Museum 703

168 Old Man (Primitive Man), 1905. Woodcut 27 × 20 (68·7 × 45·6). Sch. 237

Index

Andersen, Hans Christian 36

Bacon, Francis 9
Balzac, Honoré de 94
Bang, Herman 36
Baudelaire, Charles 36, 38, 73, 81, 99
Beckmann, Max 207
Berger-Bergner, Paul 208
Bergson, Henri 36, 95
Bernard, Emile 52
Bjølstad, Karen 12, 15, 121, 166; 5
Bjørnson, Bjørnstjerne 45, 50, 107
Böcklin, Arnold 59, 137
Bødtker, Sigurd 42, 88
Bonnard, Pierre 52, 73, 139, 198
Bonnat, Léon 45, 50, 189
Brandes, Georg 36, 107
Brunner, V. H. 208
Buffon, Georges Louis Leclerc 202
Büttner, Erich 78

Čapek, Josef 208
Carrière, Eugène 52
Cassirer, Paul 62, 103
Cézanne, Paul 29, 36, 208
Chagall, Marc 9
Clot, Auguste 79, 169, 180–1
Corinth, Lovis 9
Courbet, Gustave 27
Couture, Thomas 45, 51

Dahl, J. C. 27–8
Darwin, Charles 33
Daumier, Honoré 169
Degas, Edgar 52, 169
Dehmel, Richard 62, 68
Deri, Max 207–8
Dickens, Charles 36, 107
Diderot, Denis 94
Digby, G. W. 95–8
Diriks, C. F. 14
Dostoevsky, Feodor Mikhailovich 34, 36, 38, 106, 205
Dürer, Albrecht 169, 186

Ensor, James 9
Eriksen, Børre 147

Faure, Elie 79
Fichte, Johann Gottlieb 33
Filla, Emile 206, 208
Forain, Jean Louis 180
Förster-Nietzsche, Elisabeth 107, 200
Freud, Sigmund 95, 100

Gallén, Axel 62, 68
Garborg, Arne 50
Gasquet, J. 208
Gauguin, Paul 29, 52, 112
Gauguin, Pola 112, 166
Gerstl, Richard 206
Gide, André 107
Gierlöff, Christian 92, 114, 125, 128, 174, 177, 198–202
Glaser, Elsa 134
Goethe, Johann Wolfgang von 107, 164
Goldstein, Emanuel 45, 125, 128, 177
Gotsch, Friedrich-Karl 208
Goya, Francisco 9, 52, 101, 108, 128, 169, 186
Greco, El 9
Grünewald, Mathias 9
Gude, Hans 27

Hals, Frans 128
Hamsun, Knut 36, 166, 177, 205
Heckel, Erich 207
Hegel, Georg Wilhelm Friedrich 33
Heiberg, Jean 28
Heine, Heinrich 62
Hettner, Otto 78
Heyerdahl, Hans 27
Hodler, Ferdinand 59
Hoffmann, Ernst Theodor Amadeus 62
Hoffmann, Ludwig von 103
Hokusai 169, 186
Hoppe, Dr Ragnar 106, 186, 198
Huysmans, Joris Karl 66

Ibsen, Henrik 36, 38, 50, 59, 73–4, 106–7, 114, 205; 150
Isaachsen, Olaf 27

Jacobson, Dr Daniel 121, 123, 128; 91
Jacobsen, Jens Peter 36, 205
Jaeger, Hans 33, 34, 36, 106, 108, 147; 21
Jensen-Hjell, Karl 36; 24
Josephson, Ernst 9
Juell, Dagny 64, 66, 68–70, 147; 47
Jung, Carl Gustav 8, 95–6, 98
Justi, Ludwig 208

Kahn, Erich 208
Karsten, Ludwig 114, 164
Kessler, Count Harry 104
Kierkegaard, Søren 36, 38, 48, 106–7
Kirchner, Ernst Ludwig 207
Kittelsen, Theodor 27
Klimt, Gustav 206
Klinger, Max 59, 137, 179

Kokoschka, Oskar 7–9, 88, 169, 206–8
Kollmann, Albert 62, 103, 114, 177
Köpping, Karl 179
Kratochvil, Zdeněk 208
Krohg, Christian, 20, 22, 28, 30–1, 34, 50, 160
Krohg, Per 160
Kropotkin, Prince Peter Alexeivich 33

Langaard, Johan H. 207
Leistikow, Walter 103
Liebermann, Max 61, 179
Linde, Dr Max 59, 62, 103–4, 174, 177; family 103–4; 76
Løchen, Kalle 20

Mallarmé, Stéphane 36, 38, 73, 177
Manet, Edouard 31, 128, 169, 198
Marx, Karl 33
Matisse, Henri 28
Meidner, Ludwig 207
Michelangelo Buonarroti 9, 107, 189, 198, 206
Middelthun, Julius 20
Meier-Graefe, Julius 30, 62, 64, 70, 73
Millet, Jean-François 133
Monet, Claude 51
Mudocci, Eva 184
Mueller, Otto 207
Munch, Andreas 11
Munch, Andreas (Munch's brother) 16, 90
Munch, Christian (Munch's father) 11–13, 15, 35, 45, 90; 10
Munch, Inger 16, 38, 42, 166; 9, 20, 45
Munch, Jacob 11
Munch, Bishop Johan Storm 11, 15
Munch, Johanne Sophie 12, 22
Munch, Laura 38, 118, 166; 19
Munch, Laura Catherine (Munch's mother), 11–12, 90, 98
Munch, Peter Andreas 11, 160

Natanson, Thadée 73
Nay, Ernst Wilhelm 166
Nietzsche, Friedrich 33, 36, 38, 81, 94, 99, 104–7, 137
Nilssen, Jappe 111, 121, 128, 154; 99, 122
Nolde, Emil 207
Normann, Adelsten 50

Obstfelder, Sigbjørn 62, 68–70, 108, 177; 144

Pastor, Willy 70

Paul, Adolf 62, 64
Pechstein, Max 207
Perls, Kaethe 134
Peterssen, Eilif 27, 31
Picasso, Pablo 207
Pissarro, Camille 51
Preisler, Jan 208
Procházka, Antonin 208
Proust, Marcel 95
Przybyszewski, Dagny *see* Juell
Przybyszewski, Stanislaw 62, 68–70, 81, 99–
100, 147; *46*

Raffaelli, Jean François 50
Rathenau, Walter 62, 112; *86*
Redon, Odilon 52, 169
Reinhardt, Max 59, 186
Rembrandt van Rijn 9, 52, 101, 151, 169, 186,
189, 206
Renoir, Pierre-Auguste 52, 128
Revold, Axel 28, 160
Revold, Reidar 207
Riegl, Alois 9
Rilke, Rainer Maria 36
Rimbaud, Arthur 36
Rode, Helge 123, 128, 177; *92*
Rodin, Auguste 52, 169
Rolfsen, Alf 160
Rops, Félicien 66, 81, 99, 169
Rouault, Georges 9, 207
Rubens, Peter Paul 128

Ruszkowski, Z. 208

Šalda, F. X. 99
Schiefler, Gustav 114
Schiele, Egon 206
Schlittgen, Hermann 62, 114; *82*
Schmidt-Rottluff, Karl 207
Schopenhauer, Arthur 86, 99
Schou, Olaf 127
Schreiner, Dr K. E. 11, 95; *68*
Servaes, Franz 70
Seurat, Georges 198
Skredswig, Christian 27
Slevinski, W. 207
Sørensen, Henrik 28, 160
Sørensen, Jørgen 20; *11*
Soutine, Chaim 9
Stang, Torvald 128
Steinberg, Stanley 93
Steinlen, Théophile 180
Stenersen, Rolf 89, 91
Strindberg, August 36, 38, 55, 62, 66, 68, 70,
73–4, 78, 81, 99, 103, 106–7, 112, 147, 205;
52
Swedenborg, Emanuel 75

Thaulow, Frits 20, 28, 30, 42, 46
Thiel, Ernest 104–5
Thiis, Jens 22, 35, 62, 68, 103, 111–12, 127–8,
139, 166; *145*
Tidemand, Adolph 27–8

Tolstoy, Aleksey Nikolayevich, Count 36
Toulouse-Lautrec, Henri de 52, 169, 180
Twain, Mark 107–8

Vallotton, Félix 52, 169
Van Gogh, Vincent 8–9, 16, 29, 52, 128, 139,
208
Velazquez, Diego 52, 103, 128, 198
Verlaine, Paul 36
Vigeland, Gustav 62, 68–9
Vollard, Ambroise 73
Vuillard, Edouard 52

Weber, Max 9
Wedekind, Frank 81
Weininger, Otto 81
Weiss, Ernst 78
Weiss, Joseph 93
Wennerberg, O. 125
Werenskiold, Erik 27–8, 31, 42, 45
Whistler, James McNeil 128, 198
Willette, Adolphe 180
Wojtkiewicz, W. 207
Wolf, Theodor 61
Worringer, Wilhelm 205

Yeats, Jack B. 9

Zahrtmann, Christian 28
Zervos, Christian 79
Zola, Emile 33, 36